J.M^cK

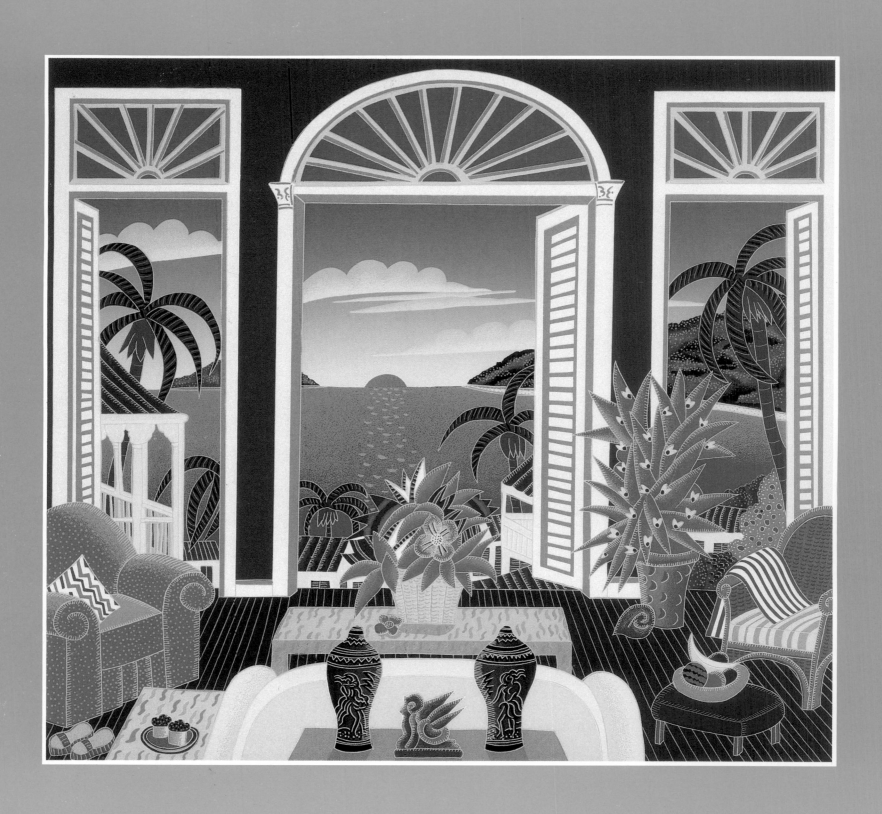

THOMAS McKNIGHT:
WINDOWS ON PARADISE

PREFACE & COMMENTARIES BY

THOMAS McKNIGHT

INTRODUCTION BY ANNIE GOTTLIEB

Foreword by David Rogath

Abbeville Press Publishers

New York

Printed and bound in Italy.

FIRST EDITION

A Balance House Book

Edited, designed, and produced by Marshall Lee

Art Director: Bettina Rossner

Library of Congress Cataloging-in-Publication Data
McKnight, Thomas.
 Thomas McKnight:windows on paradise / by Thomas McKnight.
 p. cm.
 ISBN 1-55859-126-5 : $75.00
 1. McKnight, Thomas—Sources. I. Title.
NE539.M4A4 1990 90-801
769.92—dc20 CIP

Grateful appreciation to the Management and staff of Chalk & Vermilion Fine Arts for their help in the preparation of this book.

Jacket illustration: *Mustique*
Frontispiece: *Martinique*

Contents

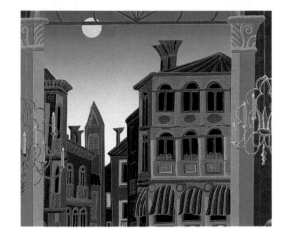

Foreword

In this rapidly moving world we are expected to meet the challenge of change: accept it, manage it, survive it. Over the years I have watched as Thomas McKnight has met this "reality" of modern life—and denied it. And we who have had the pleasure of exposure to the images he has created are the better for his denial.

In McKnight's world, no matter the number of full moons that have risen over the rooftops of Mykonos, no matter the passage of fashions or the seasons, there are places of transcendent timelessness, of peace and beauty, where change doesn't seem to exist and each chair, flower, or windmill is the ideal of its kind.

I have worked closely with Thomas McKnight for ten years as publisher of his graphics and during that time have seen his popularity grow exponentially. Besides the sheer beauty and elegance of his work, it is probably his creation of places that give us a sense of home that is responsible for his rapport with such a large public. "Home" in this case being not so much a place as a sense of yearning fulfilled, an allegory of paradise. To appreciate the work of Thomas McKnight we must not look for explanations but simply allow our feelings to carry us away.

DAVID ROGATH

Preface

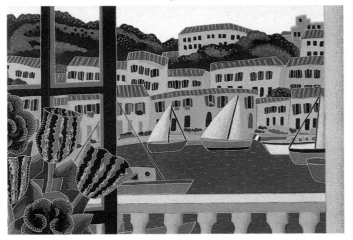

It may sound strange coming from an artist, but in the last few years I've lost interest in art—at least the "art" touted by most of the established museums, magazines, and art galleries. I flip through contemporary magazines and see nothing I'd covet for my walls. The art world has become a stock exchange for increasingly arid theories of what art *should* be. The capital raised goes to buy art commodities that dealers assure collectors will increase in value. But there is one major problem. Almost nobody wants to look at the stuff.

For me, art has an almost forgotten but most important function: to create images. Images are magic. They have the power to change perceptions, even lives. If you doubt that, remember the statue in Tiananman Square. Images create balance in our world, bring forth emotions we've neglected, add color to black–and–white lives. The creation of images is much more important than the current preoccupation of the art world: narrowly defining what is, or is not, art.

The images I make relate to a lifelong search for paradise, a land of harmony where the sun shines forever on a sparkling blue sea. Sometimes the search is within and results in fantasy realms whose landscapes are strewn with classical architecture and mythological beings. The outer search is for the perfect Italian fishing village, the ideal tropical swimming pool, the Greek island where delight will flow most smoothly.

However, the most realistic conclusion is that, certainly in the world today, the Garden of Eden exists nowhere but within. Still, there is always hope. Windows on paradise might open onto cloud castles but they could also reveal how the world will appear when we decide to take another path.

THOMAS MCKNIGHT

Introduction

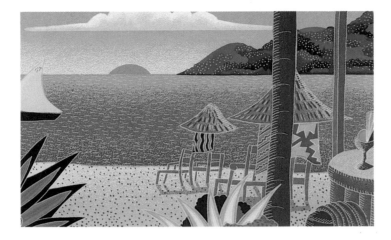

Some years ago, hurrying down a Greenwich Village Street, I glanced into the window of one of those print galleries that catch the eye and then disappoint it with their clutter of pop icons, sentimental portraits, decorator abstractions, and tired masterpieces. Expecting to see yet another Picasso dove, nude of Marilyn Monroe, and sketch of Paris in the rain—and to look away—I saw, instead, a silk-screen print of a window that made me look again.

It was the window of a hotel overlooking the Mediterranean, or maybe the Caribbean—some azure sea. I'm not sure now if it was a bay window, cozy with bright cushions and tropical vines and a parrot in a cage, or whether two airy French windows opened out onto a little balcony. But I remember luminous sky and sparkling sea gracefully framed in the white window, and the warm, clear colors of striped and flowered chairs facing the view, and something to eat and drink on a little table, and an open book, face down. It gave me the same feeling as a favorite line from Wallace Stevens: "Late coffee and oranges in a sunny chair . . . " Though there was no one in it, the little hotel room in the print was not empty. It was filled with warm sunlight, and cool breeze, and with something else . . . happiness.

I didn't know it, but I had just encountered the work of Thomas McKnight, a man who can paint happiness.

"*That* I could live with," I said to myself, envisioning it on the wall over the bed. "It would be my window." I already knew I'd never get tired of it. Something about the picture's structure contained its pleasure, so that it couldn't be drained away by repeated viewings, but would continually resonate and renew itself, like a harmonious chord in an acoustically perfect room. But, no. This was not a time to indulge myself in the expensive and time-consuming purchase of a print that would need to be framed, etc. Some other day. Regretfully, I tore my eyes away and hurried on. But I carried with me a persistent longing—to have that window on my wall, and more: to be in that hotel room on that eternal afternoon.

"Images are magic," Thomas McKnight says. Certainly his are. After journeying through the wonderful images in this book, it struck me that McKnight's pictures affect adults in exactly the way that certain children's-book illustrations affected us as children: they cre-

ate an enchanted world that we long to enter, and can, in fact, enter with the imagination. McKnight's radiant rooms beckon us in. The very absence of human figures on his tropical verandas and Mediterranean terraces becomes an invitation to the viewer to step into the story and become the protagonist: the guest, the friend, the lover, the lucky owner, the one who put the book down, draped the damp beach towel over the porch railing, and is about to reach for that tall, frosty glass. In most of McKnight's prints and paintings, we are offered food and drink. At times, he seems not so much an artist by calling as a boundlessly generous host. But his hospitality is elfin. These melon slices, steaming coffeepots, and bowls of ice cream are like the food in fairy tales, which, if you taste it, will make you small enough to slip through the keyhole of the magic world.

Once in that world, you could go up the staircase, or explore the other room whose open archway is so enticing; you might find out who is on that sailboat just entering the frame of the doorway [*Antibes*], or in the gondola nosing round the corner of a Venice canal [*Rio*

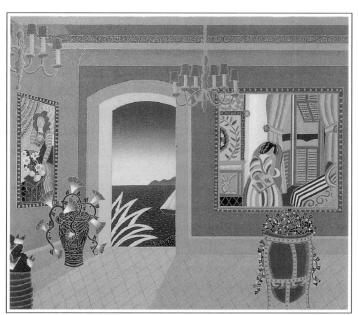

Antibes

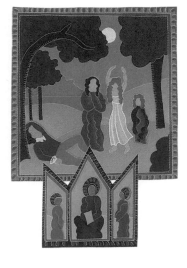

San Toma]. You could see whether the striped towel hung over the screen in a painter's Madison Square studio really does betray the presence of a nude model; and did the artist and his model abandon the easel to go to bed? You'd get to find out who your companion is—whoever you most wish!—for almost all these tables are set for two or more. This world has exquisite privacy, but no loneliness. While each McKnight room-with-a-view is squared-off, centered, here-and-now, none is closed off. Like the "spirit trail" that guides the creator spirit out of a finished Navajo rug, setting it free to create again, each of these pictures draws us first into itself and then beyond it. Some detail—a half-read book, a mirror catching a corner of sky, a painting on the wall of another season or century or continent—gives the imagination the opening it needs to "dream the dream onward," in the words of Jungian psychologist Arnold Mindell.

It is this power to bewitch us into telling ourselves stories that Thomas McKnight's work shares with the best children's picture

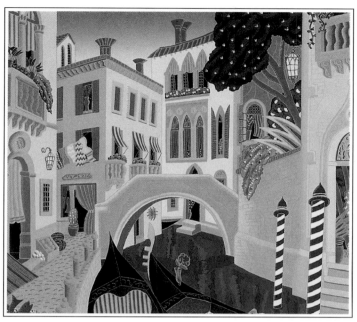

Rio San Toma

books. So it was a delightful confirmation to come across McKnight's own words in an earlier book: "I suppose every life has a leitmotif—a guiding vision. Mine has been a search for paradise, a nostalgia for an earthly Eden that possessed me even as a child. Then it was envisioned in terms of illustrations in children's books: the *Golden Encyclopedia* with its counterpaned landscapes, or Tuffy the tugboat lost in a babbling mountain stream and found in a fogbound harbor by the sea." This provokes an exciting speculation. Is it possible that the intensely magical early memories we attribute to the freshness of a child's mind are in fact the work of an imagination already awakened by art, in the form of lullabies, children's books, and fairy tales? Were the images of art teaching us to see and feel magic in the world even *before* our first memories began to form? If so, then the childhood moments for which we are most nostalgic—so piercingly evoked by McKnight's summer lakes, sandy beaches, and winter fireplaces—were moments when real life was flooded with the power of imagination, and we knew ourselves to be living inside a mysterious picture or story. Though they come

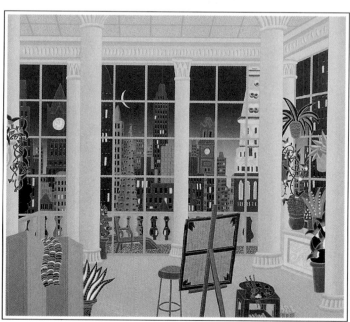

Madison Square

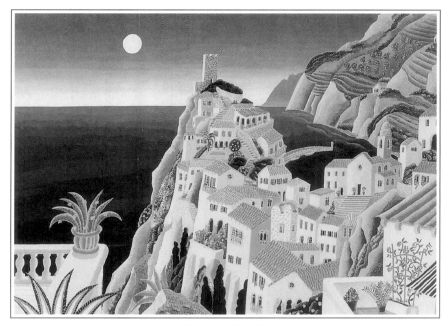

Vernazza (detail)

less often to the careworn adult, those moments when the inner and outer worlds are one (a secret meaning of the open window?) are the moments of happiness we search for again and again. It is reassuring to think that such moments depend, not on recapturing lost innocence, which is impossible, but on reawakening the imagination, which can be done with the help of travel, pleasure, and art.

Glimpses of washed perfection, of the earthly paradise found, often happen when we are traveling, and travel is a quest for them. The Wordsworthian Romantic view would be that an adult on a trip is like a child again, freed of responsibility and discovering a world for the first time. But that gives too little credit to the world being discovered. Why do we, like Thomas McKnight, seek out places like the Greek island of Mykonos or the Italian seacoast towns of the *Cinque Terre*—or their counterparts in Mexico or Thailand? Not simply for the refreshing shock of the strange. "Voyages to France, to Greece, to Korea," McKnight has written, "became revelations of how the world could be ordered better . . . than by the bland suburban style to which I was linked by birth." The places that so enchant us in his pictures, especially those of the Mediterranean world, are places enchanted in reality by their native art of living, and of designing the living environment to harmonize with nature and satisfy the human soul. When we visit such towns, we exclaim that they are "picturebook" places, acknowledging that people once built their actual homes with a fantasy we now confine to the pages of books for children. Again, McKnight is painting moments when the imagination is kindled by art embracing nature, so that life itself takes on the magical luster of a painting, poem, or story.

Mykonos and Venice are works of art to live in. So, in its own way, is Manhattan. But in a strange way old Europe is more democratic, for there soul-nourishing beauty is a free and universal gift of tradition; in New York it is a privilege of wealth. The foreground of almost every McKnight image is a lovely refuge, a protected niche or perch that frames and tames the powers of nature even as it lets

them in. In Manhattan, ambition and commerce *are* the forces of nature, expressed by the raw vertical striving of the skyscrapers. To be less than rich is to be mercilessly exposed to the street-level grinding of those forces; one must have money to be lofted into twinkling space, to dine in peace among the civilized culminations of the Art Deco spires. And one must have money to flee the city as beautifully as McKnight does in his fantasies of Barbados, Palm Beach, and Newport. "Most people only dream of paradise," he observes wryly. "Here [in Manhattan] people buy it." McKnight's obsessive return to rooms only money could buy must be understood not as snobbery, but as a portrayal of the freedom from necessity that is part of every vision of paradise. His paintings redistribute the true wealth, which is beauty; they invite us to enter and inhabit rooms more perfect than their counterparts in reality—rooms of enameled brightness and clarity that never need to be cleaned.

As we visit more and more of these rooms, without losing freshness they grow familiar, just as one can recognize as Bach or Mozart a piece one has never heard before. The same pieces of furniture and art crop up in rooms supposedly oceans apart, welcoming us like old friends: the fat blue chair with spiral armrests, the chair with the round back and vertical stripes, the winged sphinx sculpture, the statue of the cubist embrace. These recurrent motifs tip us off that a room with a sea view in Porto Ercole, Italy, and one on the Caribbean

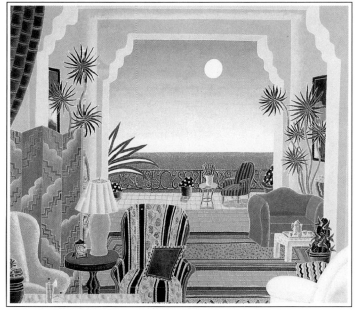

Porto Ercole

island of Tortola are versions of the same archetype of the soul's home—an archetype which, like that of the ideal lover, can be endlessly pursued and projected in the world without ever being exhausted, or quite fulfilled. Maybe the abstract embrace suggests the fleeting union of the artist with his nymph, his vision, before it slips away to be pursued again. And the visual echo of crescent moon and crescent sail—how many of these pictures, and pictures-within-pictures, can you find it in?—may hint that our earthly journey reflects a spiritual one. But whatever their esoteric resonance, these motifs also give pure formal pleasure, like recurrences and symmetries in

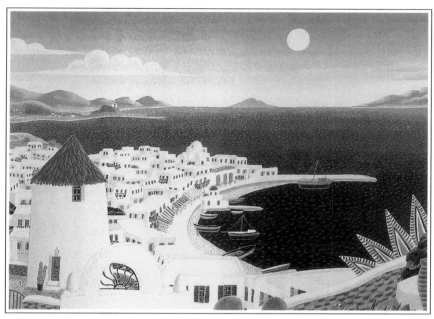

Mykonos Harbor (detail)

music. The crescent appears again in the Mykonos harbor, and in many a Caribbean cove and sandy beach. It's appropriate that McKnight calls his series of images "suites"; in both form and function, music is the art his art most resembles. The careful composition and color palette of each painting correspond to structure and tonality in a piece of classical music. And these elements are chosen for a particular effect.

McKnight is candid about the purpose of his art. To give pleasure is, for him, no frivolous diversion; it is more like an act of healing. "By gazing upon balanced and beautiful imagery," he has written, "one can restore what is missing." If, as Shakespeare wrote, "music hath charms to soothe the savage breast," McKnight intends his images to soothe and compose the harried post-industrial soul, tattered by stress and ugliness. "The eighteenth-century Neapolitan philosopher Vico thought that civilization passed through four ages—of gods, heroes, men, and chaos," McKnight wrote in 1984. "Obviously, with our failing institutions and systems of belief . . . we live in the Age of Chaos." Our disenchanted utilitarian eye has cast its gray film over the actual world, so that all we see around us reflects our own soullessness. And yet: "It is my belief, shared by others more knowledgeable than I, that we are at the end of one Great Year and at the beginning of another . . . in time a new myth can be born." But first the dismembered soul has to be recomposed and revived, and a McKnight image is a cool drink held to its lips. That club soda with lime on a Florida patio could be the elixir of the gods.

For if we are about to enter a new cycle, it would start with a new age of the gods. How curious, then, that as in the great rebirth called the Renaissance, we are seeing a renewed fascination with ancient Greece, the Greek gods, and Greek myths—not as true history or religion, but as the archetypal wellsprings of imagination, the "Dreamtime" of our culture. This fascination appears in the wild popularity of Joseph Campbell's *The Power of Myth*, and in the works of psychologists such as James Hillman (*Re-Visioning Psychology*), Ginette Paris (*Pagan Meditations*, *Pagan Grace*), and Jean Shinoda

Bolen (*Goddesses in Everywoman, Gods in Everyman*). It appears, too, in some of Thomas McKnight's other work: startling visions of great night-black goddesses and blue gods, tiny winged nymphs and satyrs, that he admitted in 1984 might be "closest to my core." In this book, the gods have discreetly withdrawn behind the scenes, except for making an occasional appearance in works of art: a fabulous Nubian goddess, with rebozo-striped wings and a haunch coiled like a conch, crouches over the purple sofa of—no less—a Manhattan penthouse! Yet every McKnight print shows a world divinely alive; his beaches smile, and the warm pagan perspective of the Mediterranean presides over even his New England reveries. This is a perspective that does not set spirit against flesh, but finds its icons in the beauties of this earth and takes sensuous delight for holy communion.

These pictures, then, offer refuge from ugliness, but they are not escapes. They are reproaches, reminding us that, in James Hillman's words, "The soul is born in beauty and feeds on beauty, requires beauty

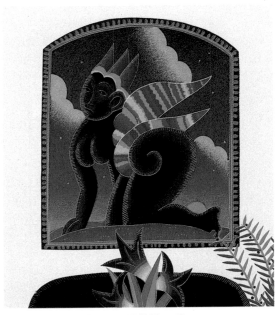

Murray Hill (detail)

for its life."* They are refreshments in the deepest sense, antidotes to the deadening sights of mall and sitcom. They quicken. And though no place on earth quite measures up to that inner image of paradise, these pictures do suggest how beautiful the real world still is, and still could be if we cared for ourselves enough to cultivate it. McKnight's vision is very different from the despair of the radical ecologists, who would expunge man from the earth as a malignant mistake and let the wilderness take over. In his view, man is an essential part of nature, who breathes in its vitality and breathes out order. The gods who govern McKnight's work are both patrons of culture: Apollo, lord of music, is present in the composed proportions of the architecture, Aphrodite in the bright, textured fabrics and ornamental gardens. Both charge us to appreciate beauty and to surround ourselves with it.

Images, Thomas McKnight insists, "have the power to change perceptions, even lives." It's true. A sojourn among his images has

*From *The Thought of the Heart* by James Hillman. The Evanos Lectures. ©1981 by the Evanos Foundation, Ascona, Switzerland. Spring Publications, Dallas, 1984. p.25.

changed my seeing and feeling. First of all, looking at them reawakened memories of my own magic moments while traveling, moments I hadn't thought of in years. Mother-of-pearl twilight in the town square of Cuernavaca, black rooks streaming into the cupola. A picnic on the grassy wall of Old Sarum, the ancient ruin near Stonehenge. A thatched shelter by blue-green water on the West Indian island of Bonaire; nearby, a beach of smooth coral tubes that made fluty sounds when you walked on them. A tiny Shinto temple that was a slice of silence in busy Tokyo. You'll have your own list. None of my own images looks like anything McKnight has painted, so what made me remember them? The nimbus of the enchanted moment—the *feeling*, not the view, that McKnight paints over and over again: "This is heaven. I've come home."

Then I actually *came* home, to my little apartment. The first thing I noticed was that the philodendron vine looked great over the bedroom archway, dark green dancing against white. I'd trained it to grow there—I'd just never *seen* it before. Nor had I noticed how consciously my different-colored cats posed themselves on the levels of their carpeted "tree." How did they know what a composition they made? Why hadn't I seen how much beauty there was here already? Of course, it could be improved upon. That naked black TV cable had to go. Maybe a set of hanging baskets for the green peppers and red onions . . . pink and purple petunias under the skylight . . . and a window. No—a pair of tall French windows, thrown open on a smiling beach and azure sea.

I had been wrong, you see, to walk away from it. Thomas McKnight tells us that beauty can't wait. We *must* indulge ourselves. Our souls, and the soul of our world, depend on it.

ANNIE GOTTLIEB

NEW ENGLAND

New England to me represents coziness, familiarity, what used to be called "old shoe." It is the essence of America—its houses, churches, and barns are imitated as far away as Beverly Hills. It is where "nothing happens"—at least lately. There hasn't been a war since the Revolution. Its resonance lies in other directions—medical, scientific, intellectual. It is part of the youthful memories of many adults from other parts of the country—so many schools and universities preside there over leaf–strewn towns. The only time I ever lived in New England was during my own college years and I must confess I couldn't wait to get out, to see the great world, to have adventures. For a twenty–year–old, coziness is not a first priority in life.

HYANNISPORT
(overleaf)

Hyannisport represents this view of New England. It is a study I could have located in other towns—perhaps that is why it has proven to be one of my most popular prints.

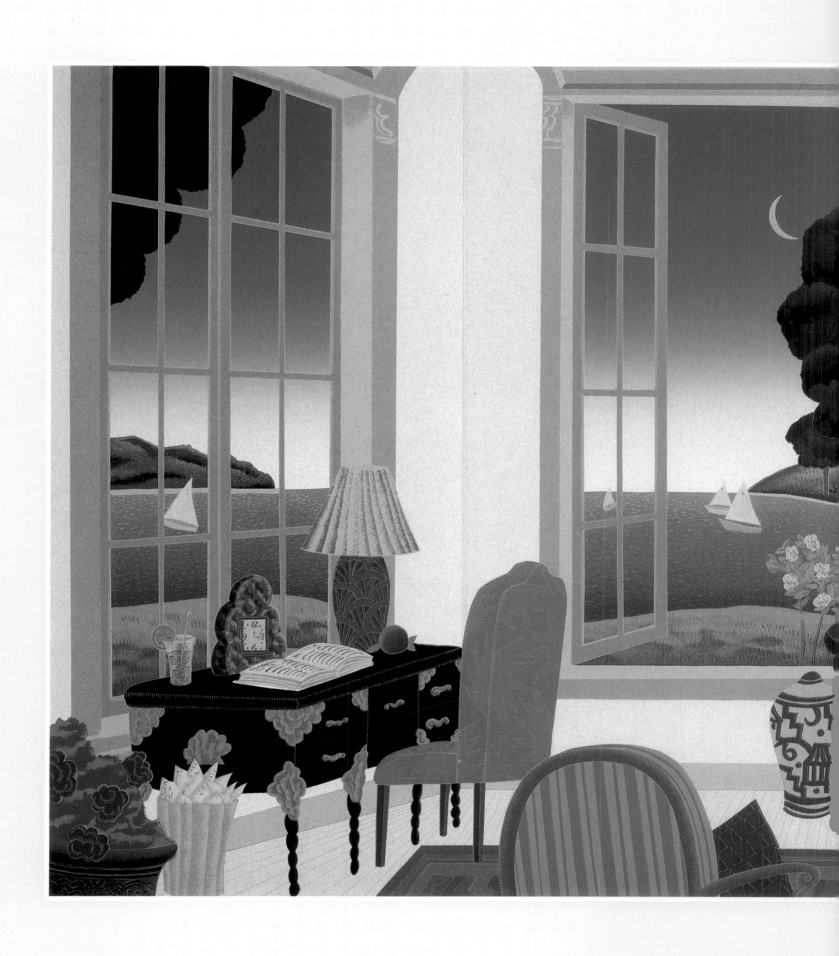

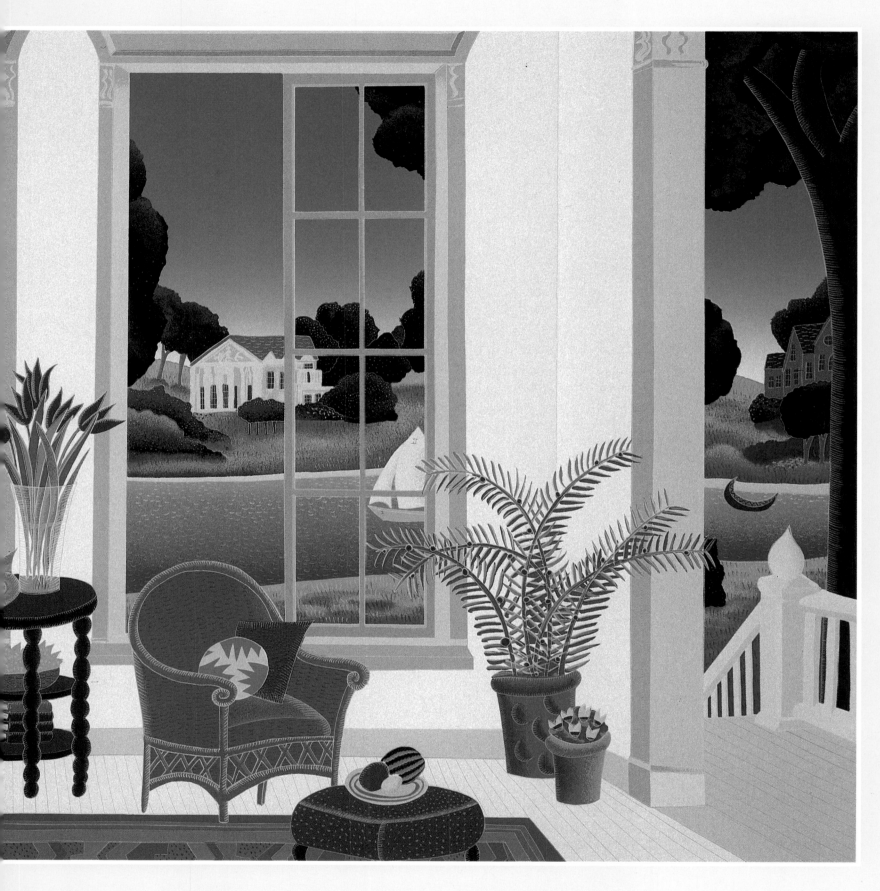

HYANNISPORT

Once a major Boston dealer in my work told me (from a commercial point of view) which were the elements that made certain prints best–sellers. He said his ideal print would have a high horizon, a sweeping view, a piano with champagne glasses on it, a fireplace, warm colors, and, naturally, would be in Boston. Since I was there at the time and was staying at the Ritz Carlton, I sketched a fantasy of the Boston Public Gardens from my hotel window. I included all the elements he'd mentioned, rather as a joke. (Although it was October, I gave the park the green leaves of May, because I have poignant college memories of that lilac–time after the hard New England winter.)

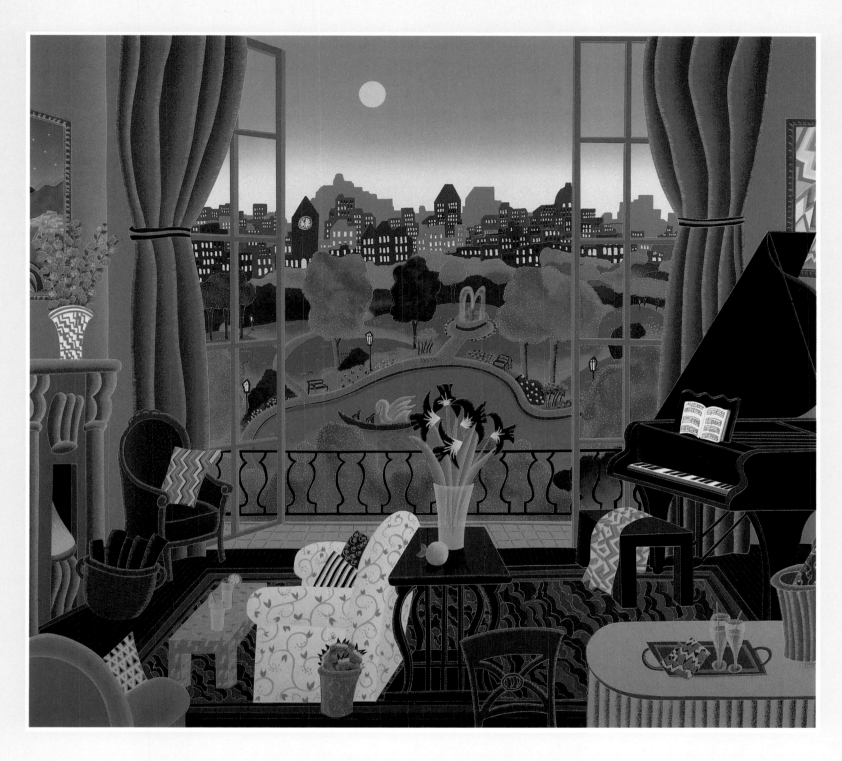

BOSTON PUBLIC GARDENS

What could be more American than the official print of the United States Constitution Bicentennial Commission? Former Supreme Court Chief Justice Warren Burger and I signed a couple of the prints together—the only prints of mine ever officially jointly signed. It was a sweltering June day in the New Hampshire State House during celebrations for the Constitution's final ratification. The building smelled of wax and old wood and reminded me of the school where I went to kindergarten. Meeting the former Supreme Court Chief Justice was like being introduced to your teacher the first day of school— a little scary but fascinating all the same.

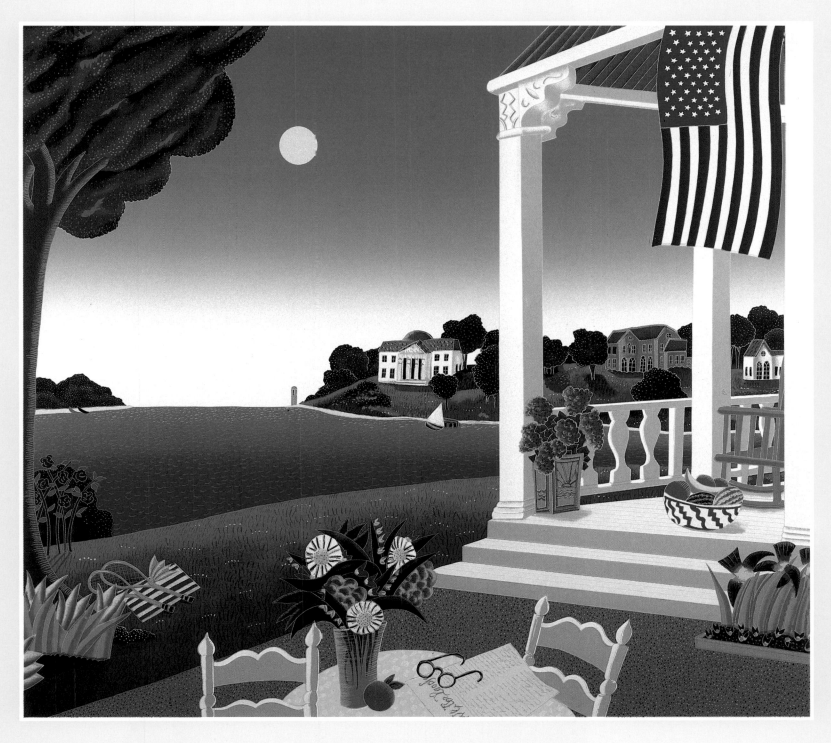

CONSTITUTION

The motif of the traveler as a cloaked man with his odd dog is a theme I used in my work more often when I was younger. I traveled lighter through life then, and the path was less clear and fraught with more peril. The landscape the wanderer traverses here is reminiscent of that around Middletown, Connecticut, where I attended college. Today it is a tame, domesticated arrangement of farms, villages, and woods. The once–fierce Indians who used to roam here survive only in tongue–twisting place names.

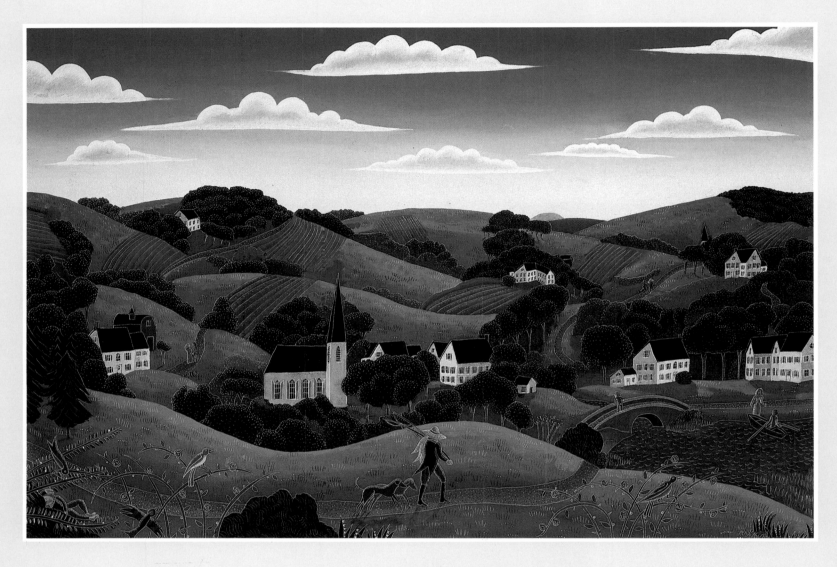

CONNECTICUT VALLEY

A collector of my work lives in the house that was the inspiration for this work. As far as I know, he is the only one who has bought one of each of my prints published almost since the beginning. In this huge old Federal–style townhouse overlooking Boston Commons, the high–ceilinged rooms are filled with paintings and sculpture—everything from Dubuffet to Giacometti to Warhol. One item he doesn't own is the Greek scene I made up for the mantel.

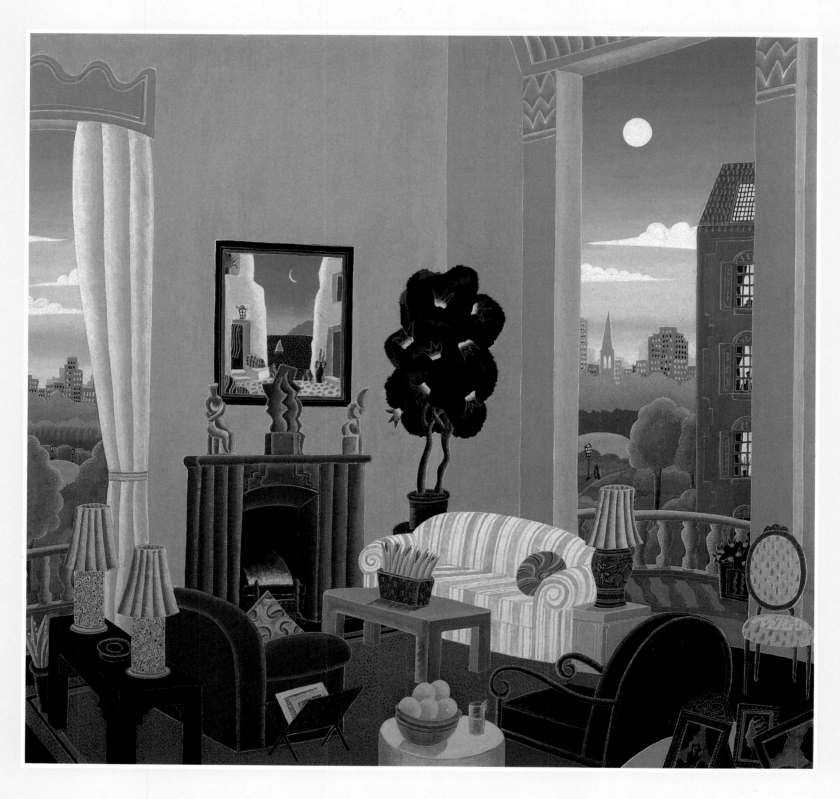

BEACON HILL

The words Old Lyme remind me of a pleasant shore town in Connecticut, a color, and a brand of shaving cream. This title was affixed after the print was finished because it fit two of the three attributes. Interiors like this are for me what still lifes of vegetables and fruits were for Cézanne. These variations on themes possess a personal emotional resonance for the artist that does not die after one painting. For example, an interior with arched openings to a garden and the sea beyond means something important to me. I vary the motif by color, place, and perspective, but each time a new facet of its unfathomable meaning is born.

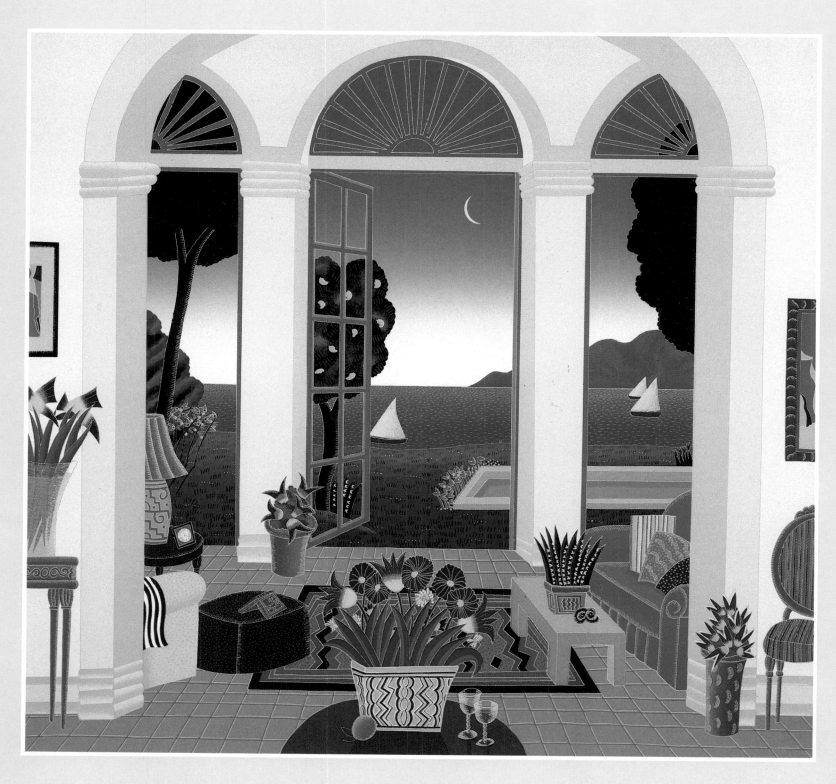

OLD LYME

The title of this print is a tribute to Sidney Hamer, the late Washington, D.C., antiquarian bookseller. His reverence for and familiarity with the past created a whole new dimension in the life of a thirteen–year–old boy raised in cookie–cutter suburbs. His bookshop was called Leamington, after the English spa town he came from. Behind his glass–fronted bookcases were all kinds of wonderful old books and manuscripts. Actually to leaf through a Nuremberg Chronicle of 1492 with its strange woodcuts, or touch a note in Haydn's own hand, was like touching history.

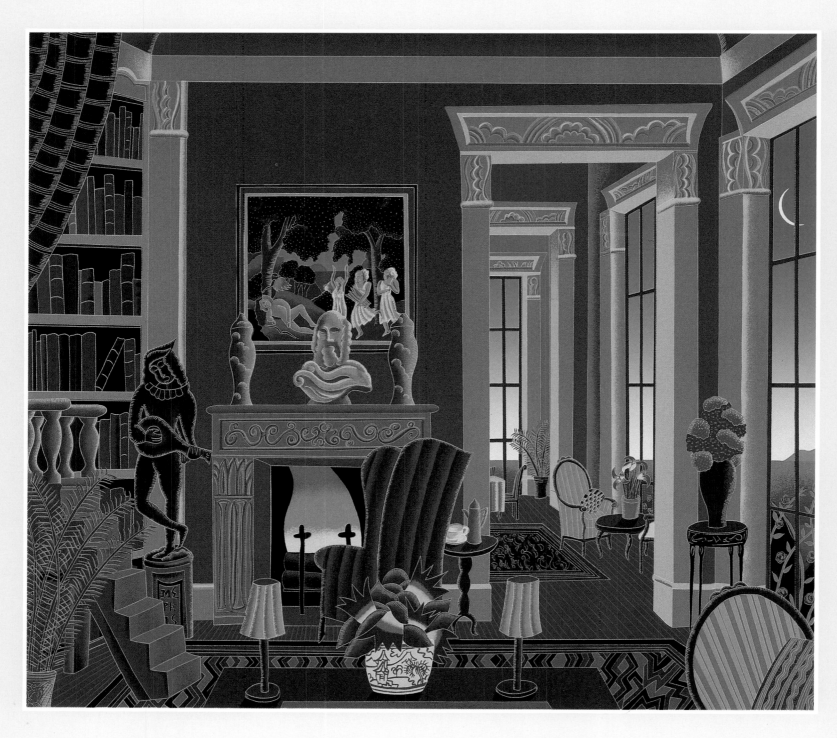

LEAMINGTON

NEW ENGLAND SUITE

Although I named the images in this suite after New England towns and places, they are all fantasies—attempts to get at the archetypal heart of the meaning of New England. I included landscapes in all four seasons, which in New England stand out stronger, perhaps, than anywhere else in America. My most intense and delightful memories of New England are seasonal events—walking through dried November leaves in a chilly twilight while a bell on the college tower tolls the hour, or feeling the first cool fall breeze in late August on a Newport cliff as a regatta flashes by. The intense quiet of snow falling at night is equaled by the silence of a drowsy July afternoon. The yearning of lilactime in May is sister to the smoky haze of Indian summer.

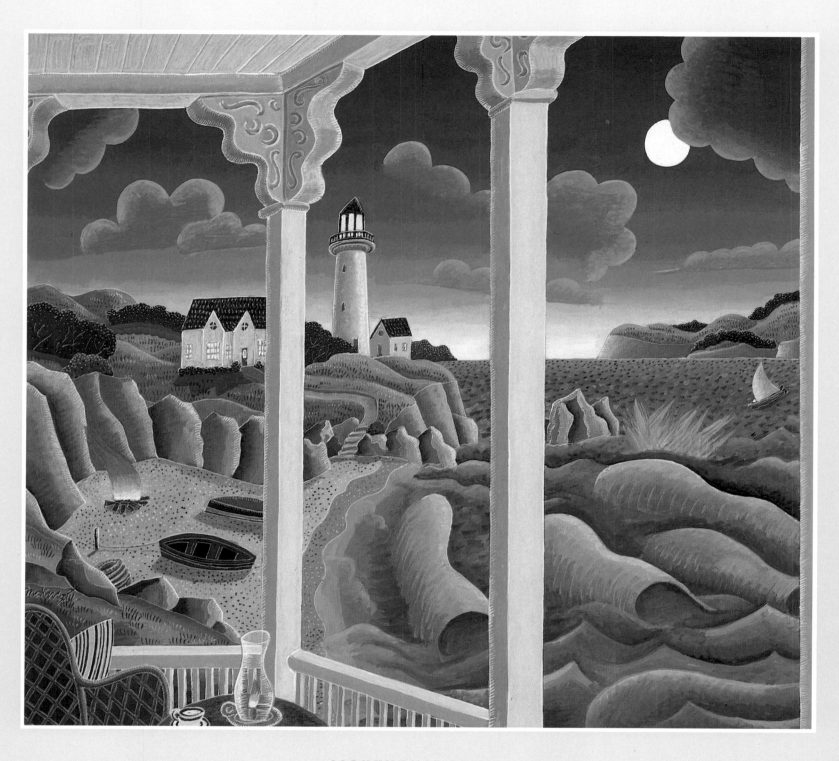

LIGHTHOUSE POINT

New England Suite

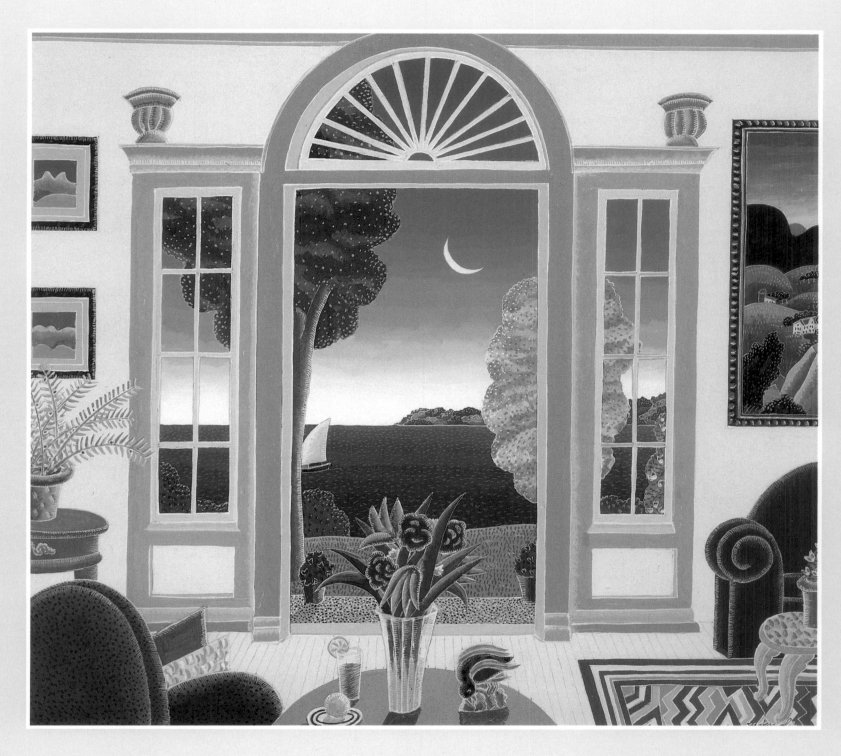

STOCKBRIDGE

New England Suite

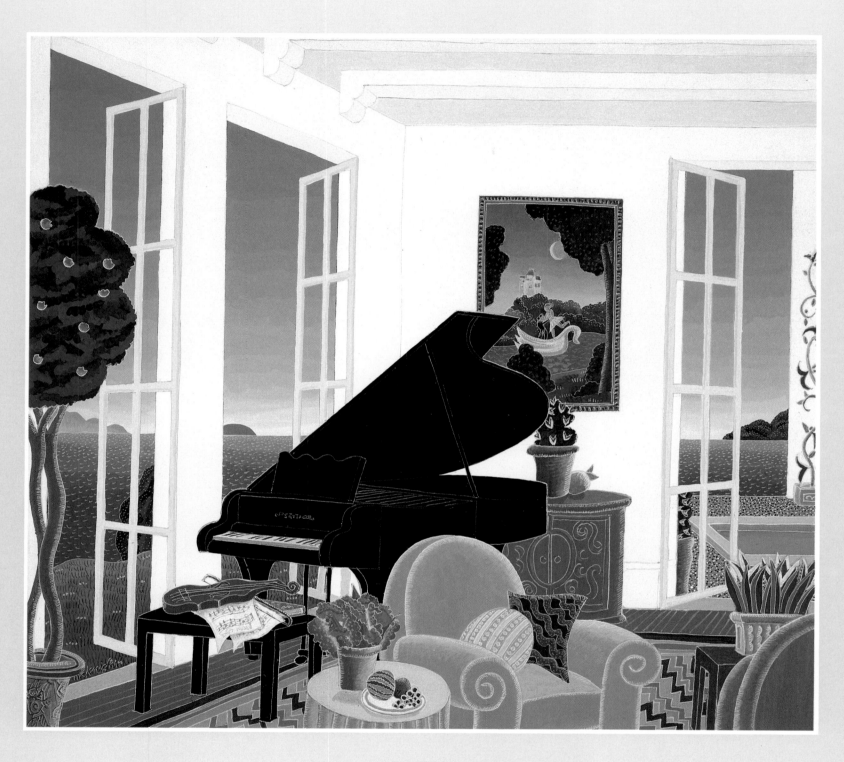

SWANSEA
New England Suite

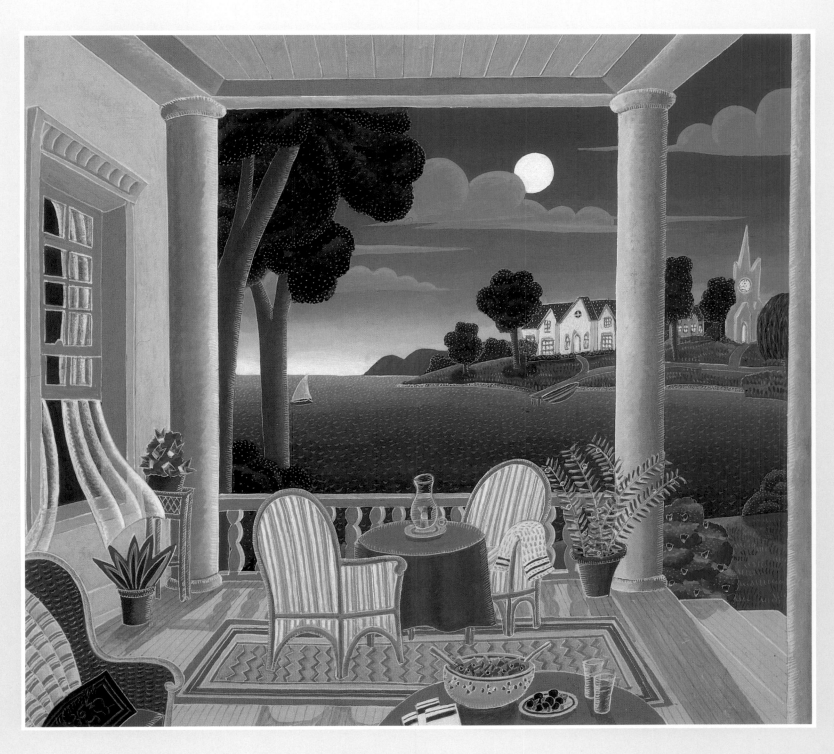

PEACOCK POINT
New England Suite

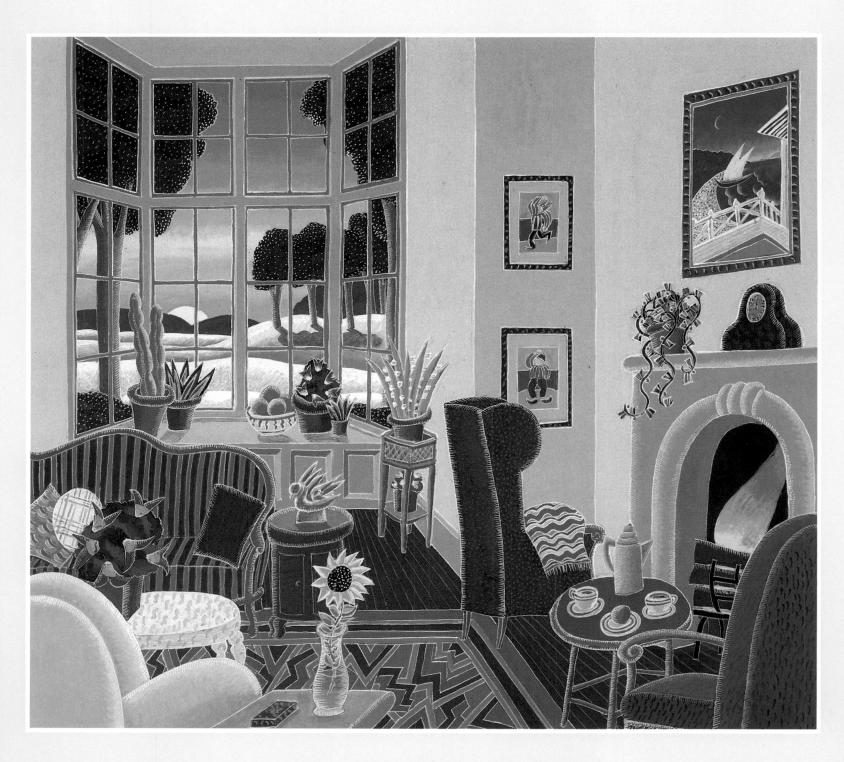

CONCORD
New England Suite

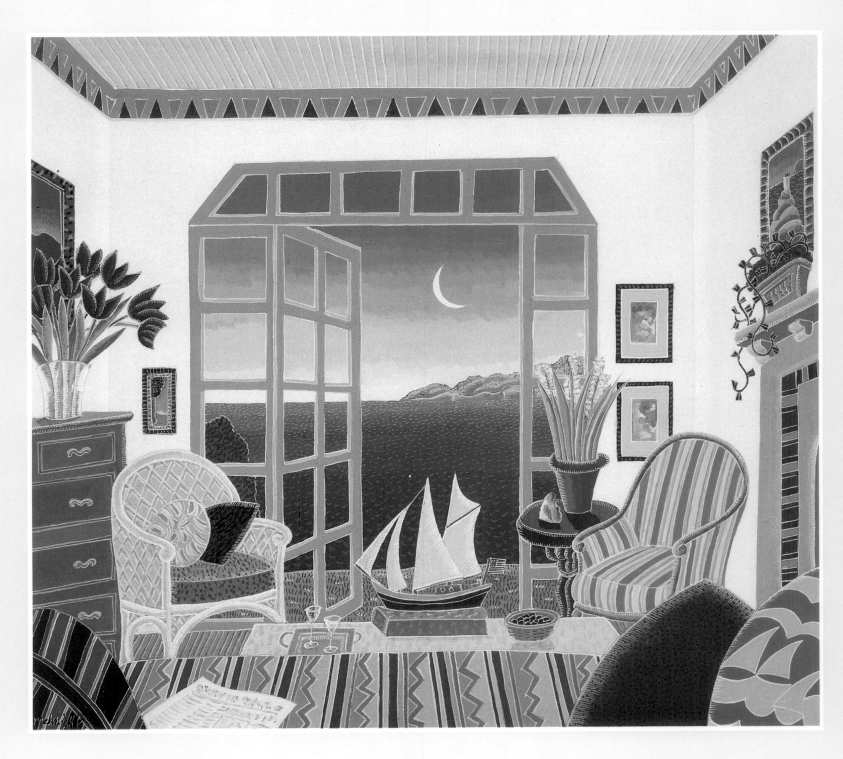

GLOUCESTER

New England Suite

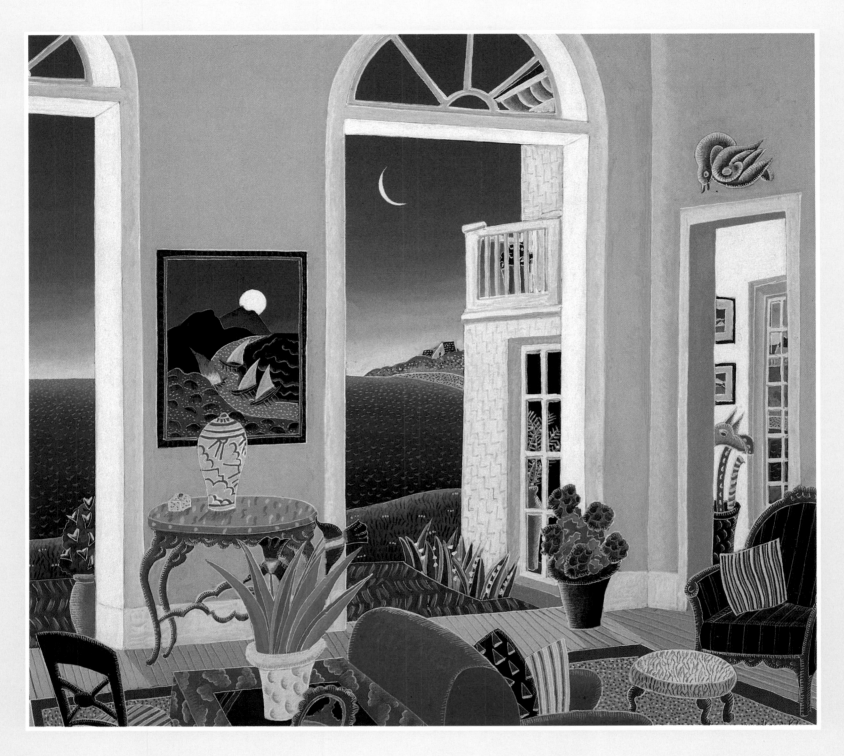

PROVINCETOWN
New England Suite

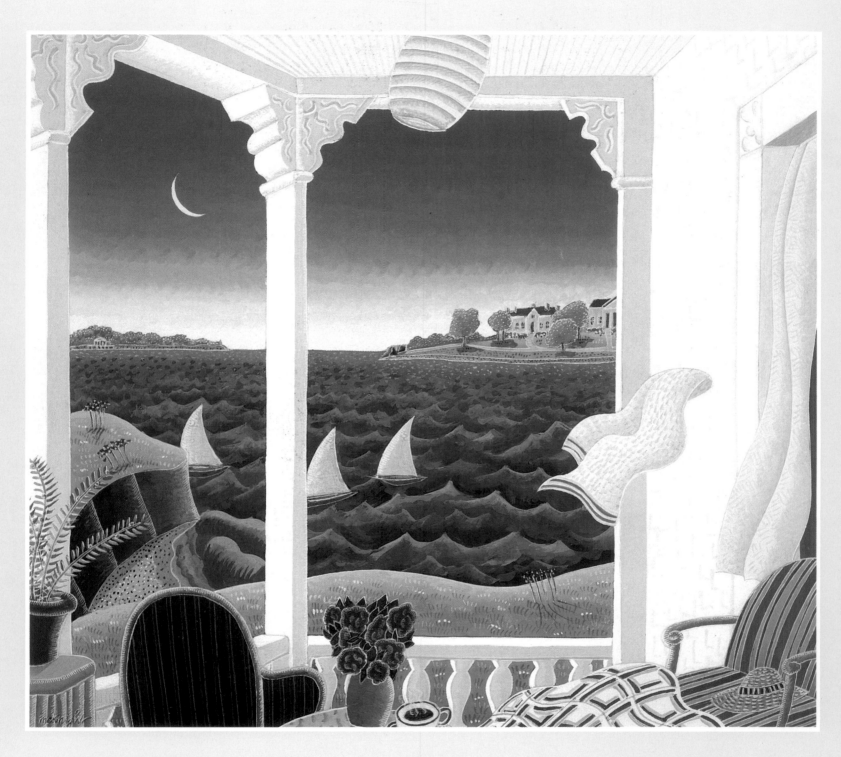

CAPE ANN
New England Suite

MYKONOS

The Mykonos I know is an island where I can place myself outside of normal life . . . stay up all night reading Balzac . . . sleep in the sunshine on a sun–warmed rock . . . reflect on the next step in life. Telephones and mail are chancy at best, so the world of obligation stays away. For years I traveled there with a roll of blank canvases under my arm and returned three months later with an exhibition—now I go for two weeks and take my sketchbook.

MYKONOS WINDMILLS
(overleaf)

The official symbols of Mykonos are its windmills and Petros, its pelican. The real symbol is the wind, a cool, northerly trade wind called the meltemi, *which brings travelers, scours the beaches, rustles through the grain fields and over dry rock walls, and loses itself in the white labyrinth that is the town of Mykonos.*

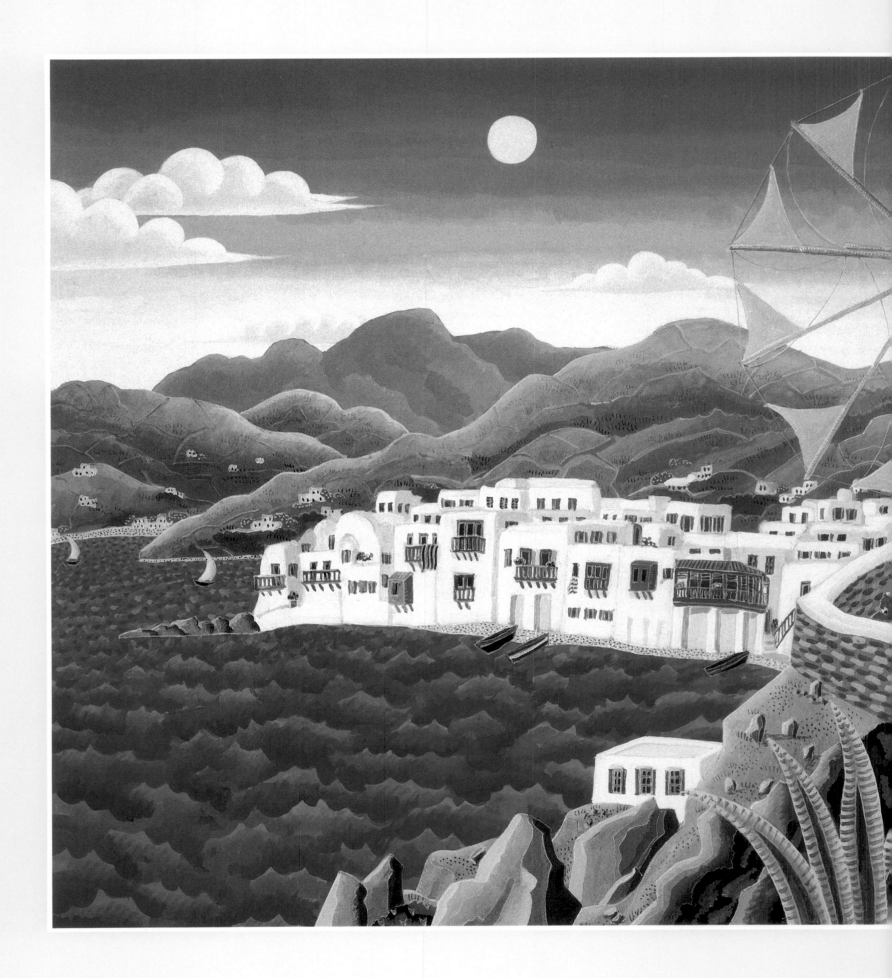

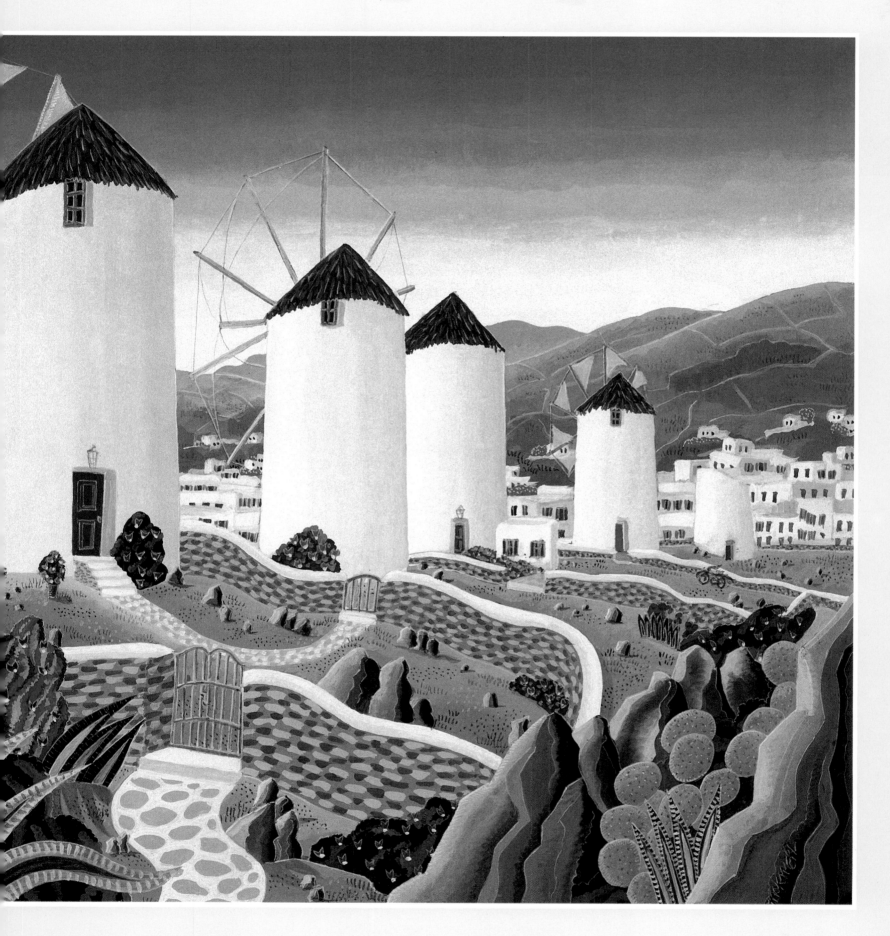

MYKONOS WINDMILLS

Tourists know this as Taxi Square, where, if you are lucky, you can arrange a ride into the deep interior—all five miles of it. This is actually named Mavrogenous Square, to commemorate a local nineteenth-century heroine, the pedestal of whose marble bust is often surrounded by temporarily stored backpacks. The T-shirt with figures is a tribute to my oldest friend from Mykonos, Michael Cohen, who makes them and whose love for Mykonos is more persistent, but not stronger, than mine.

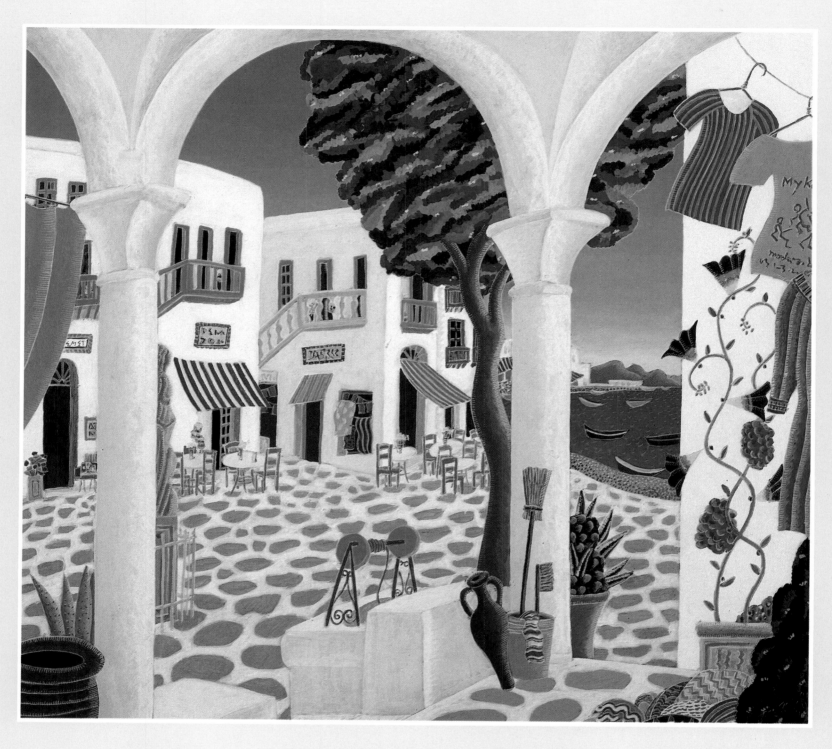

CHORA

There is a chic sundown bar in Mykonos called Caprice, where one orders complicated tropical drinks and watches the gilded youth of Athens and elsewhere at play. I made a print of it in my second Mykonos suite. Now I imagined the bar space turned into a Cycladic living room. I could not resist its arched window, like a blueprint of the setting sun. Themes are worth variations when, like a fat grapefruit, they do not give up all their juice with one squeeze.

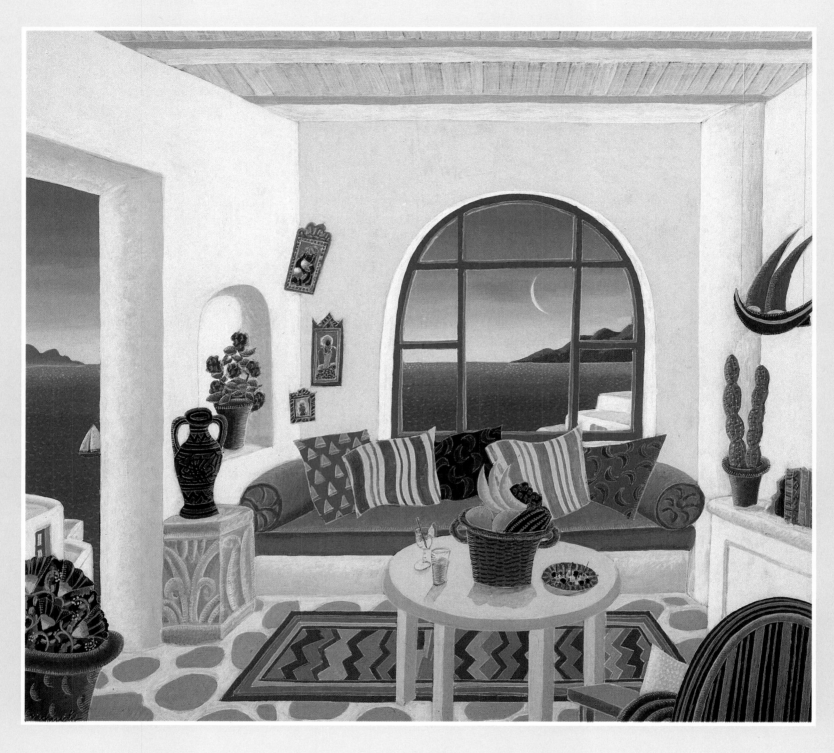

PANORMOS

RETURN TO MYKONOS
SUITE

What can I say about my third portfolio of Mykonos images? The first was based on the island's most typical views, the second on taverns and bars where the tourists spend most of their time away from the beach. This suite is a mixture of fantasy and reality, and attempts to arrive at the heart of this dry, white, Cycladic island. Why does it resonate so with my soul? Why does an image of Mykonos mean more to me than one of any other equally picturesque place? Did I spend past lives here? Am I indebted to this Aegean paradise for some psychological bonding built up over my years here? If as an artist I am ever identified with a certain locale, as Hokusai is with Mount Fuji, Canaletto with Venice, or Van Gogh with Arles, I hope it will be Mykonos.

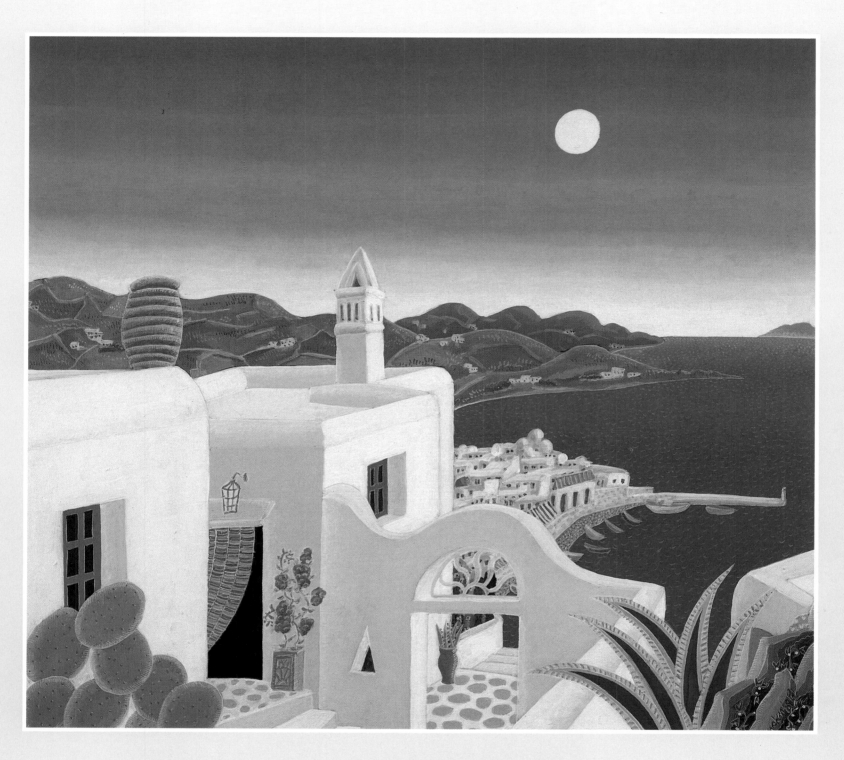

KAMINAKI

Return to Mykonos Suite

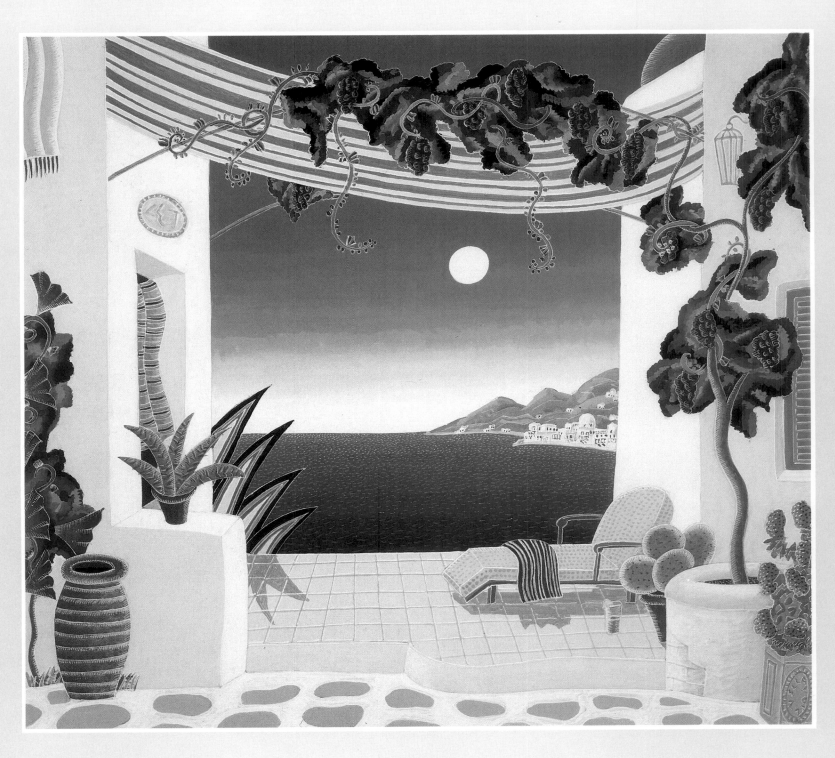

KORFOS

Return to Mykonos Suite

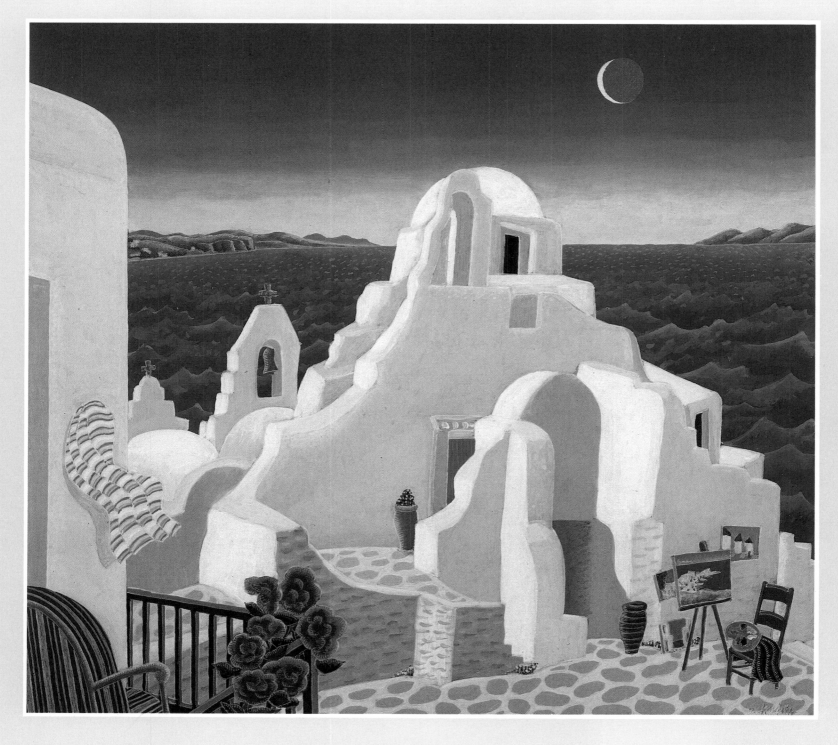

PARAPORTIANI

Return to Mykonos Suite

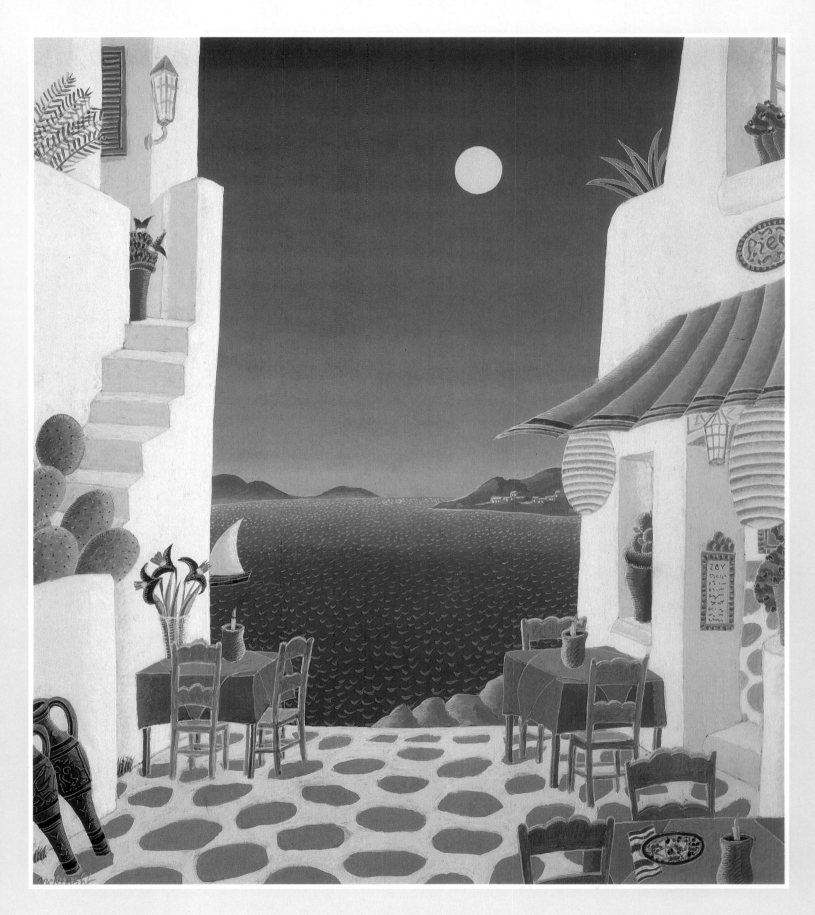

VENETIA

Return to Mykonos Suite

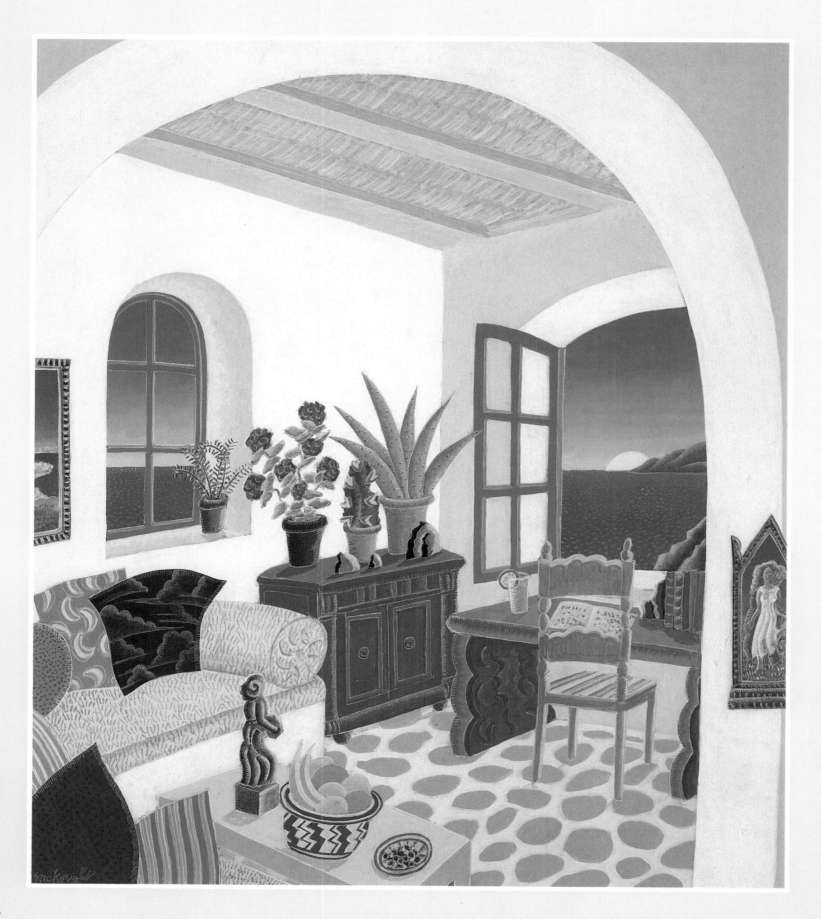

KALAFATI

Return to Mykonos Suite

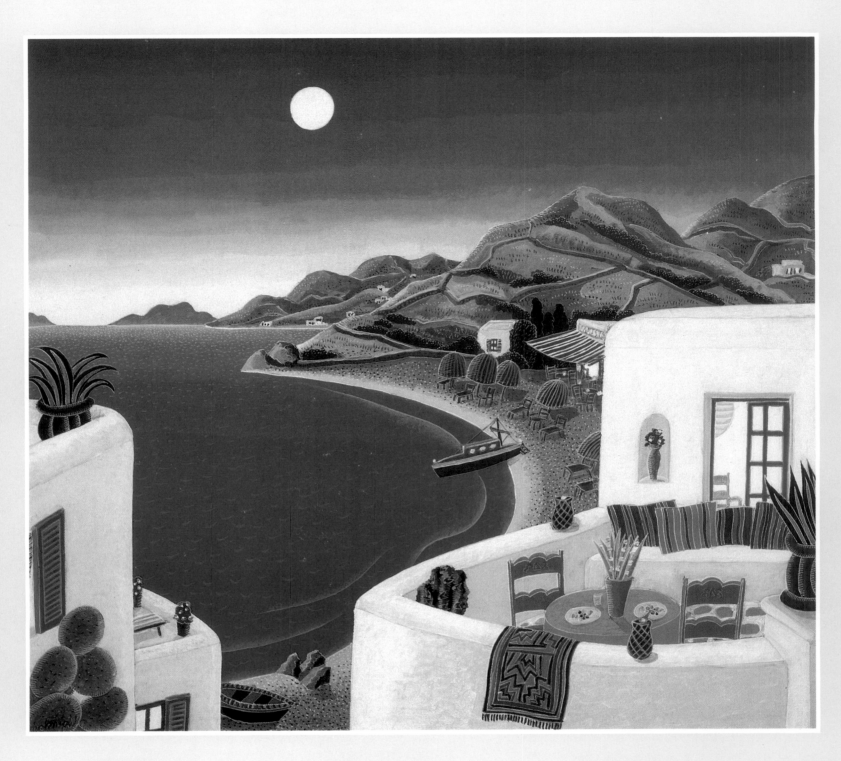

L I V A D I
Return to Mykonos Suite

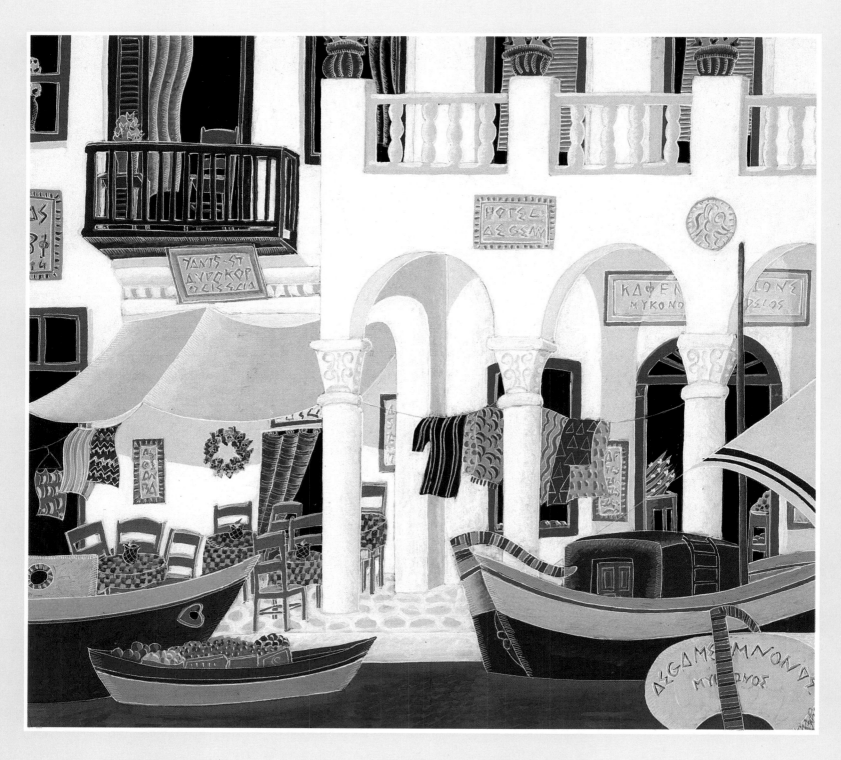

PARALIA

Return to Mykonos Suite

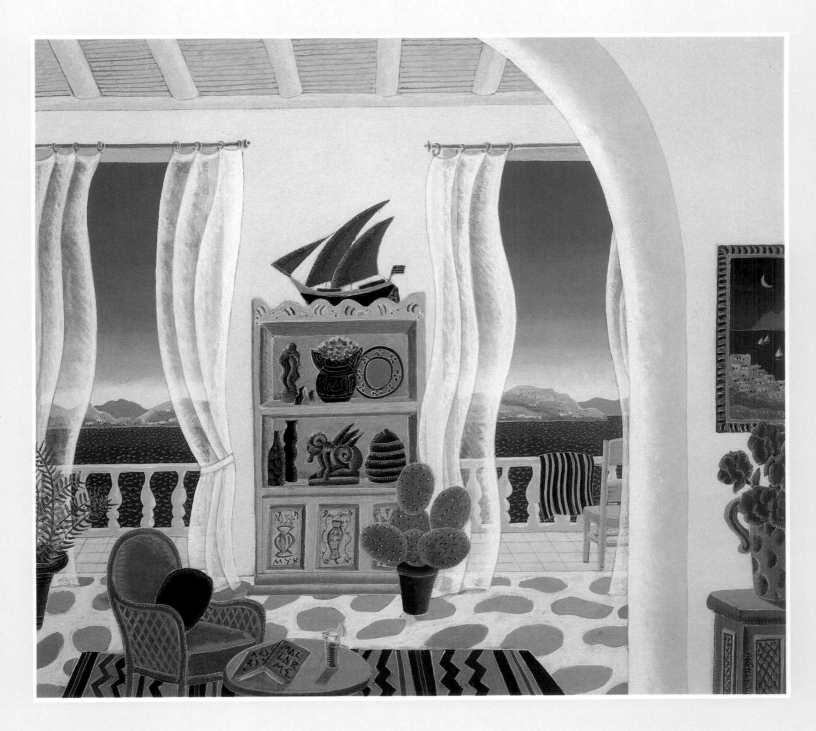

ALEFKANDRA

Return to Mykonos Suite

MYKONOS HARBOR
(overleaf)

Mykonos is a vacation island that has fine beaches and rocky coves, but for me its archetypal image is its whitewashed cubist labyrinth of a town that jumbles around the curves of its harbor and coastline. The view of its piled–up shops and houses is beautiful when you arrive by sea, but spectacular from the road that leads out of the island's interior. After crossing a rolling plateau of dry, boulder–filled fields fenced with rock and punctuated by oasislike farms, one reaches the edge and there is the port, spread out below like an amphitheater. The sea is the stage, cruise boats and caiques riding at anchor are the players. In the morning, with the whitecaps on an indigo sea or at twilight when the air is apricot, this view is as much the essence of the place as Manhattan's skyline or London's Big Ben.

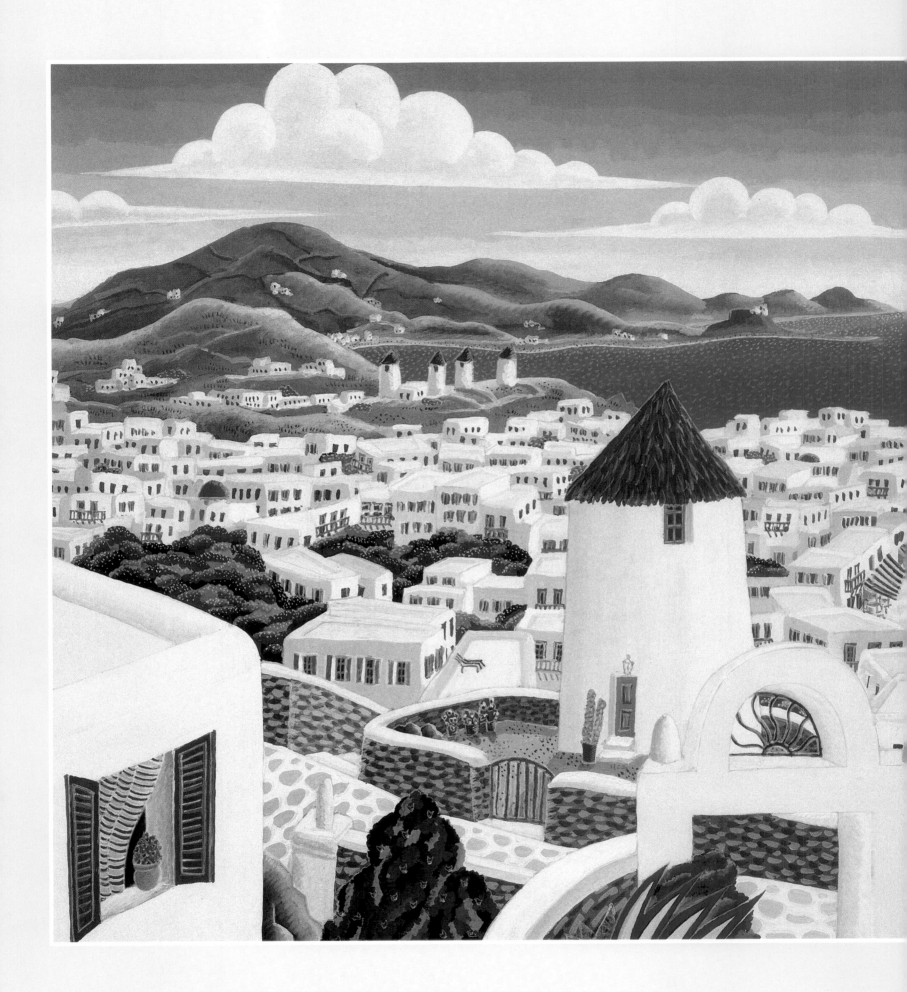

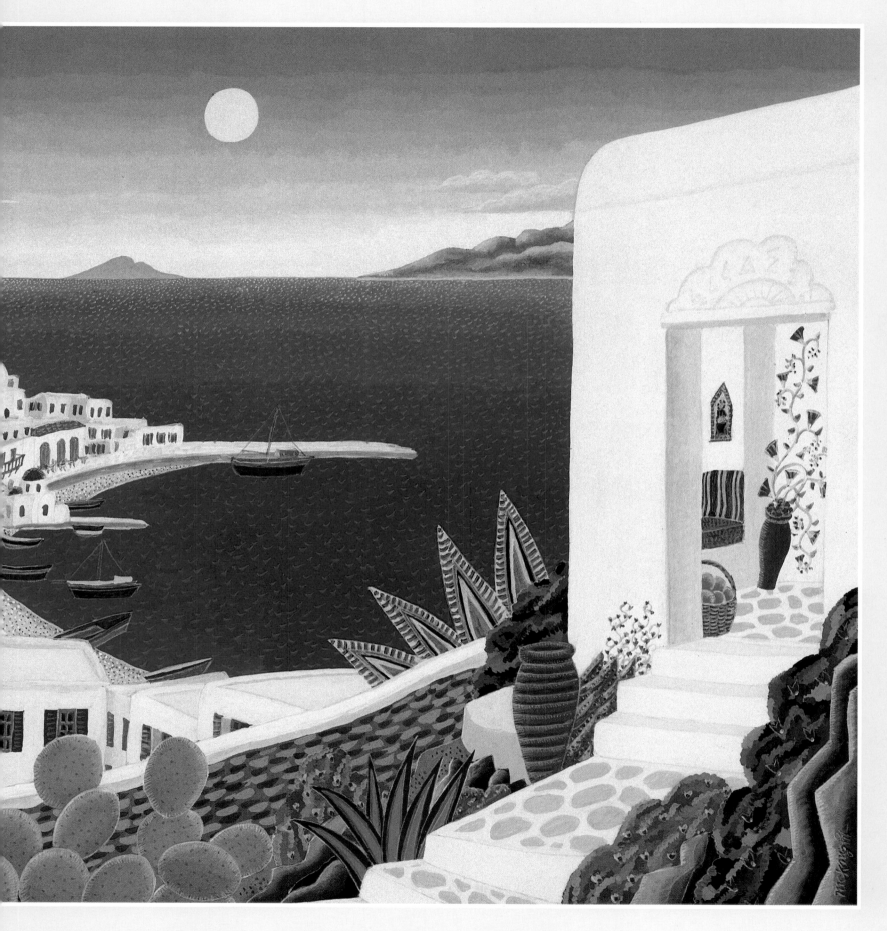

MYKONOS HARBOR

This bar is really named Kastro, a romantic place in the oldest, most labyrinthine quarter of Mykonos overlooking the sea. Here one repairs after the beach and before or after dinner to sit quietly, listen to classical music or just the lap of the waves, and nurse the sting of one's sunburn with this season's fruit cocktail. It was here that Renate and I retreated after I had spent all my remaining traveler's checks on an engagement ring. As she watched it sparkle by candlelight, we planned a future together. Eleven years later, our plan continues to unfold. When we return to Mykonos, we always spend an hour here, a still point in the twilight of a turning world.

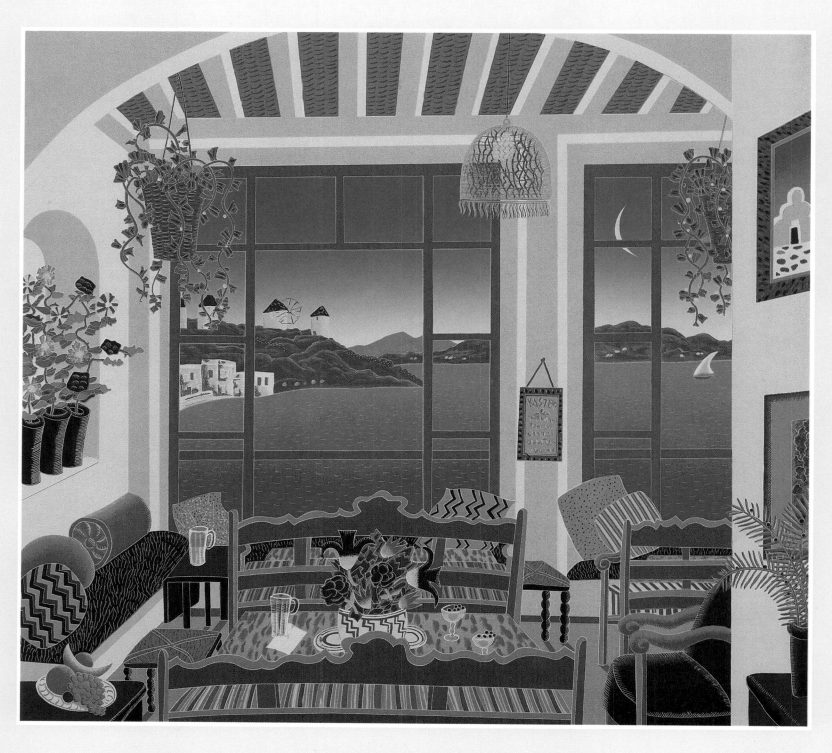

AEGEAN BAR

Travelers of a century or two ago reported Mykonos to be an island with hundreds of windmills and a thriving business provisioning ships with flour and bread. Now there are just a handful of windmills. Two of them have become round vacation homes for those who do not mind the summer meltemi *wind that whistles through their thatched roofs and sets their sails a–clacking, or the cars whose owners use the promontory with windmills as a parking lot.*

LINO
(overleaf)

One of the questions I am invariably asked is "Why do you paint moons (or are they suns) in almost all your pictures?" At first I didn't have an answer. When I composed an image, it always seemed to require an illuminating orb as a finishing touch. When I reflected further, I realized that a function of art is to help us connect with spiritual as well as aesthetic energies. A work of art that is itself the center of illumination makes it like an icon—a container of spiritual energy waiting to be tapped.

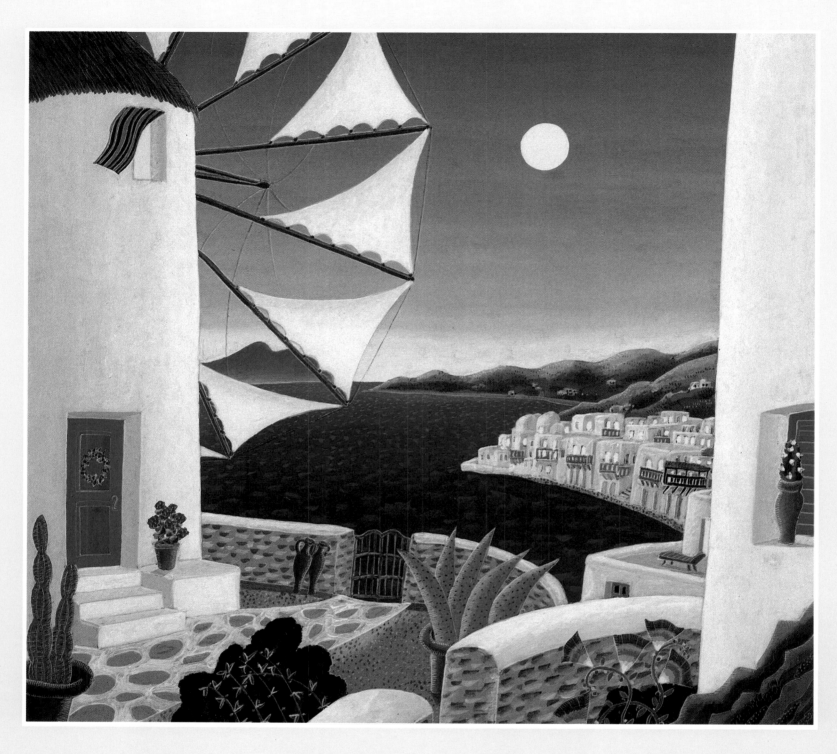

KATO MYLI

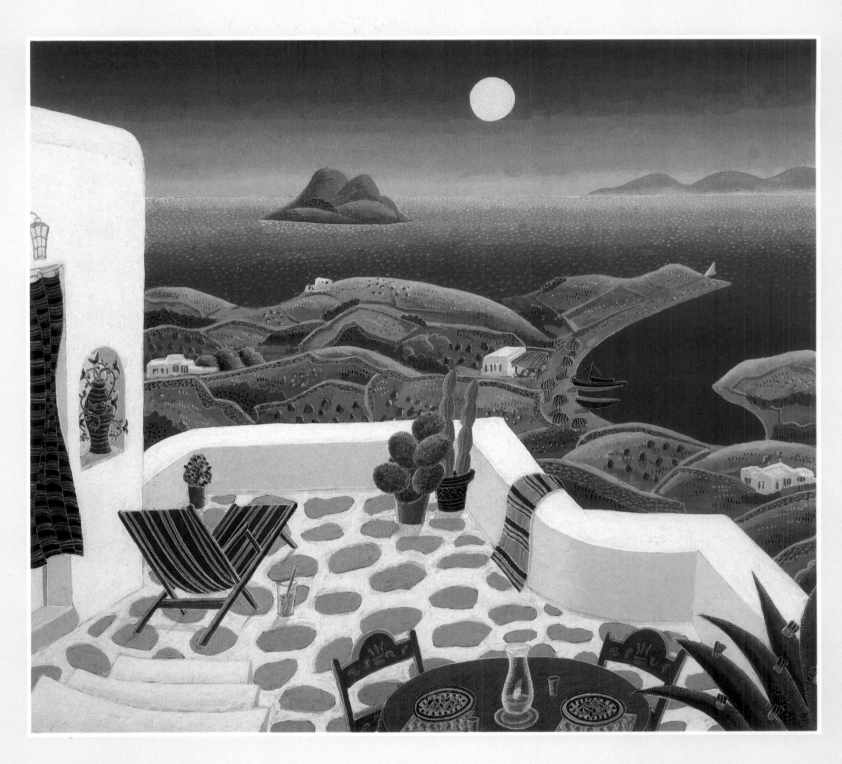

LINO

MANHATTAN

Manhattan has always been a magic island for me. Between its grids that extend horizontally as streets and vertically as towers are found all things portable that make the world so full of wonder. Two blocks south is an Indian grocery store, two blocks farther cowboy boots are bespoke. Across the street rare books come and go at auctions. Instead of leafy trees, nature in Manhattan is the towers that contain rooms and lofts all colored differently.

MANHATTAN FANTASY
(overleaf)

Manhattan Fantasy *is a children's–book version of a New York apartment, seen inside and outside simultaneously. The date of its creation could be ascertained by knowing the year Van Gogh's sunflowers were transmuted into auction gold.*

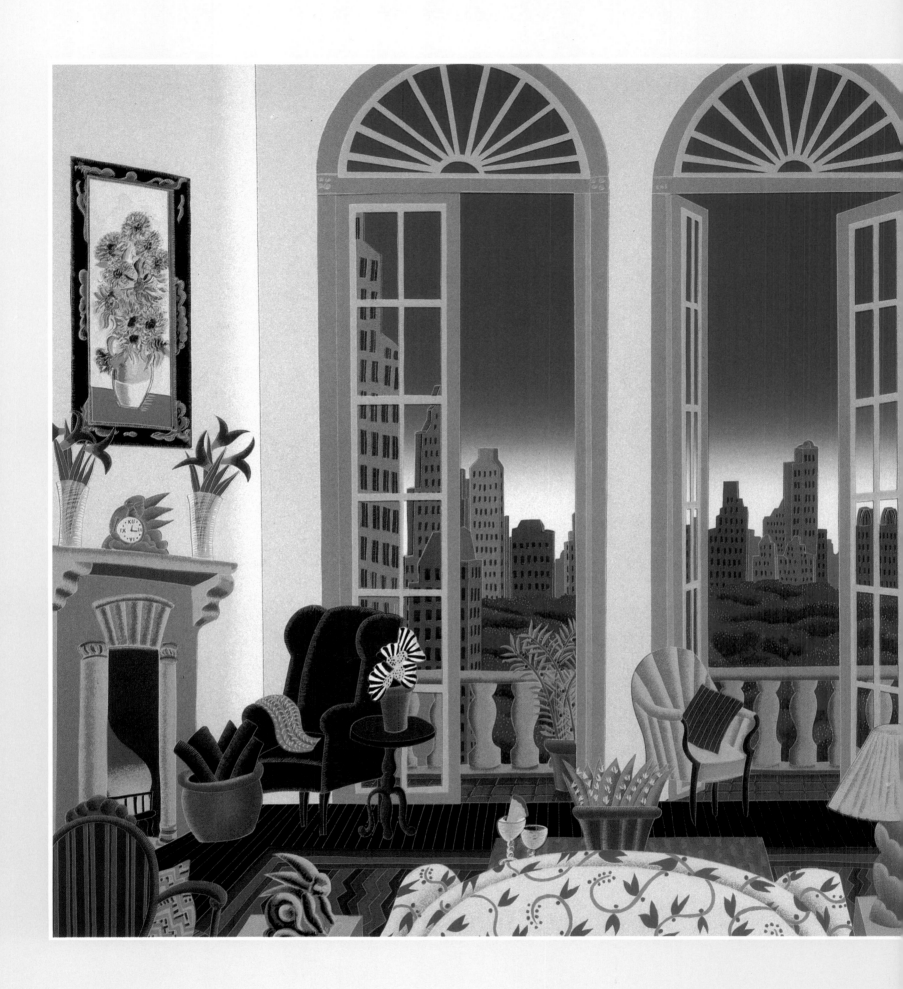

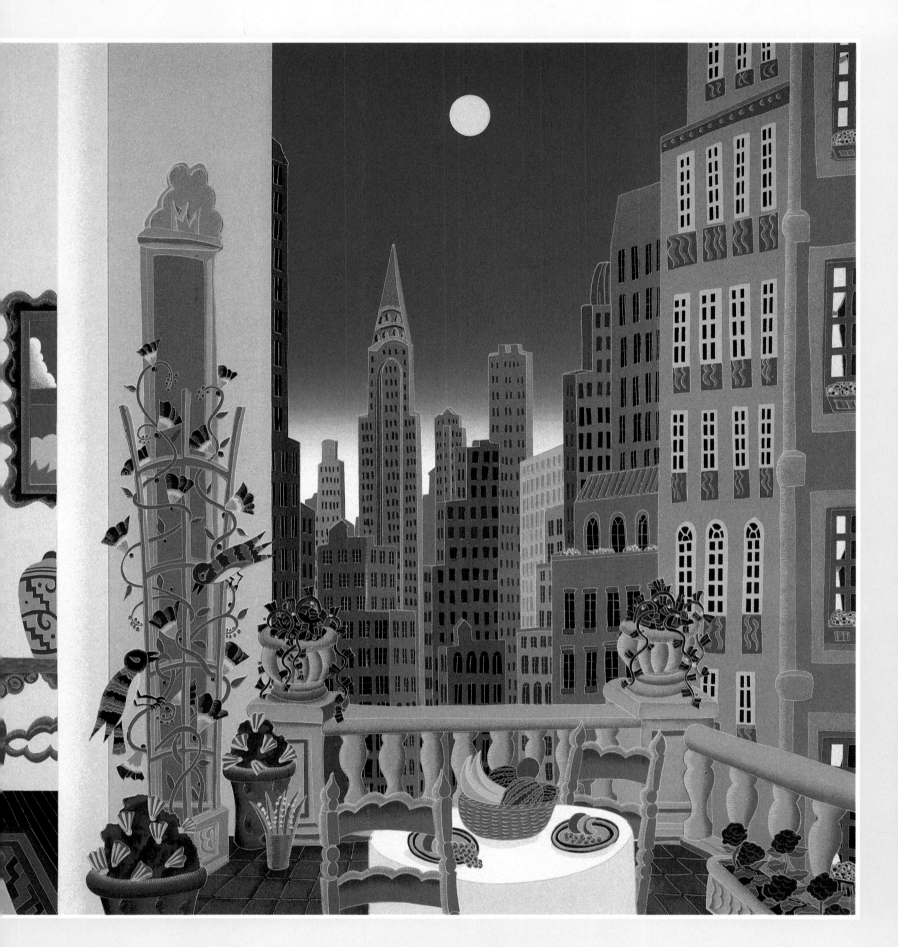

MANHATTAN FANTASY

When I was living in New York, first as an impecunious graduate student in art history at Columbia, then as a threadbare clerk at Time *magazine, a stroll down Central Park West—past grandly named apartment towers on one side, the sunshot park on the other—was, for me, the essence of the metropolitan experience. I watched as gold–braided doormen whistled smartly for taxis, or jeweled dowagers dragged pampered dogs toward hydrants. I wondered about the lives lived within the towers. Somehow they must be more glamorous than mine. When I grew up, I found the truth— that nothing mattered to me more than having the freedom to sit in a private room and illustrate my dreams. The dreams were more alluring than the real thing.*

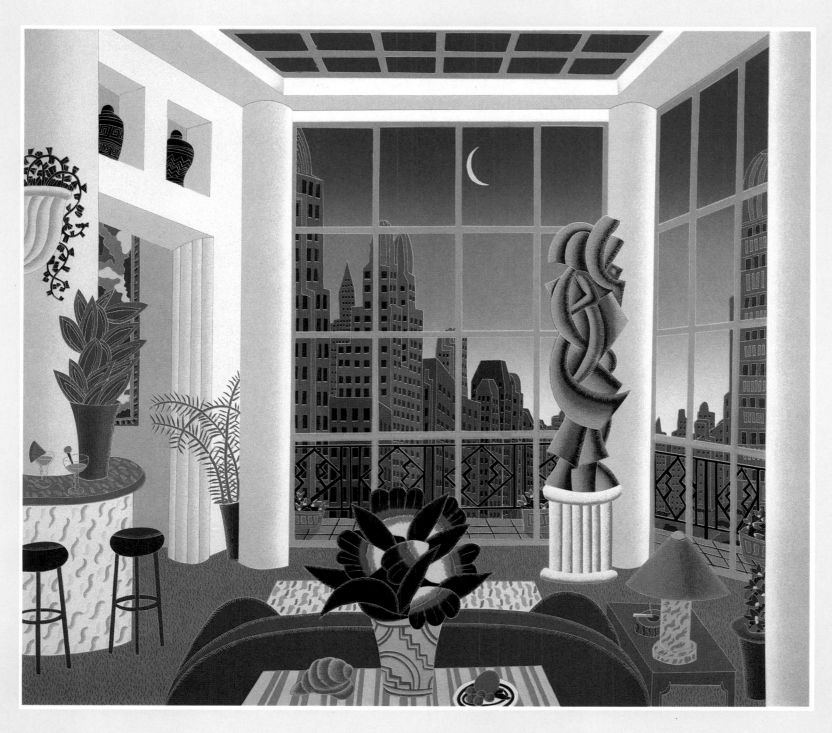

EL DORADO .

MANHATTAN PENTHOUSES
SUITE

These five penthouses are versions of the place in which I would have liked to live when I was a full–time inhabitant of New York. High atop the city, surrounded by spires and celestial blue, is another world. Down below the honking cars herald the early shadows of winter afternoons. Here sounds are dimmer, the air cleaner. Below is the grit of daily reality. Up above one can dream as the sun glints off the upper, more fanciful sections of workaday skyscrapers and dusk turns on their lights.

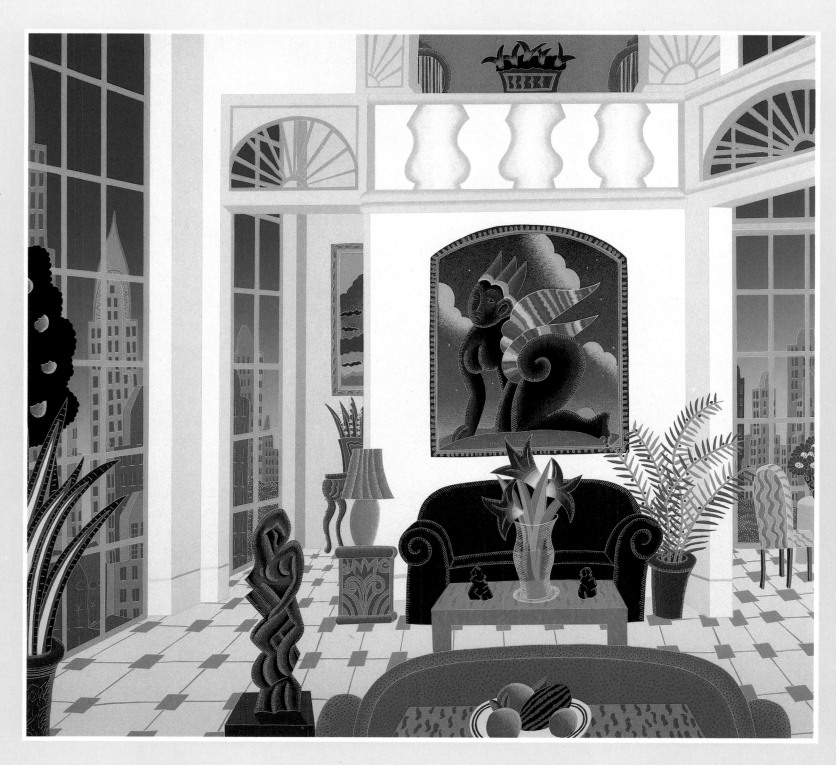

MURRAY HILL
Manhattan Penthouses Suite

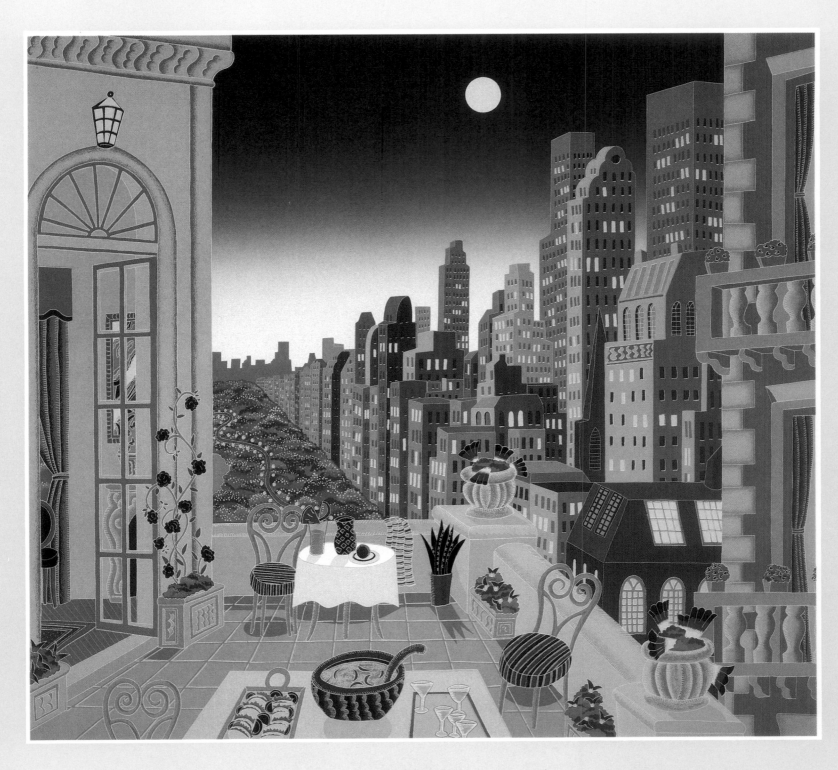

MIDTOWN

Manhattan Penthouses Suite

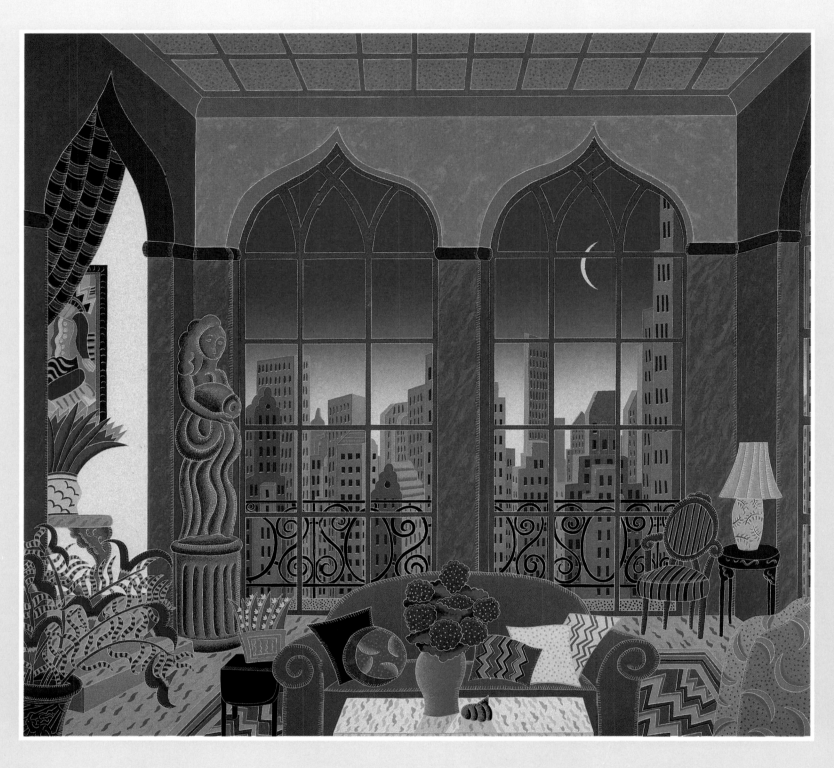

TURTLE BAY

Manhattan Penthouses Suite

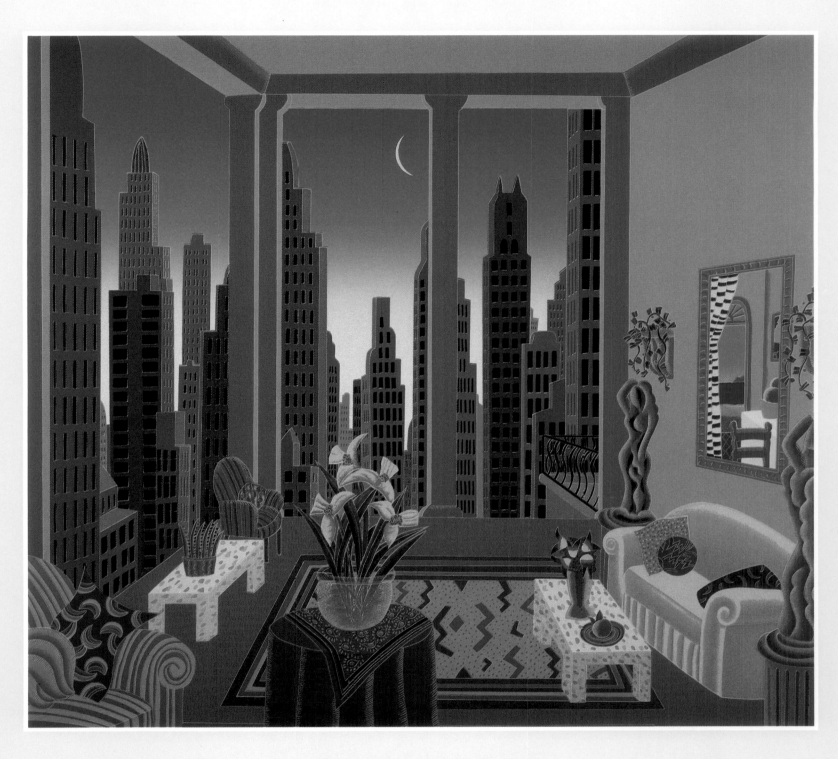

ROCKEFELLER CENTER

Manhattan Penthouses Suite

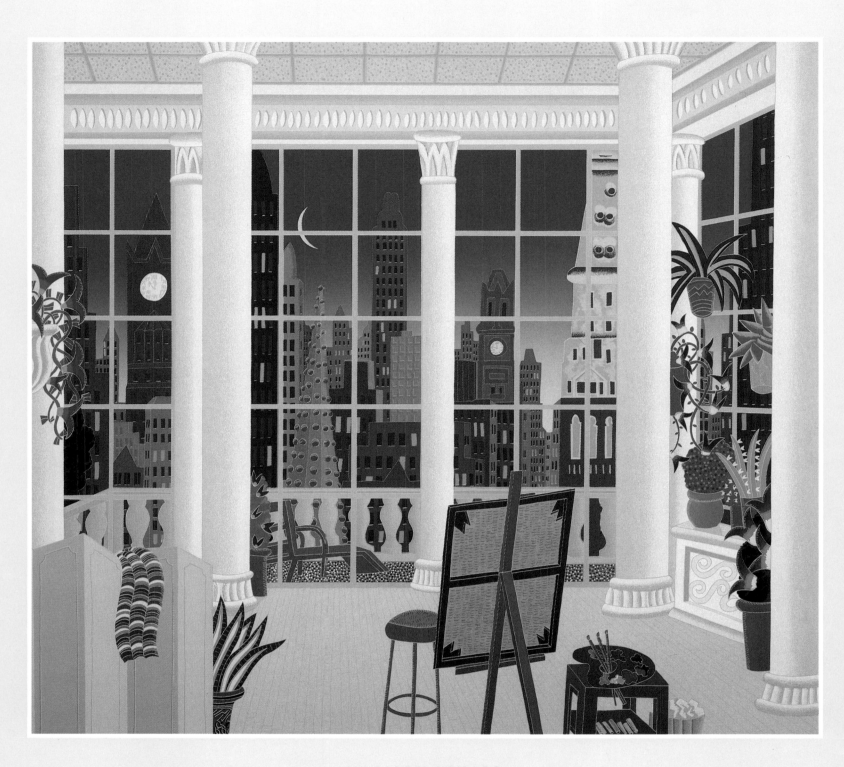

MADISON SQUARE

Manhattan Penthouses Suite

This prospect, facing east from my old apartment in midtown Manhattan, includes the distinctive Chippendale top of the AT&T building, which was new on the skyline then. My earliest memories of Manhattan were of Art Deco buildings; my father worked in Rockefeller Center, which at the time was the essence of metropolitan glamor. These impressions were deepened by a book of Andreas Feininger's photographs of New York in the 1940s that I received once for Christmas. Perhaps this is why I rarely include buildings of later than that time in my New York views.

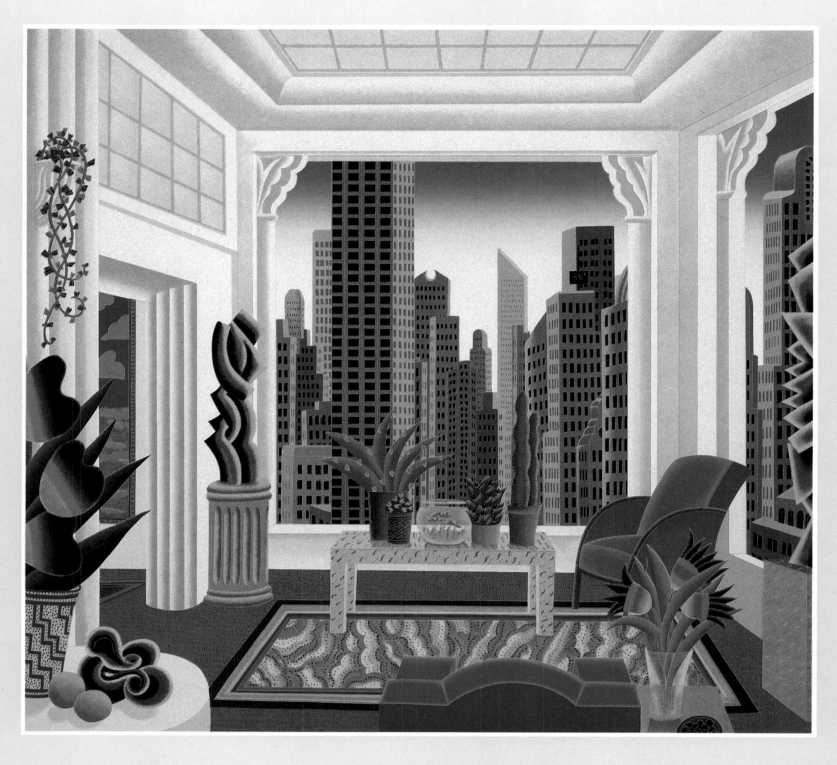

ART DECO ROOM

The title **Beresford** *derives from the apartment building by that name on Central Park West. In the print, the interior and its contents were modeled after the living room of my former home in Water Mill on Long Island, except that the room there was white. The red here comes from Matisse's painting Red Studio, where he uses red (as I often use white) to bind together disparate elements. Before Matisse, atmosphere was used as the binder, whether it was old-master violin brown or impressionist pastel. In my work, relationships and proportions of colors create the space.*

CENTURY
(overleaf)

I'm often asked why there are rarely people included in my interiors. For me, they get in the way. There is less mystery. Interiors that are empty of the human form (except maybe as statues) are enchanted. Like the fairy-tale home of the three bears, someone has just left. With nobody present, you can imagine yourself more easily walking in.

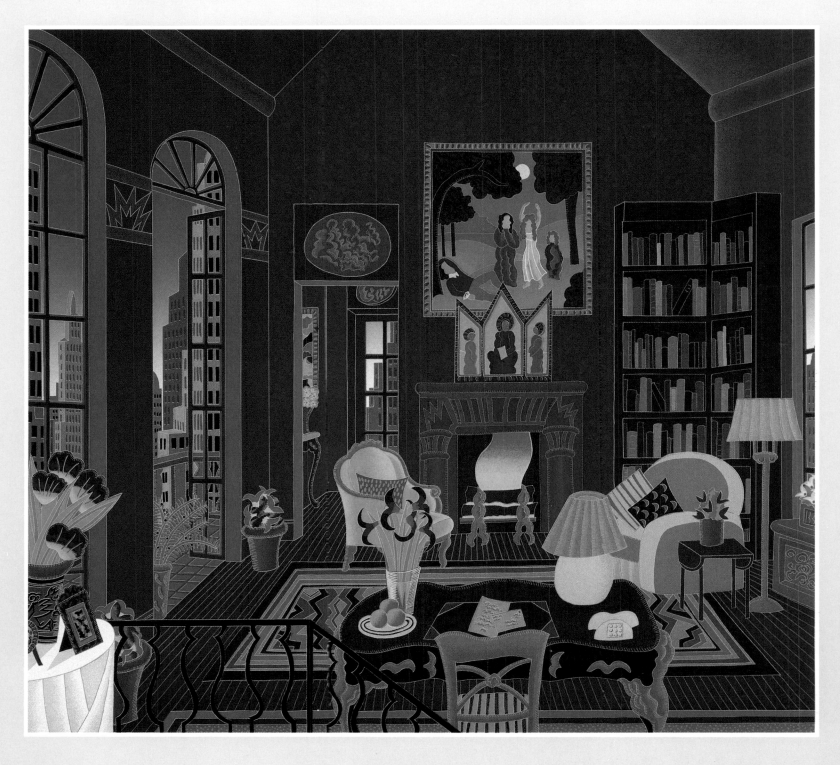

BERESFORD

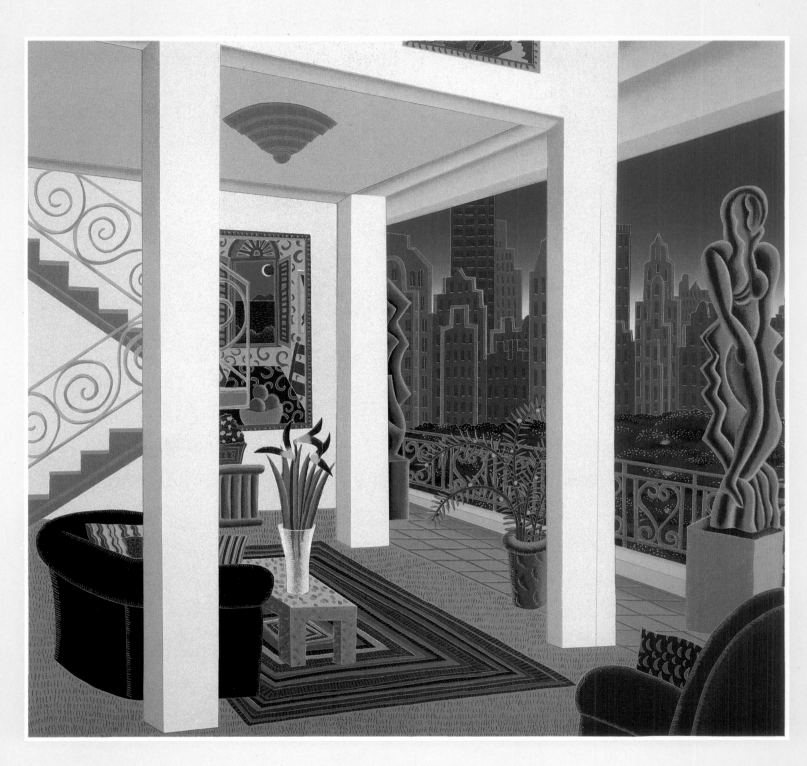

CENTURY

TROPICS

The softness of nature in the tropics (aside from hurricanes) offers us a week–long experience of paradise, a Garden of Eden with no work, few clothes, and fewer inhibitions. The balmy trade winds make up for the tin cans rusting on grocery shelves, the shabby standards of living, and the other evidence of physical and moral decay. The tropics are what resorts have always been—places of refuge that for a while are lifted out of time.

It really is true—it is harder to do great things when I am surrounded by tropical luxuriance. I become indolent. The search for physical paradise is over—I am there. But what is that gnawing feeling? Can it be that life is more than palm trees swaying in soft breezes?

CRESCENT BAY
(overleaf)

The format of the print of Crescent Bay derives from a walk down 57th Street in New York one winter's day. I glanced in the window of the sales office for a new skyscraper. What caught my eye was a montage photograph, a panorama of the Manhattan skyline from a rooftop. A panorama, I thought, is made to walk around in. When I returned home, I tried to imagine the lushest panorama, the place I would most like to be. This is the result.

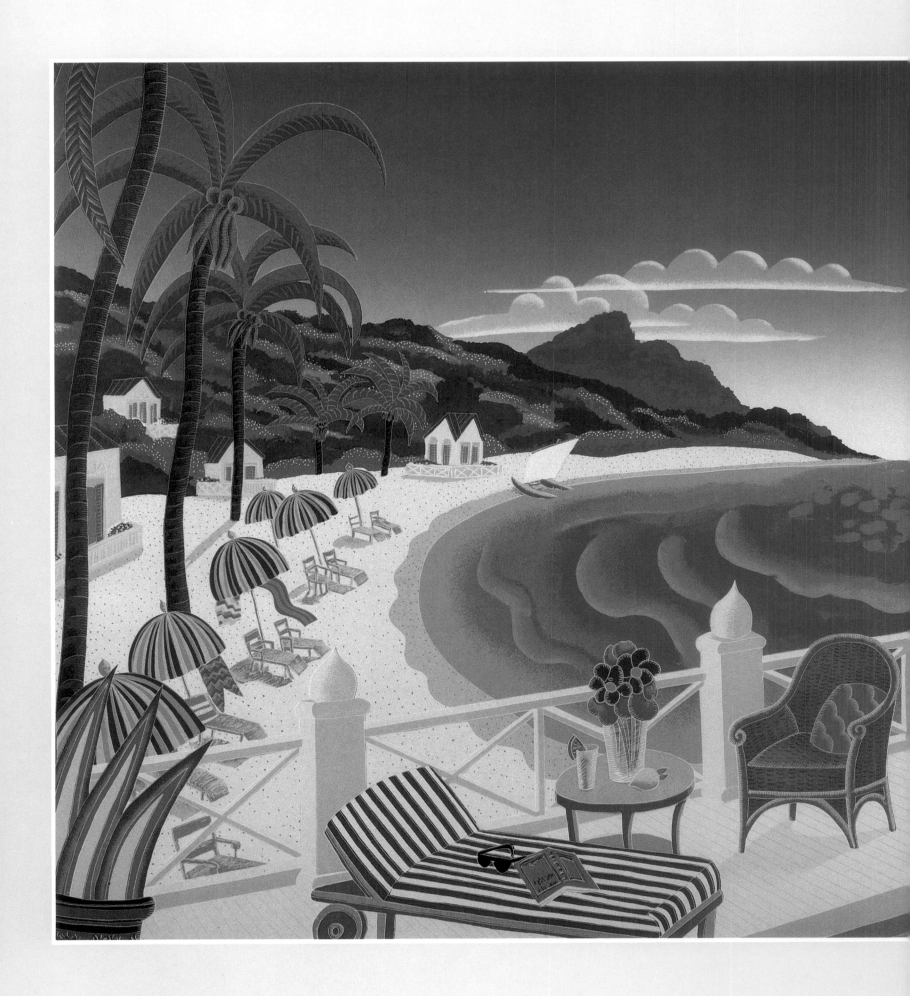

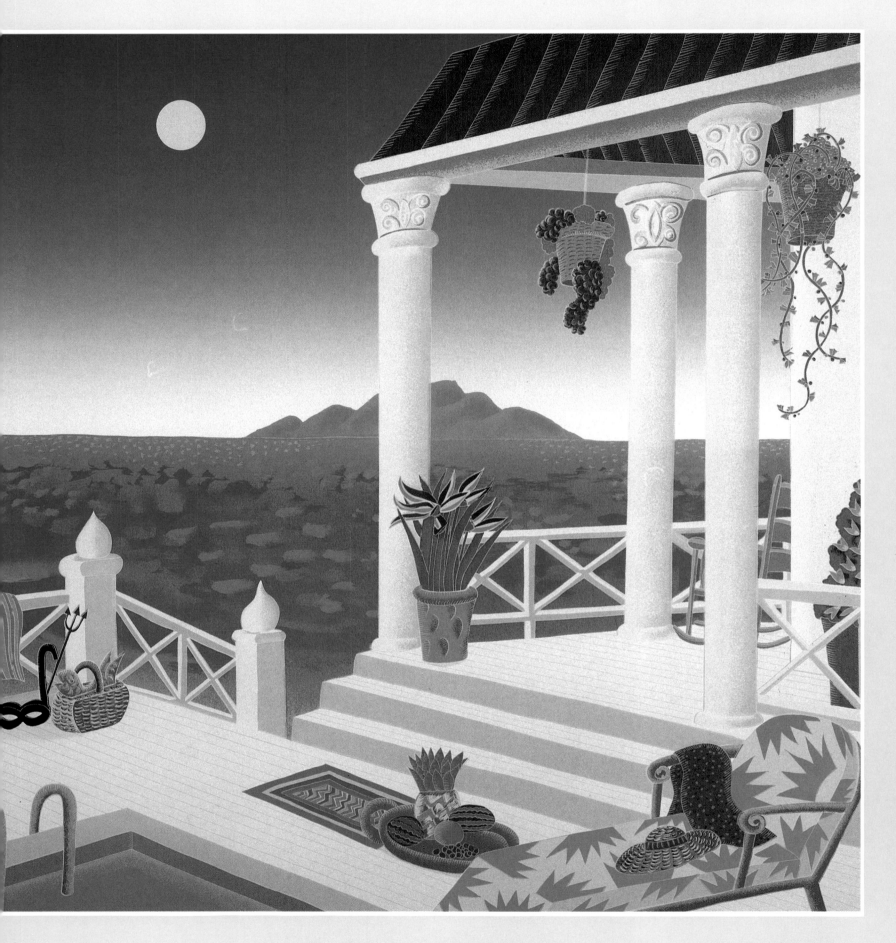

CRESCENT BAY

IN THE TROPICS SUITE

Here is an imaginary tour of the Caribbean, even though some of the prints are based on real places. I actually drank coco locos and bought a Mexican rug on the beach in Puerto Vallarta. I roasted in the St. Martin sun and later listened to Bellini's **Norma** *atop a La Samanna bungalow, just like the one here. However, I have never been to Nassau. Creating suites of prints like this allows me to explore a theme and peer at it from different angles. Putting them together creates a flow, like the narrative of a story.*

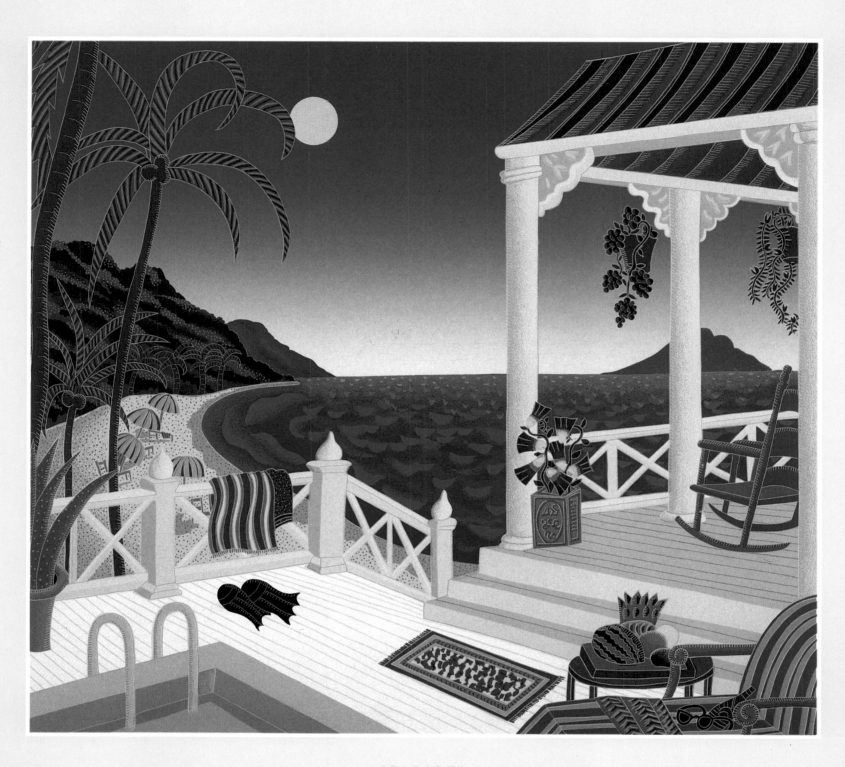

S T . B A R T S
In the Tropics Suite

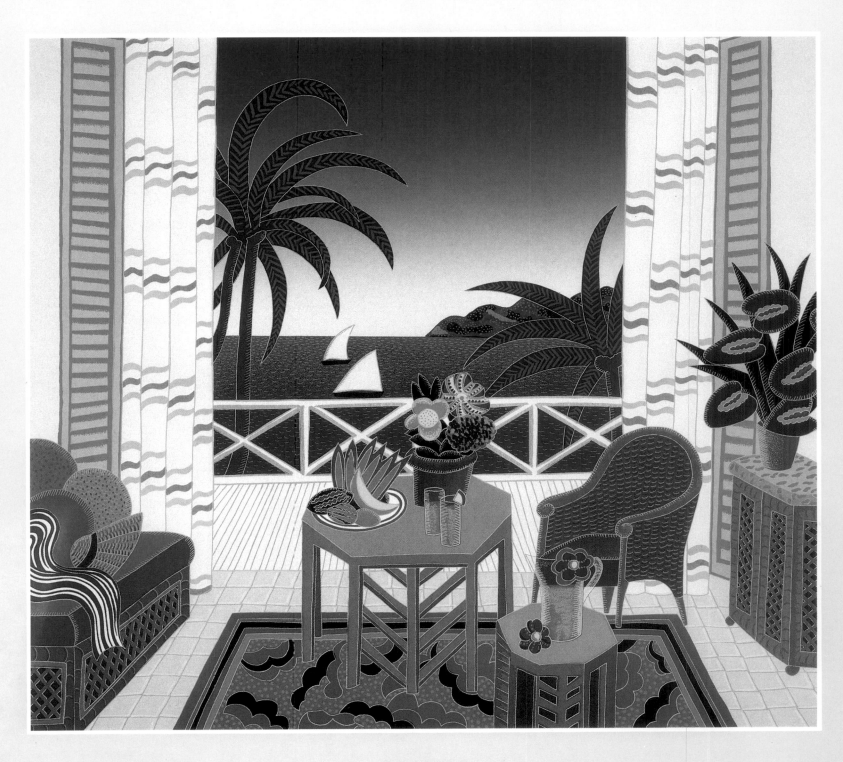

TORTOLA

In the Tropics Suite

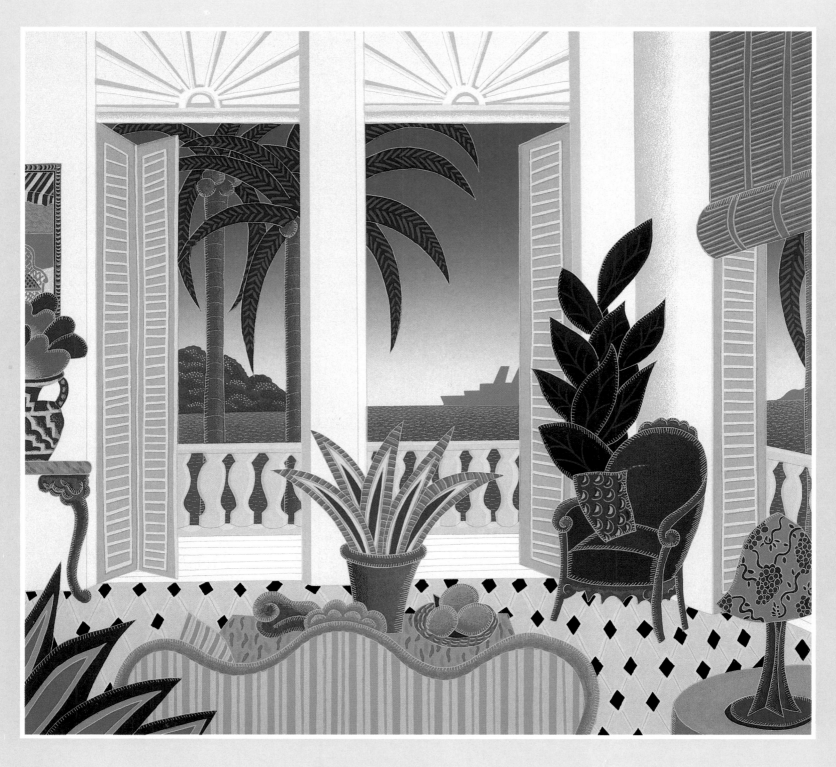

NASSAU

In the Tropics Suite

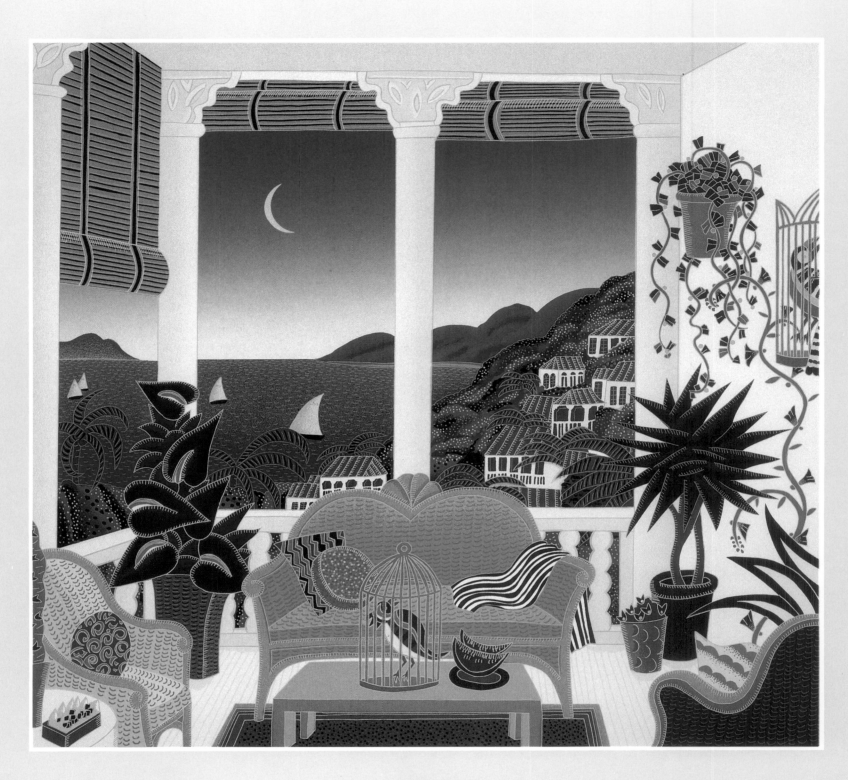

DOMINICA

In the Tropics Suite

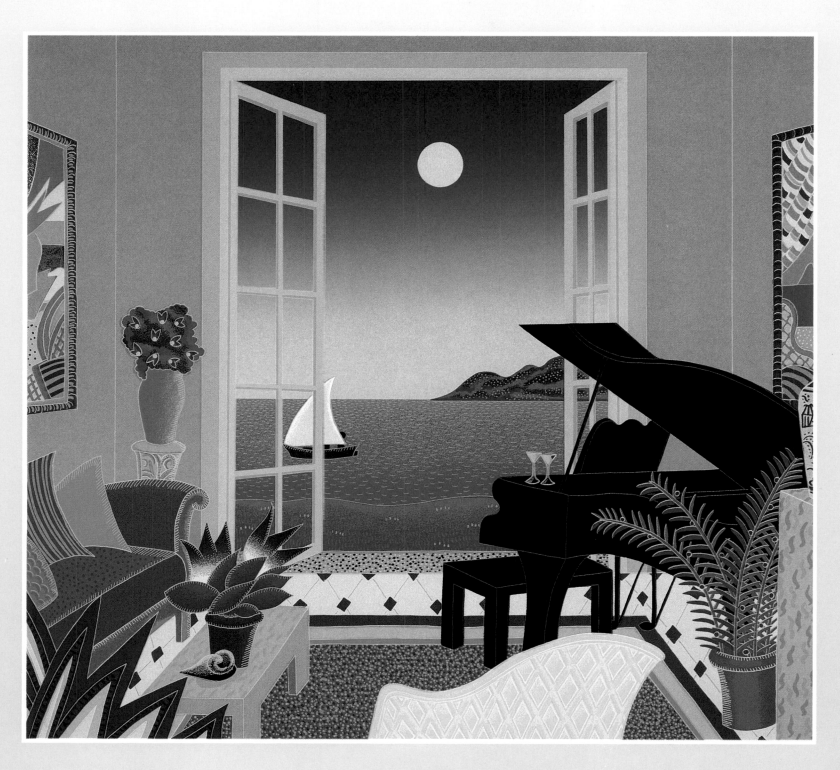

BARBADOS

In the Tropics Suite

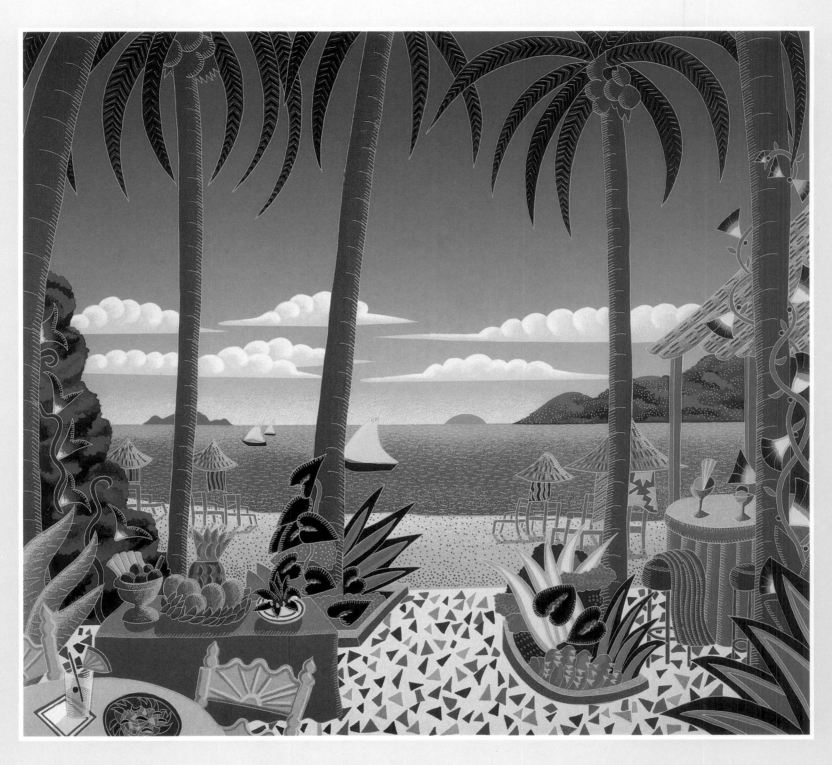

PUERTO VALLARTA

In the Tropics Suite

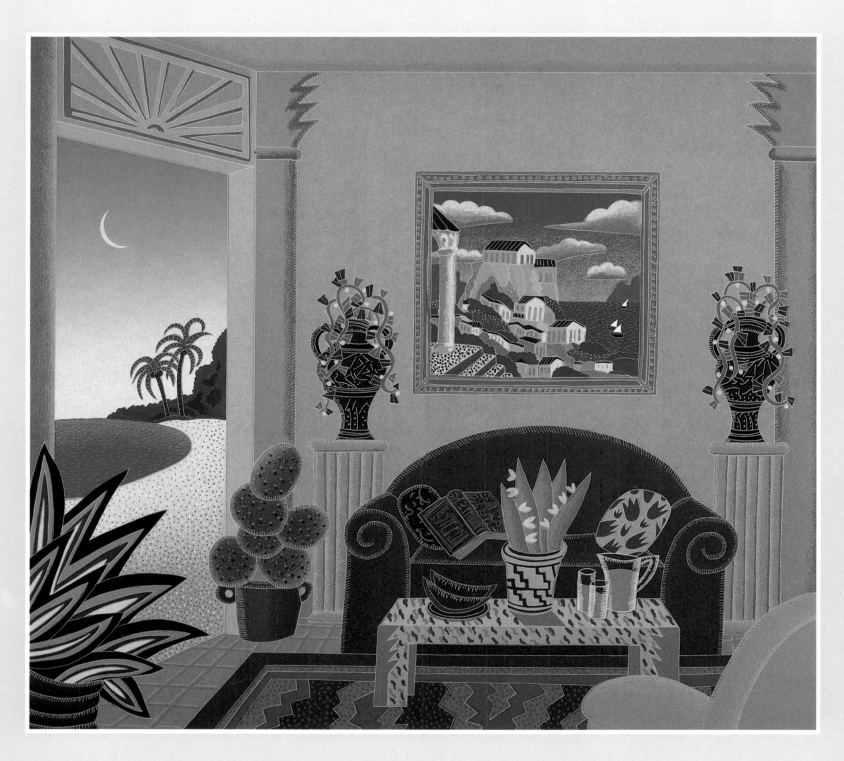

ANTIGUA

In the Tropics Suite

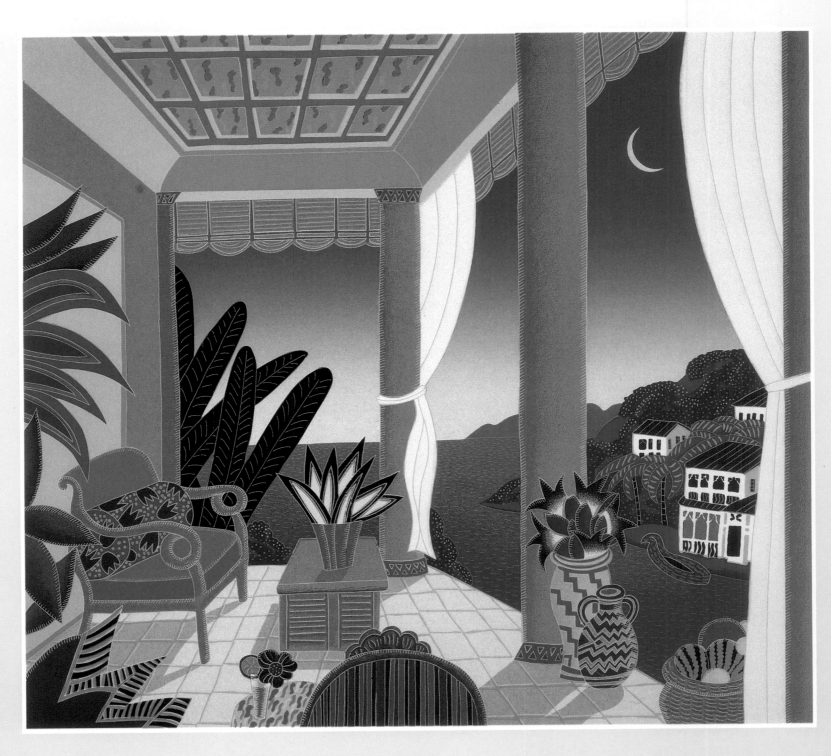

GUADELOUPE

In the Tropics Suite

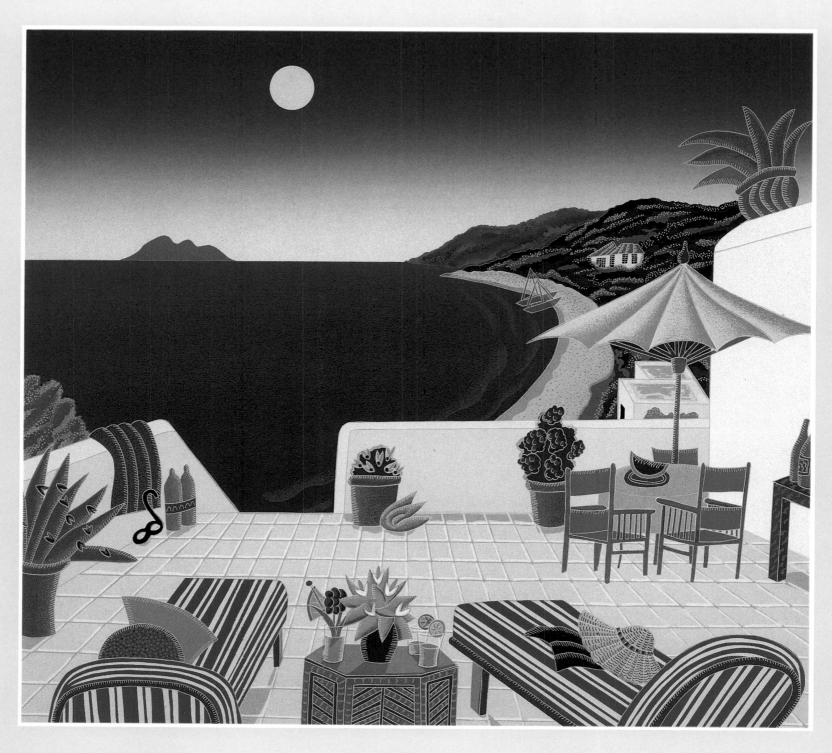

LA SAMANNA

In the Tropics Suite

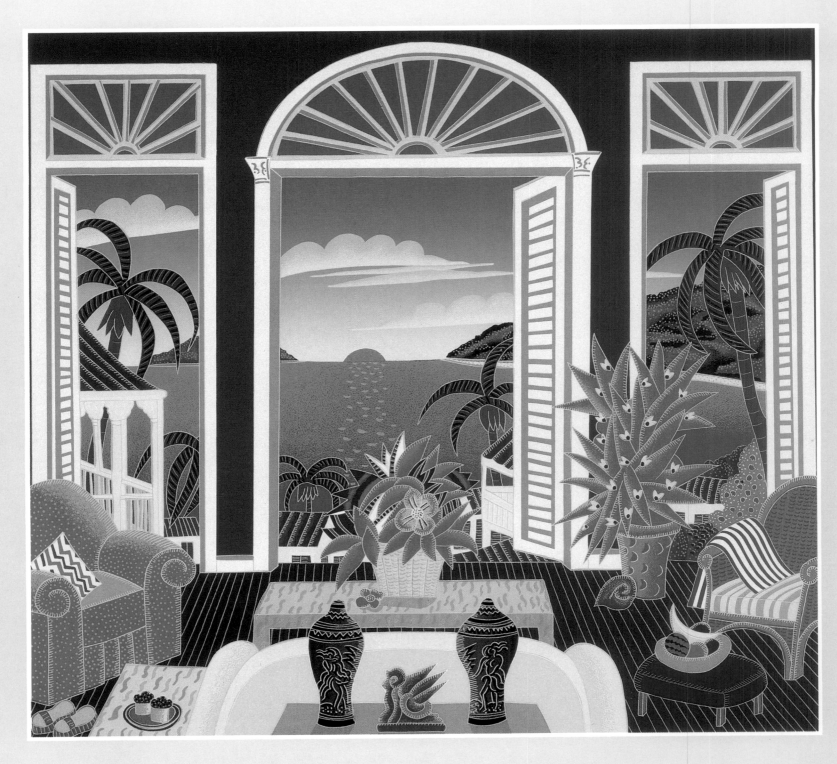

MARTINIQUE

In the Tropics Suite

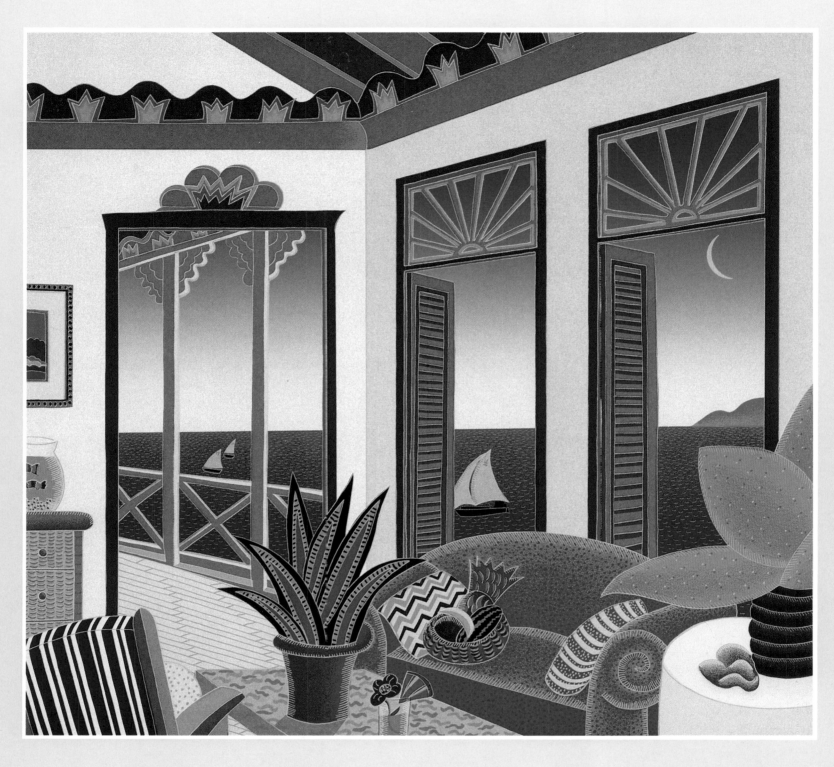

ANGUILLA

In the Tropics Suite

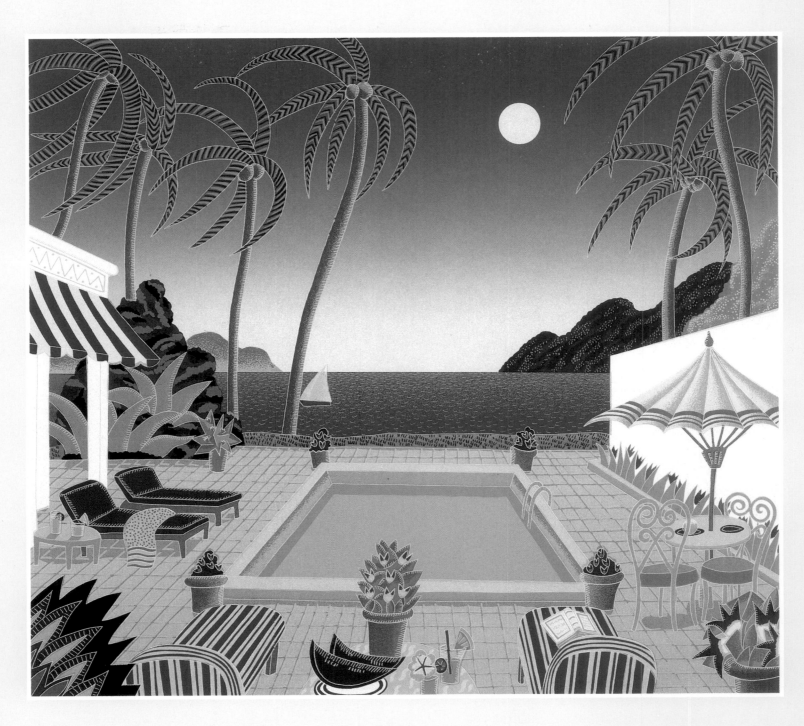

MONTEGO BAY

In the Tropics Suite

GULFSTREAM
(overleaf)

On bright Manhattan midwinter days, when the sun would slant enough to penetrate warmly into my thirty–third story living room, I would sometimes open the window and sunbathe on a rattan chaise. It may have been freezing outside, but inside a potted ficus tree rustled overhead and I could imagine myself on a hill overlooking Florence or seaside in St. Barts. Lying in the sun with my eyes closed is for me the equivalent of a good massage. Then I keep a sketchbook by my side and harvest some of my best ideas.

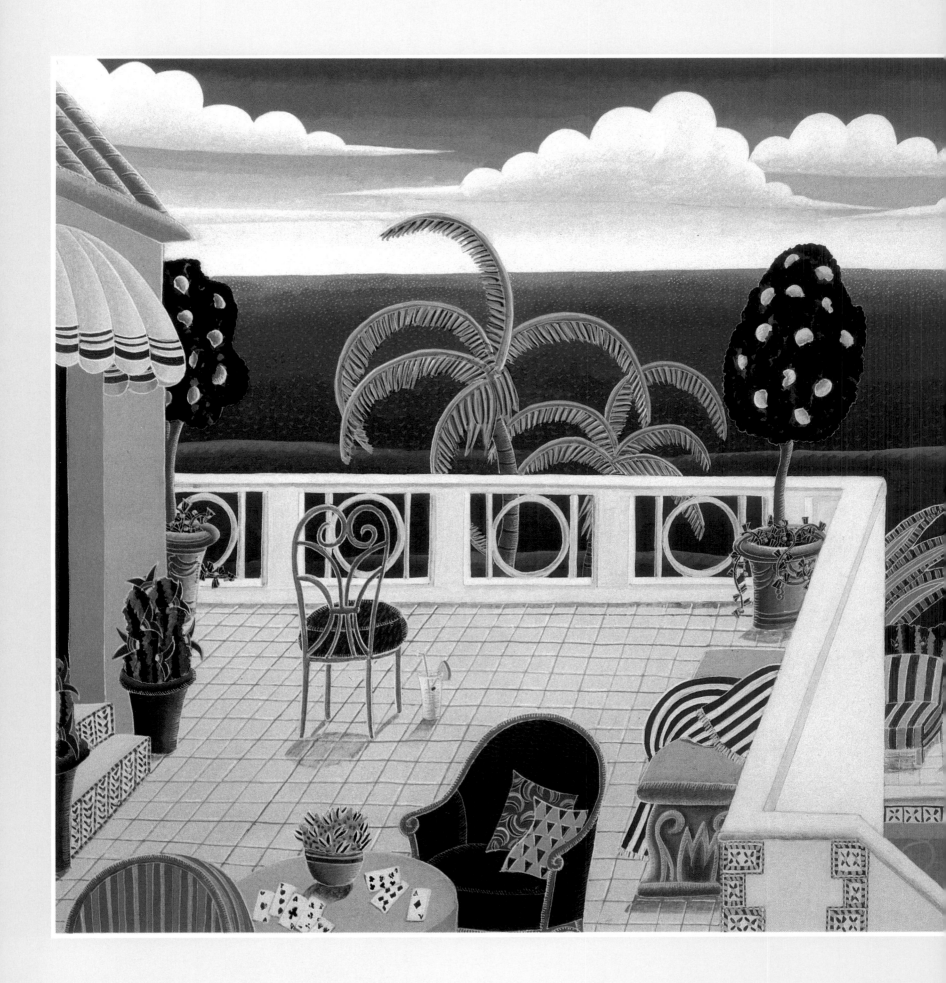

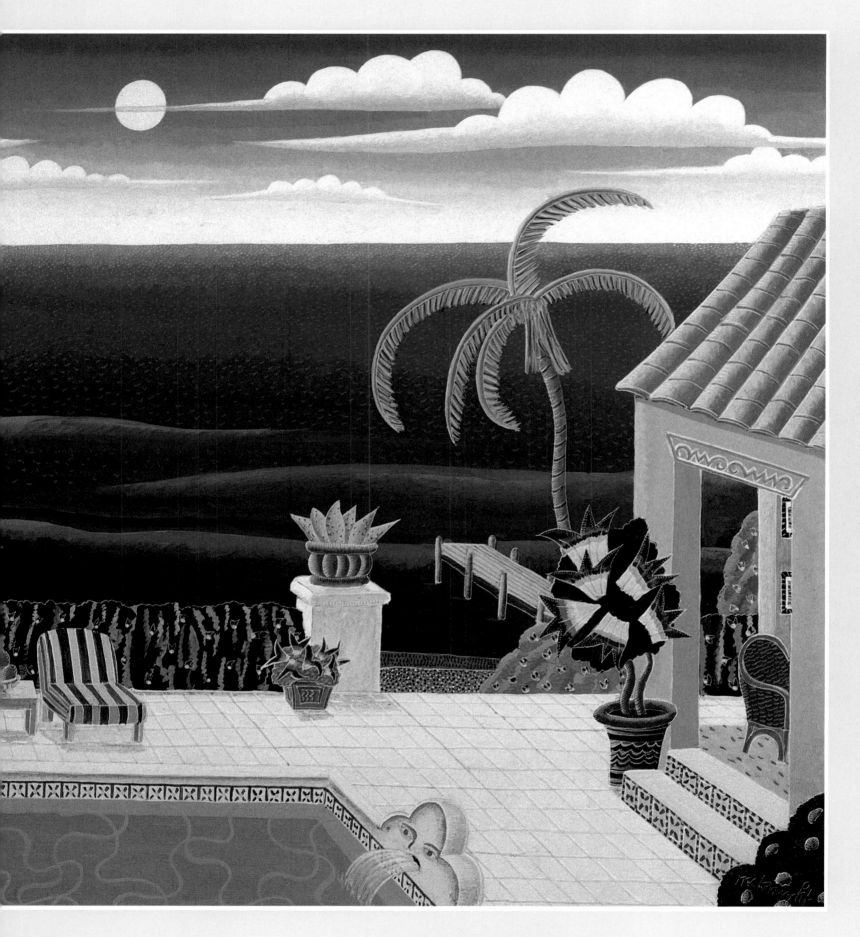

GULFSTREAM

The tropics are where colors become most themselves. Purple bougainvillea, red hibiscus growing like weeds, parrots, lemons, shiny green leaves, and a sky so blue it is nearly edible. Up north the light is slanted—it creates ancient shadows and in winter casts a lingering pall of brown and gray over everything. Tropical light is now. It shines brighter, but like short tropical sunsets it also disappears faster.

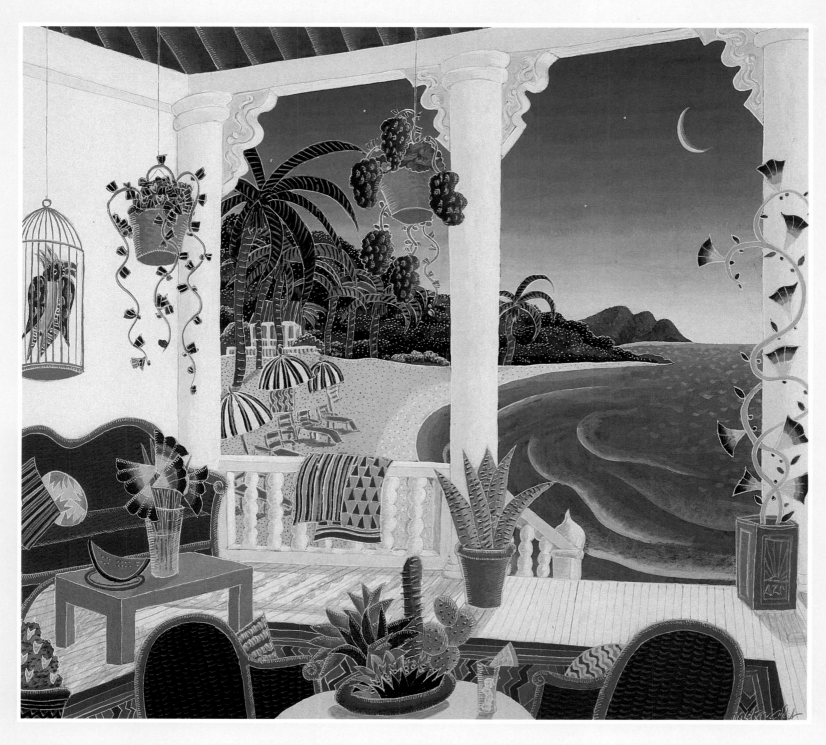

SANDY POINT

What is the meaning of windows and doors? In my work they function in a formal way. They square off nature and make it art. You might say they create a metaphor for transcendence—Nijinsky leaping out the garden window in La Spectre de la Rose. *The interior is our everyday world—fireplace, couches, tables, objects in harmonious order. Outside, the world of nature is partly ordered—into cities, gardens, and swimming pools, but there are also wild blowing winds, insects, falling leaves, and plants that crackle as they grow. To live fully we need both, the contractive comforts of the known, the expansive adventure of the unknown.*

ST. MARTIN
(overleaf)

I have long admired the luggage labels one sees plastered on decaying leather steamer trunks at garage sales. Once, every hotel and transatlantic liner had its own label. With the merest image—a silhouette of the Eiffel Tower or the Taj Mahal—they evoked the romance of a place for the travelers of fifty or a hundred years ago. I try to evoke the same response with my work, to pick those vistas and features most essential to a place and flirt with the clichés they represent, hopefully without falling into them.

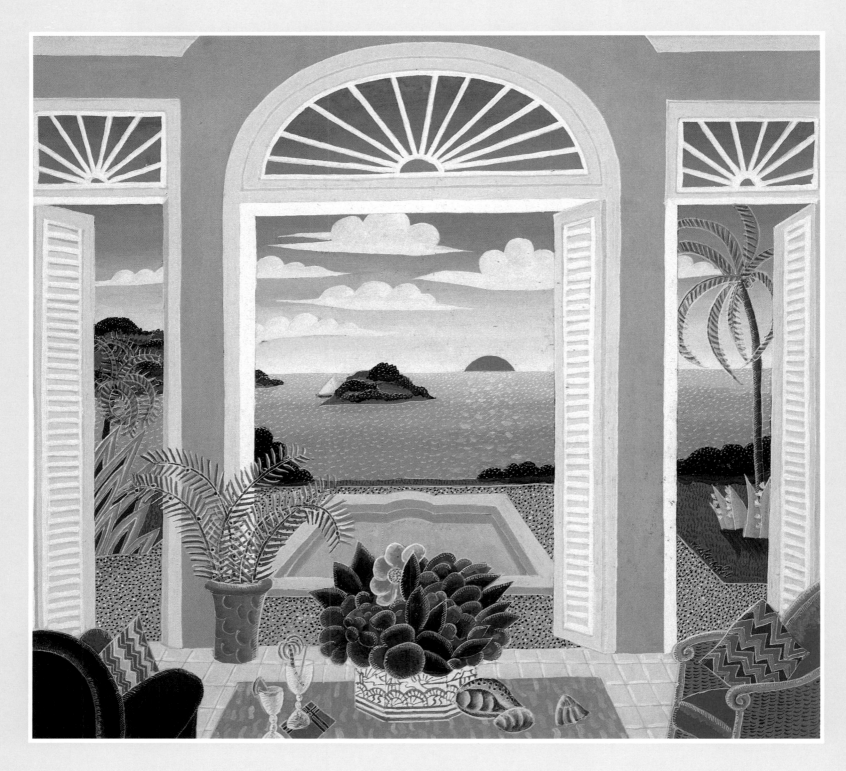

MUSTIQUE

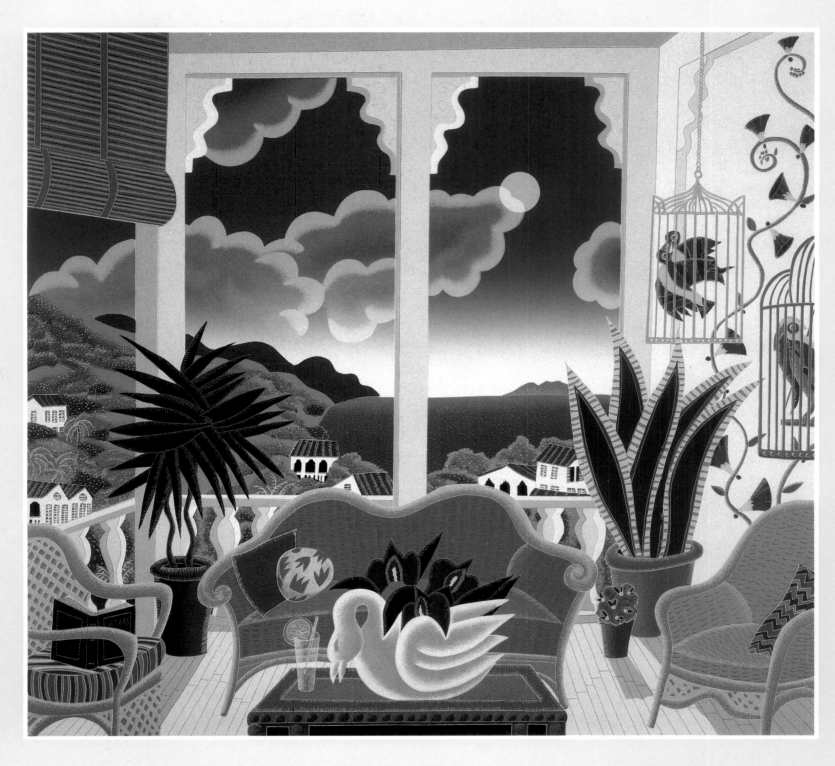

ST. MARTIN

MEDITERRANEAN

The Mediterranean balances on a fine point between nature and civilization. Too far towards nature and we bask in the indolent tropics; too far towards civilization and we huddle behind doors in icy Northern cities. The lands that surround the Mediterranean are tailored to man's scale—variations on a Scarlatti theme whose resonance is deepened by a rich history that flows over and under its peaks and valleys.

VERNAZZA
(overleaf)

Last June my wife and I traveled to the Cinque Terre on Italy's Ligurian Coast. Connecting the five nearly inaccessible towns is a footpath that winds perilously through ancient vineyards on the sides of cliffs that plunge vertically into the sea. We passed through olive and pine groves, by natural gardens of cactus; we smelled jasmine and oregano and admired flowers in all the spring colors. Miraculously, just at lunchtime the first town, Vernazza, appeared and we were soon fortified with pasta, tomatoes, basil, and wine for the rest of the walk. This to me is the essence of the Mediterranean: rocky cliffs, exotic vegetation, ancient habitation, and lunch from the land—all of it measured on a human scale. But go quickly. We smelled sawdust where the first chic swimwwear boutique in town was being prepared to open for summertime.

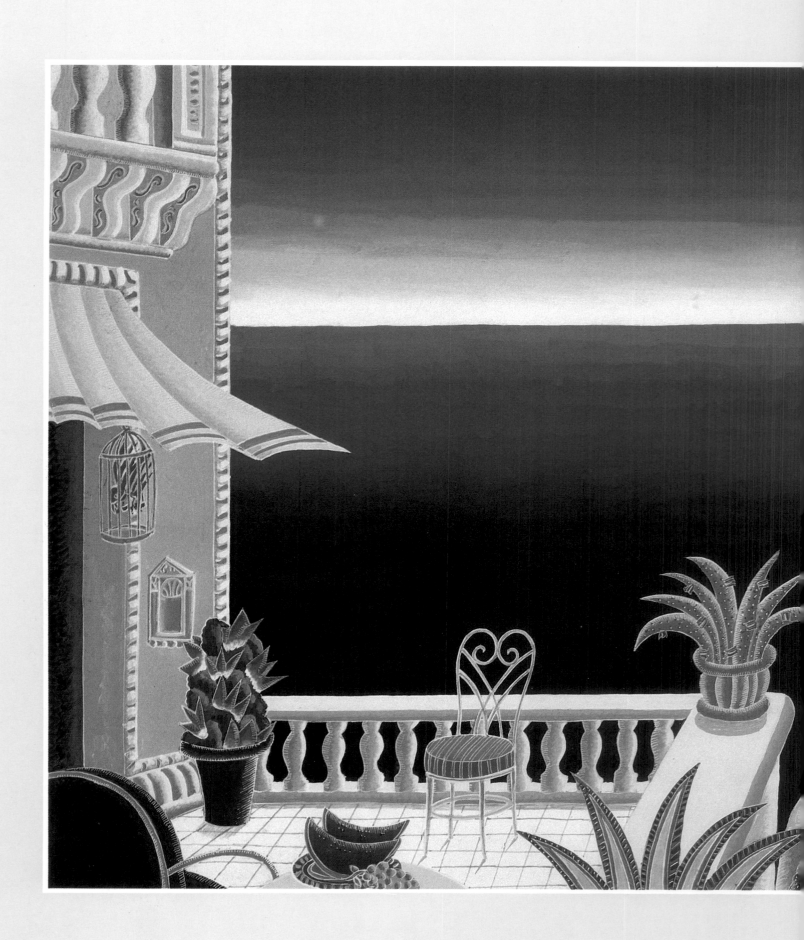

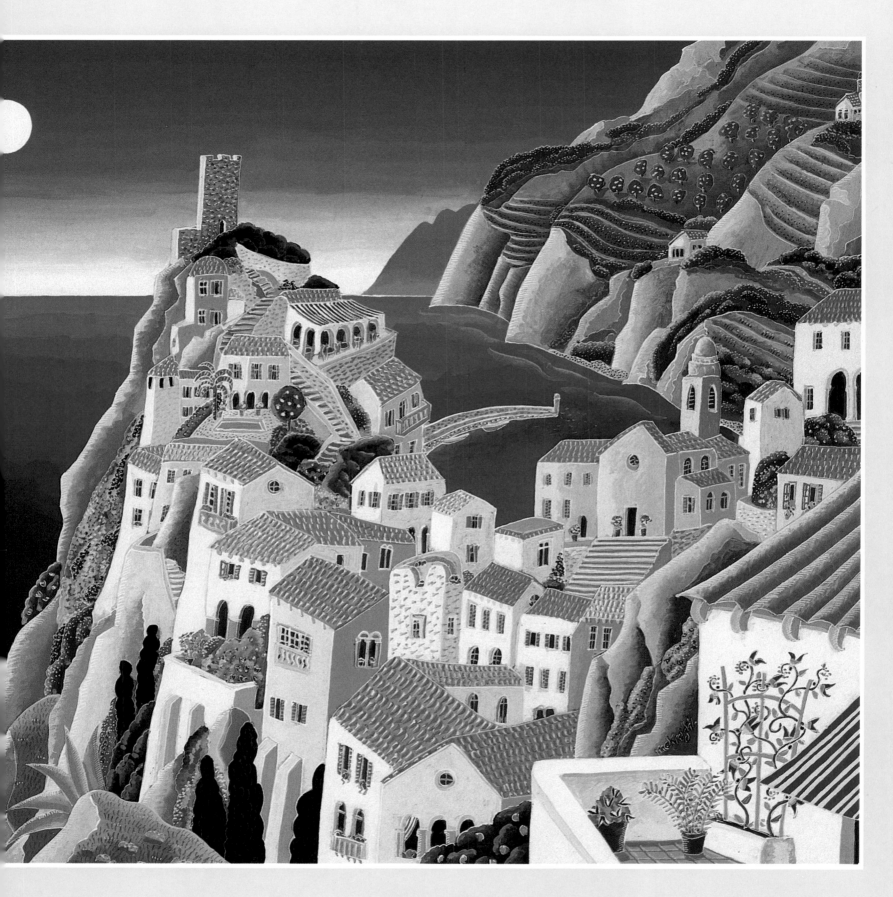

VERNAZZA

Calm objects and images are not much in demand in the art world these days. Instead there is a glut of images that create their own inflation as they yell "Look at me." The spiritual function of art, to provide images that restore the soul has been forgotten in the clatter of spiraling prices and art that tries to shock. Maybe serenity will be a characteristic of the next avant–garde, but I doubt it.

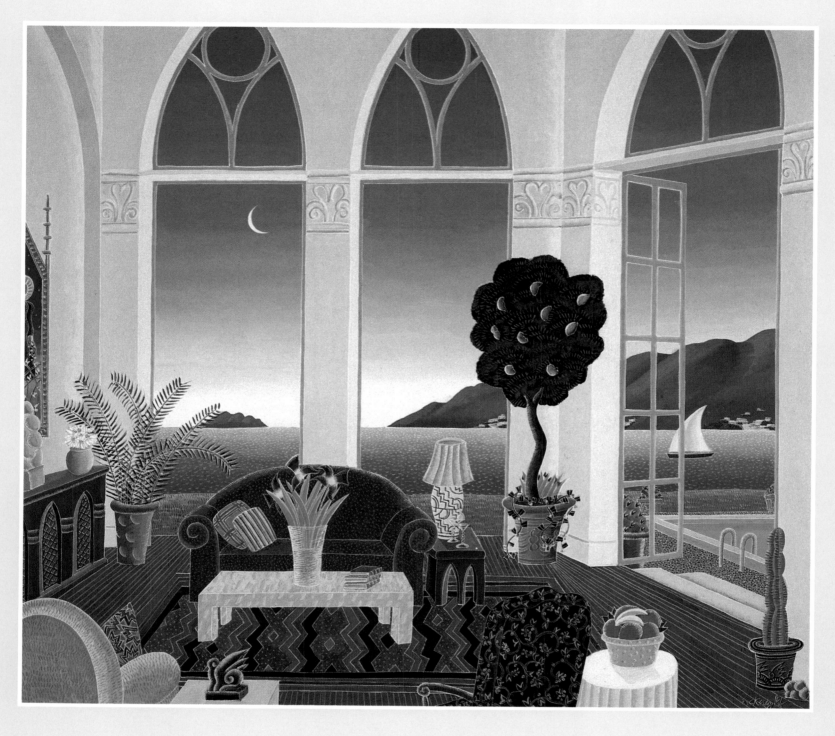

RED COUCH

The desire for visions of an earthly paradise seems to be a constant need in the human psyche that goes back at least as far as Daphnis and Chloe in pagan Sicily. In my work, I have for the first time created rooms for them to live in, and terraces from which they may gaze at the moon.

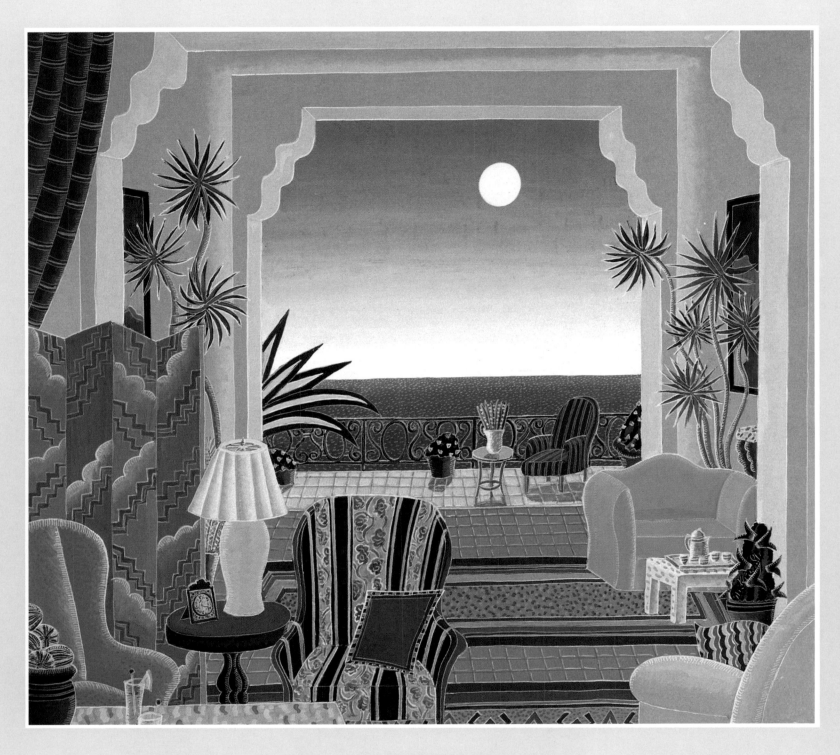

PORTO ERCOLE

CÔTE D'AZUR SUITE

When I was growing up, the Côte d'Azur *meant Grace Kelly and Cary Grant in* To Catch a Thief. *Like the movies, the place is not quite real. That's because resorts are created for leisure, with appearances following rules closer to fantasy than function. Hence their sites and architecture have more dash than places where people work. Their colors are brighter. Monaco, for example is a musical comedy version of a country, the sentries guarding its princely palace are all pomp and no circumstance. The variety of the French Mediterranean coast makes it a complex symphony of hill towns, flower markets, stony beaches, fading Grand Hotels, and mint–fresh villas. All of it is strung together by the corniches, those winding roads up on the cliffsides, whose lights appear to be necklaces in the night sky. Unlike Mykonos or Palm Beach, the Côte d'Azur has had its artists, and so, as in much–painted places like Venice, you see it through their eyes. Chagall at St. Paul–de–Vence, Picasso at Antibes, Matisse in Nice, Dufy everywhere.*

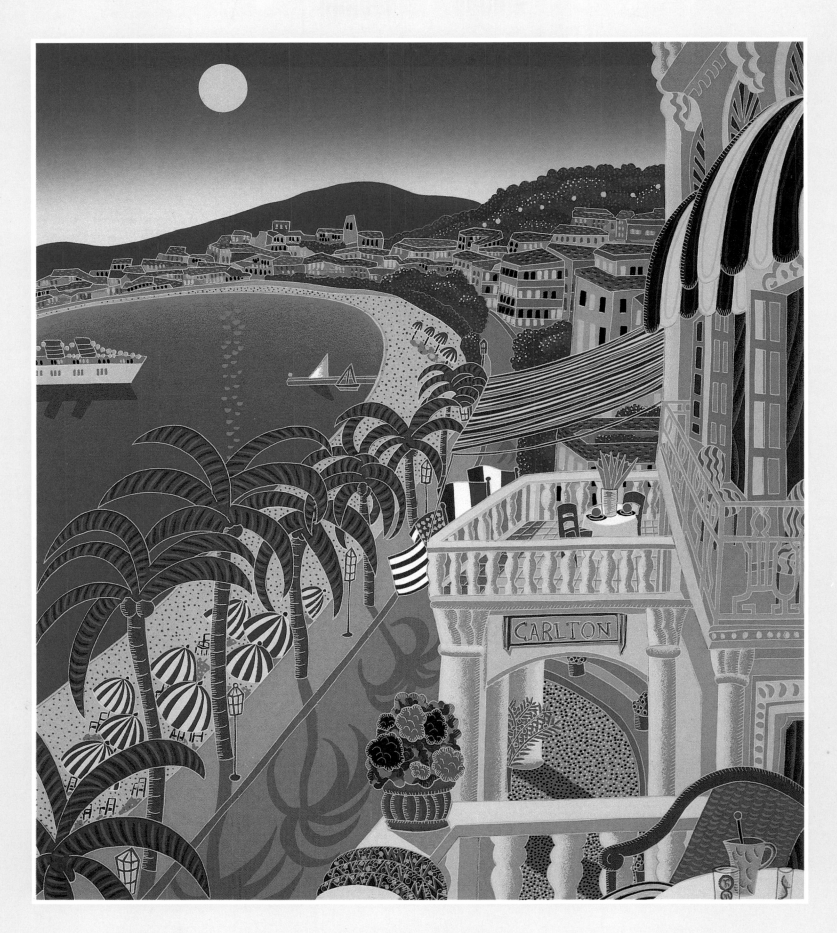

CANNES

Côte d'Azur Suite

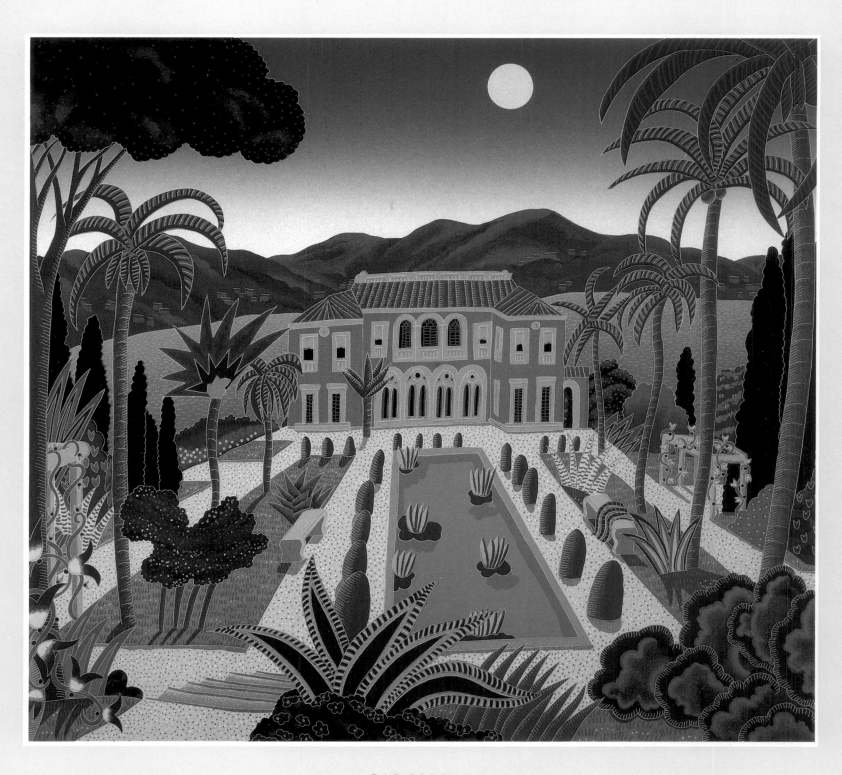

CAP FERRAT

Côte d'Azur Suite

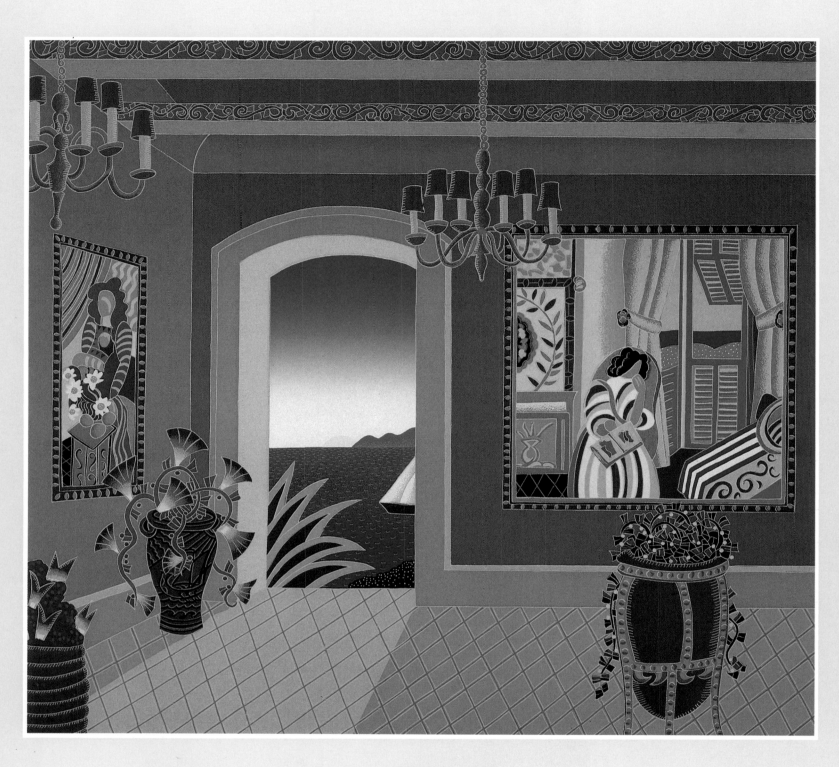

ANTIBES

Côte d'Azur Suite

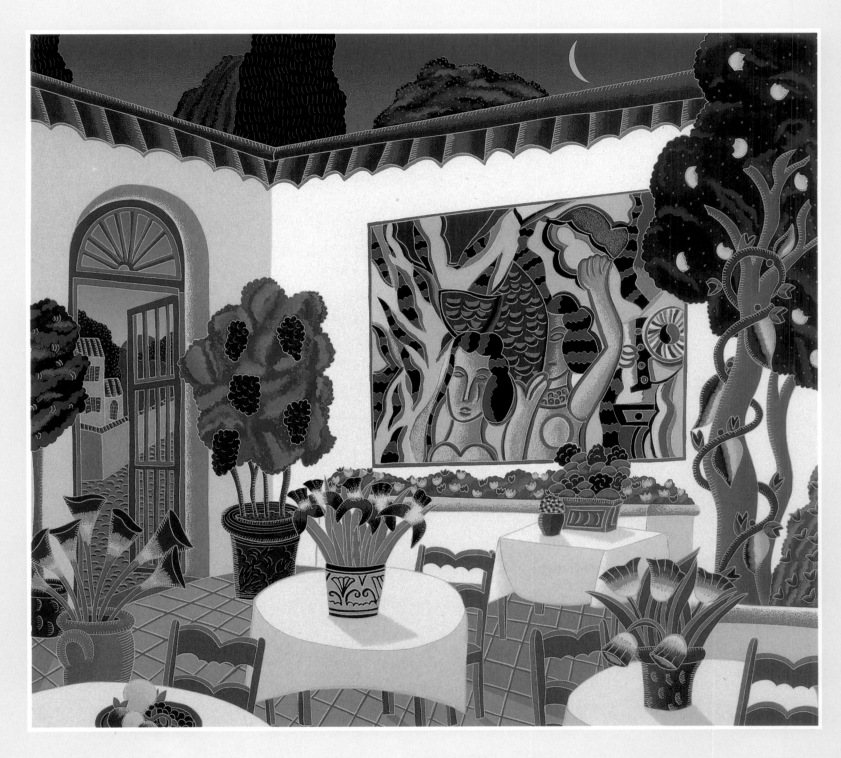

ST. PAUL–DE–VENCE

Côte d'Azur Suite

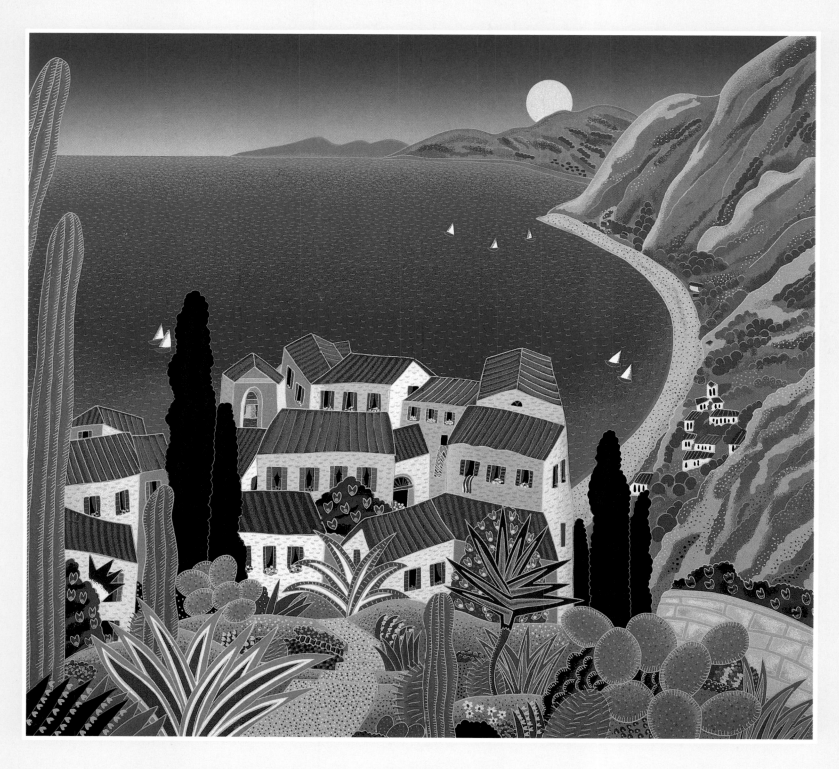

E Z E

Côte d'Azur Suite

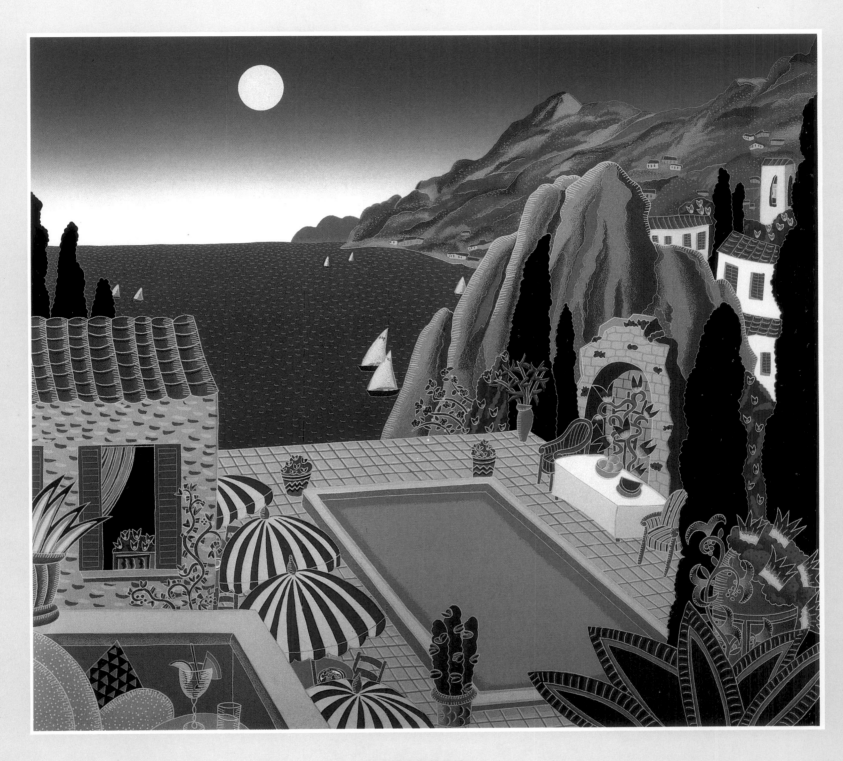

MENTON

Côte d'Azur Suite

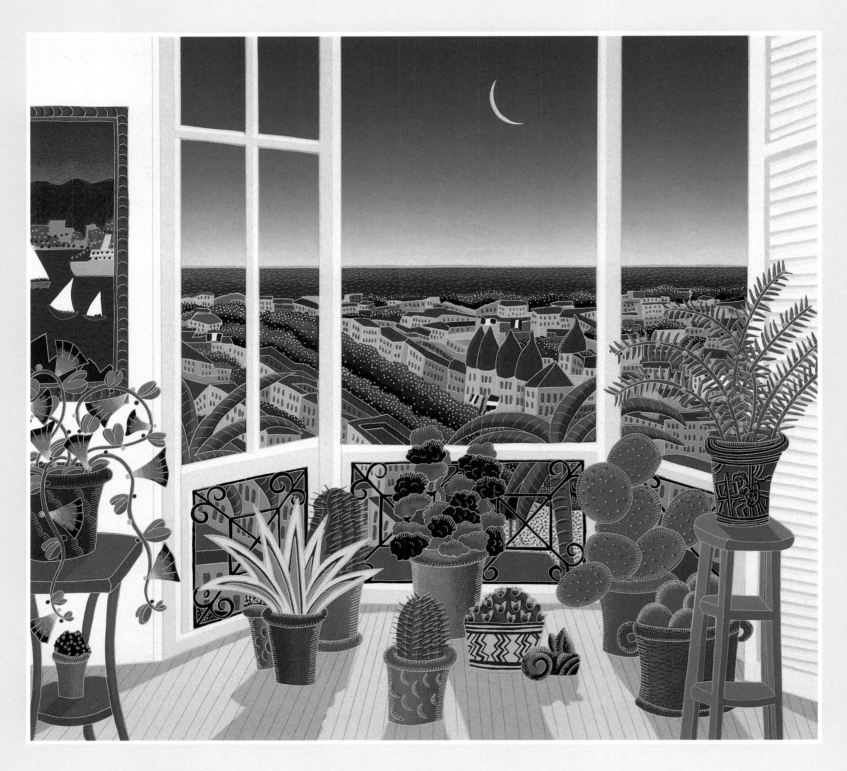

NICE

Côte d'Azur Suite

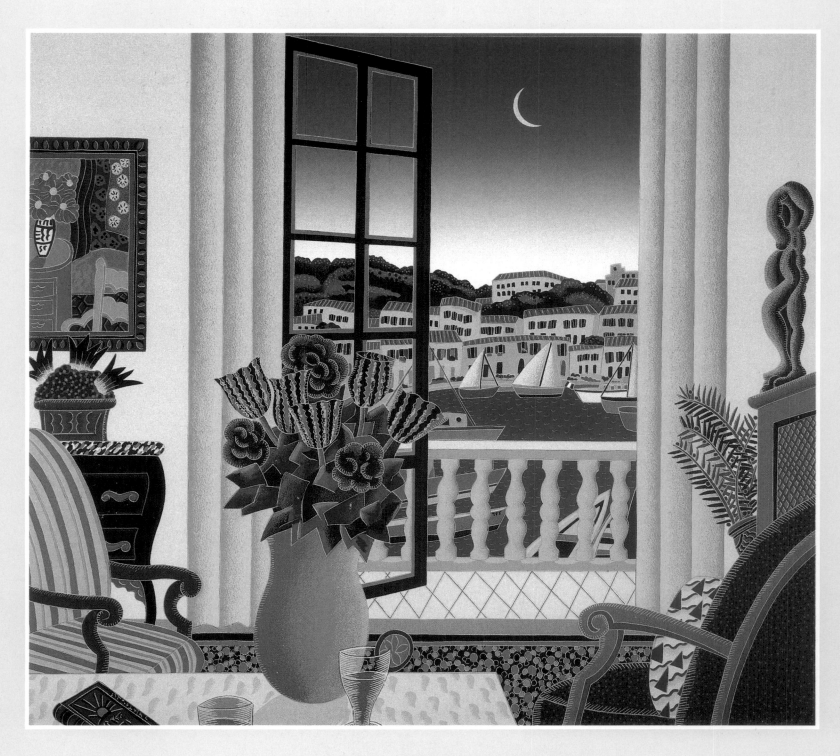

LA VOILE D'OR

Côte d'Azur Suite

ACROSS AMERICA

Across America is a grab bag both as a category of prints and as a place. What other country has such diversity? Where else do tropics, deserts, snowy mountains, grassy plains, and giant cities coexist? When I am in America I often become tired of its blandness and of our habit of sweeping problems under the carpet. When I am away and surfeited with picturesqueness and machines that don't work, I long again for smoothly functioning showers, cash machines, and stores with books in a language I can read. America is no Arcadia, but then, no place is.

GOLF
(overleaf)

Sometimes I suspect that playing golf allows adults to pretend they inhabit Arcadia, as they march over manicured lawns and skirt tame sand traps. The game itself and the accoutrements of its players are as ritualistic as an Elizabethan pastoral masque. Perhaps one attraction of golf to executives who live in towers and deal in abstractions is that it is horizontal, with a few straight edges and a real ball.

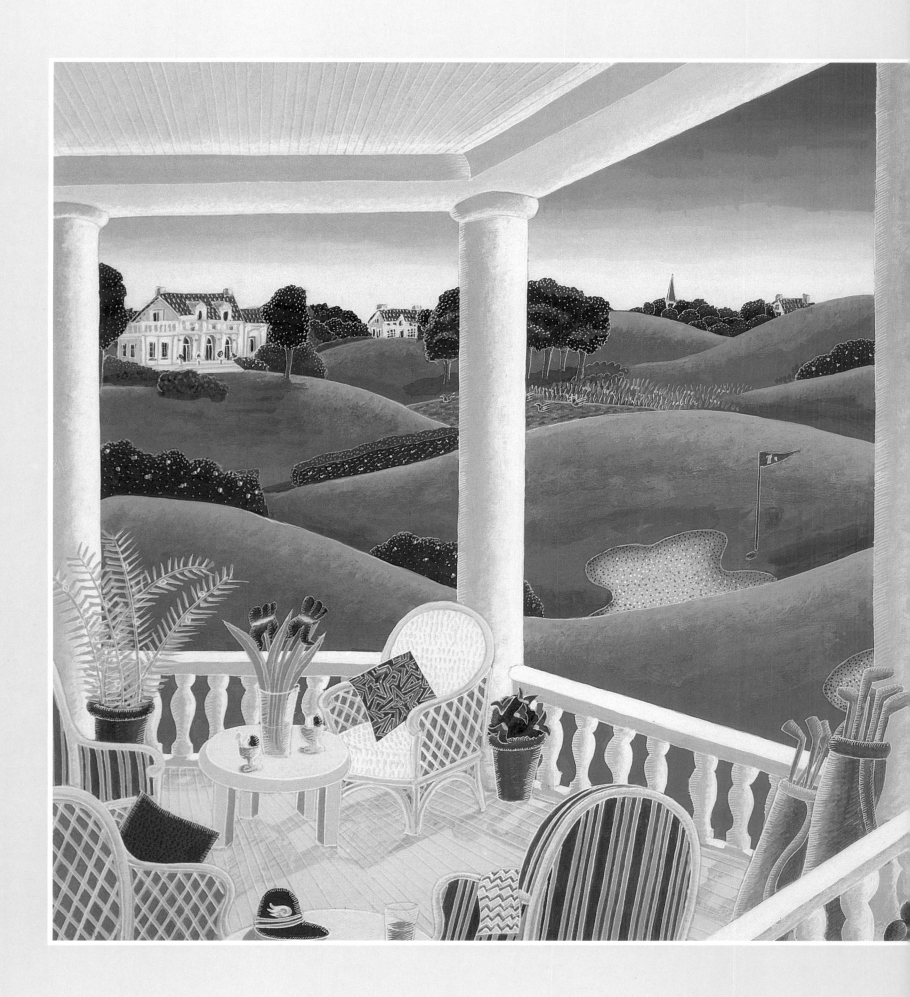

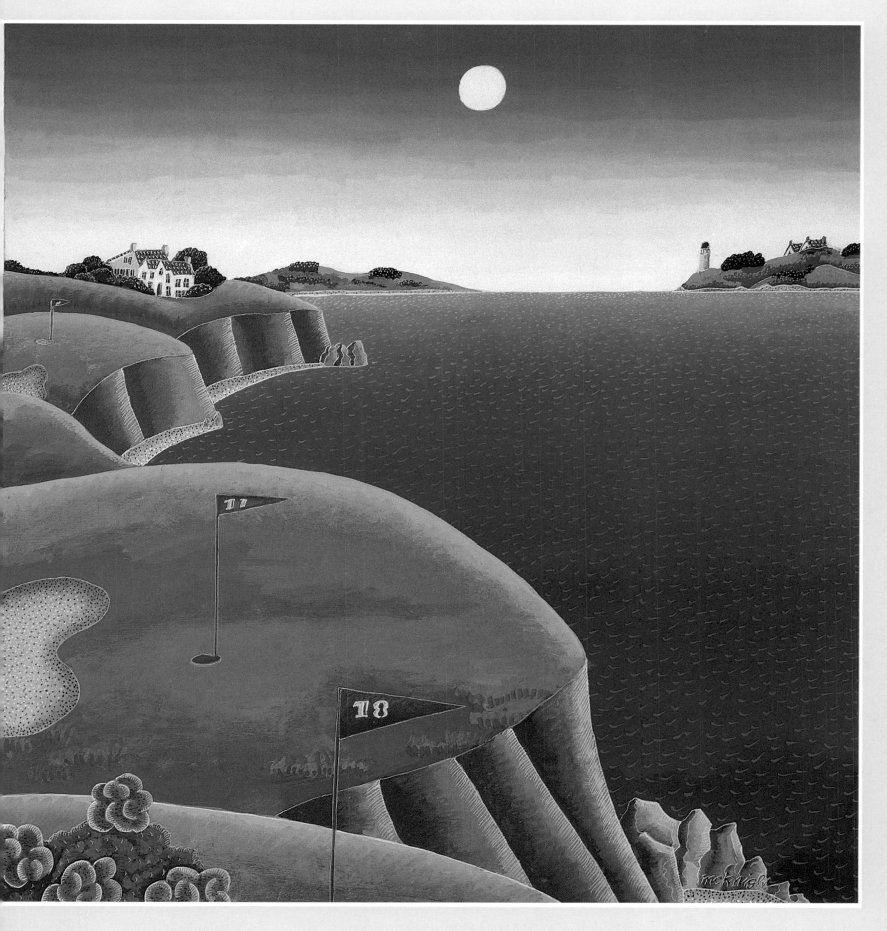

GOLF

A prominent art dealer shown a group of my prints picked out this one and said it was the essence of my work. I disagree. It is atypical. Here I try to exclude things. Usually I include, so that my work can be read almost like a narrative. Personally, I would never want to live in a modern house such as this, but to paint it is a different matter. There is something peaceful about space architecture and this is what attracted me to it. My own surroundings are filled with things—I see spareness when I lie in the sun and shield my eyes to look up into the sky. A place one feels compelled to paint is not always where one wants to be. Sometimes painting is an exorcising, or coming to terms with a certain kind of image.

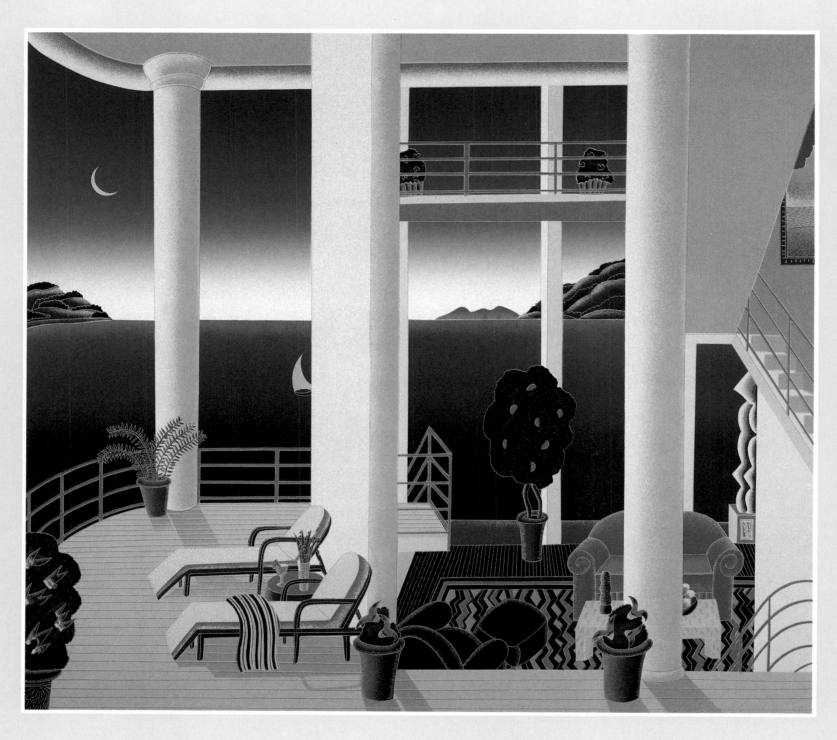

CATALINA

Most people only dream of paradise. Here people buy it. The last time I was in Bel Air and its more flamboyant sister, Beverly Hills, the talk was of megamillion–dollar real estate and clothes closets as big as other people's houses. It would be interesting to know why people congregate in certain places and make them beautiful. Or is it that beautiful places draw people who can afford them? Which is the American dream?

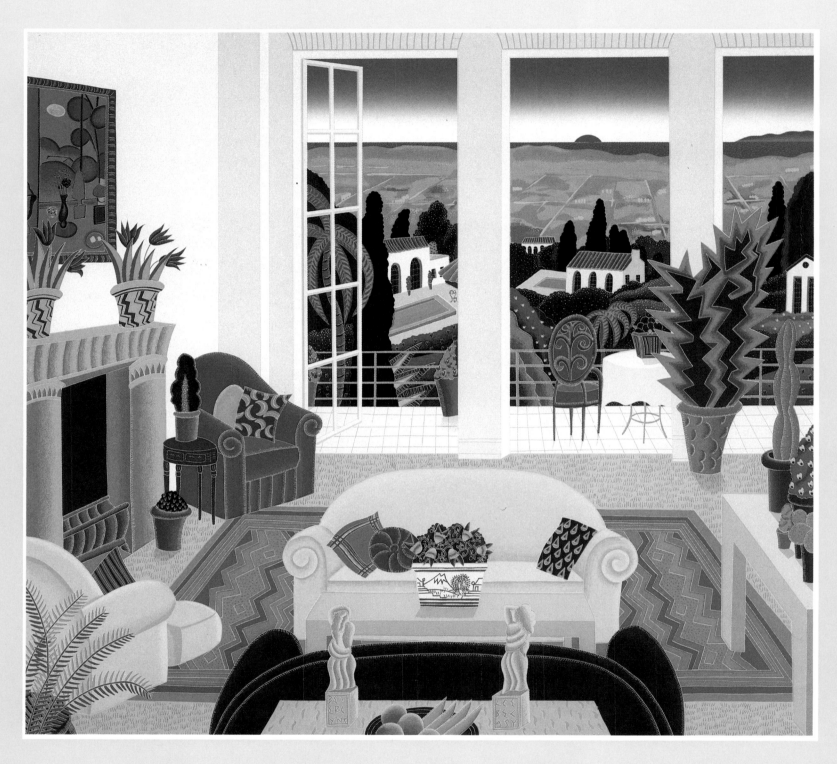

BEL AIR

I must confess that the only time I go to Chicago is to attend exhibitions of my work. But I find it a city whose brisk air makes me energetic. It throws off a big city feeling like New York without having that city's warts. The view here is from a hotel room facing north toward the Gold Coast. I sketched it on hotel stationery but didn't make color notes and forgot my camera that trip, so the colors of the building are probably off.

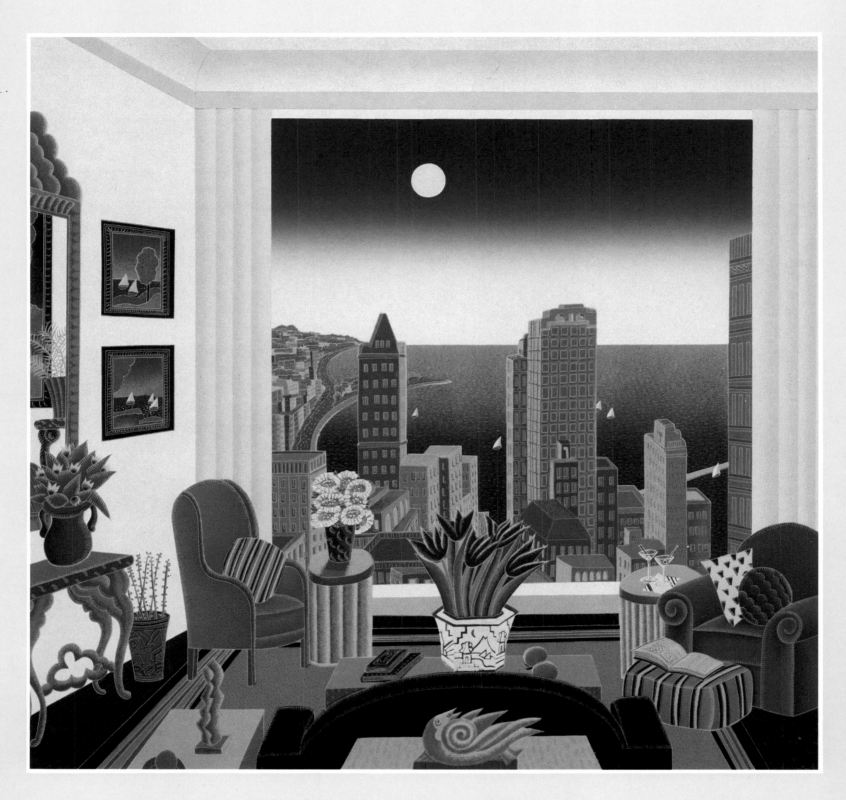

LAKE MICHIGAN

Some of my high school years were spent on the North Shore of Long Island. At that time, and still, as far as I know, Centre Island on the Sound was one of its choicest enclaves. One summer a friend of mine, Doug Wheeler, and I delivered telephone books, earning a sum of money for each one delivered. We picked a route with large estates, partly for curiosity's sake but mainly because each estate was good for multiple phone books. In those days it was one telephone book per telephone. Our scheme proved inefficient. The multiple books per mansion did not make up for the long driveways. The next day we delivered one book each to tract houses, and made a lot more money.

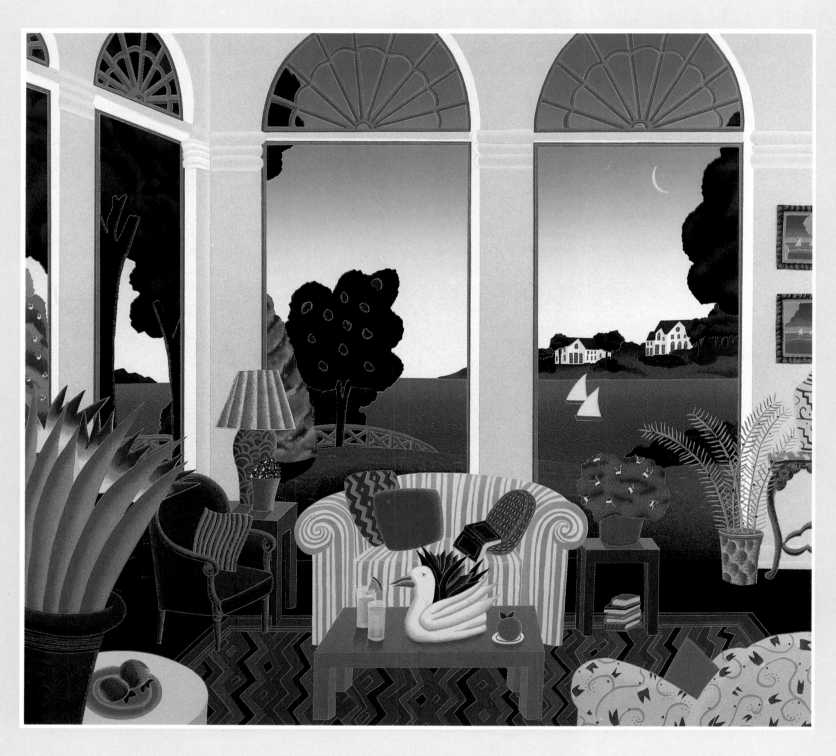

CENTRE ISLAND

FOUR SEASONS SUITE

These images are what some might call signature pieces. That is to say, they possess the most typical, easily identifiable subject matter of an artist's style. A painted American flag brings Jasper Johns to mind; a flying lover, Chagall. My signatures are rooms with views, usually to a watery horizon. When I look back, even my earliest work had these characteristics. My process of development is not so much change as focusing—on what is most useful in presenting a personal vision. The styles chose me, not the other way around.

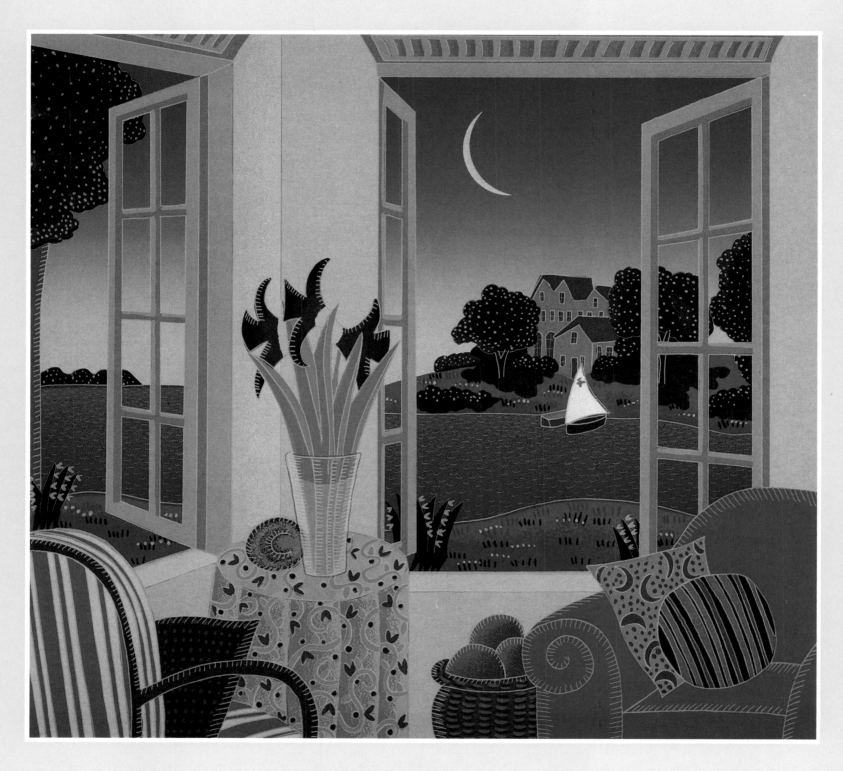

SPRING
Four Seasons Suite

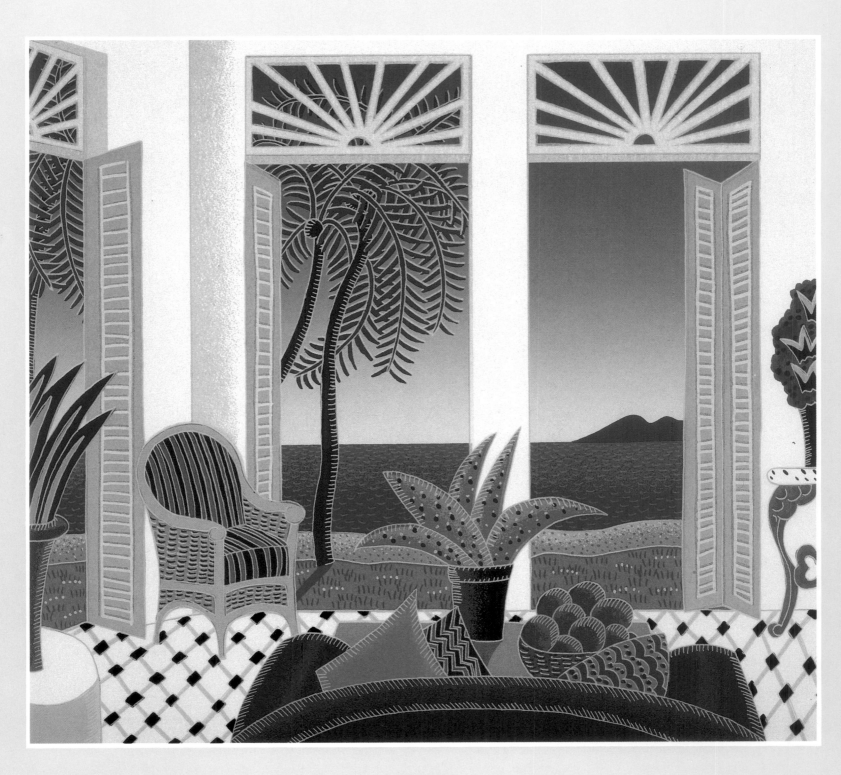

SUMMER
Four Seasons Suite

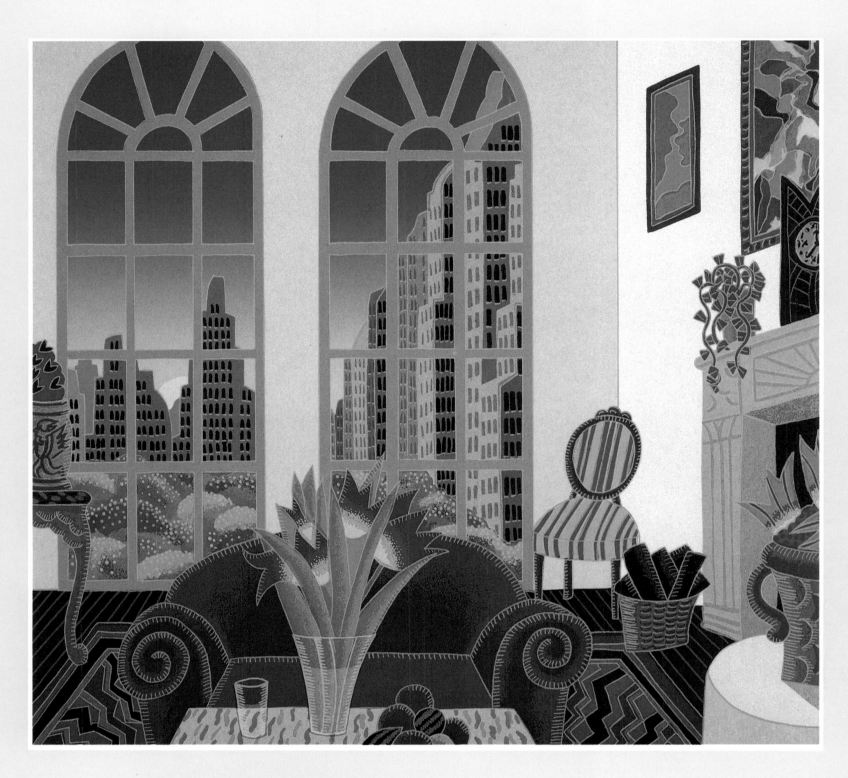

FALL
Four Seasons Suite

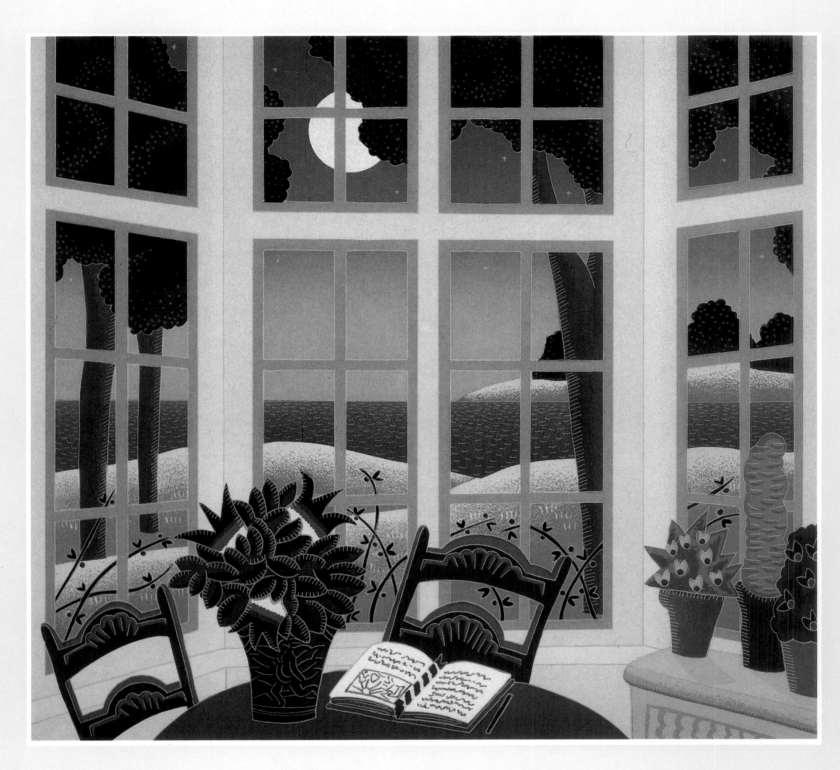

WINTER
Four Seasons Suite

PALM ISLAND
(overleaf)

This is a total fantasy. Made–up interiors like this are my equivalent of the capricci *painted by eighteenth–century Italian artists like Canaletto and Pannini. Instead of painting real views with architecture and ruins,* capricci *were imaginary versions or pastiches— eighteenth–century fictions. They could exist, but they did not, just like Palm Island.*

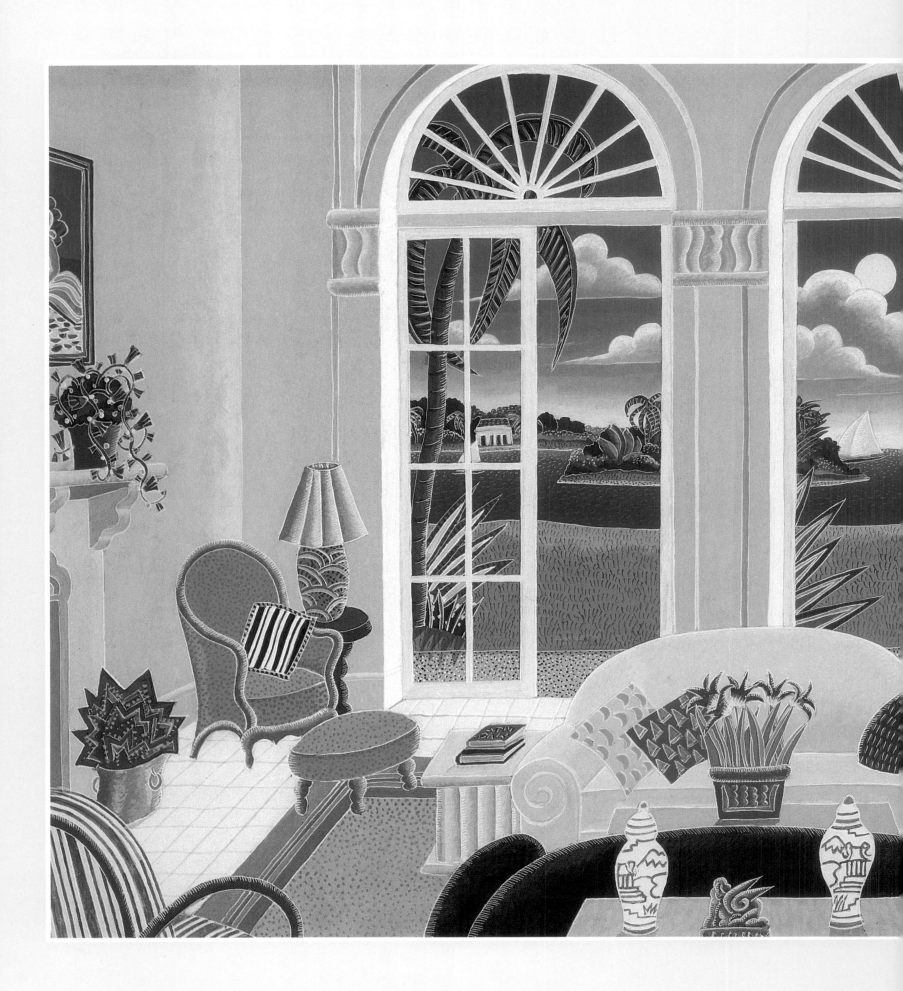

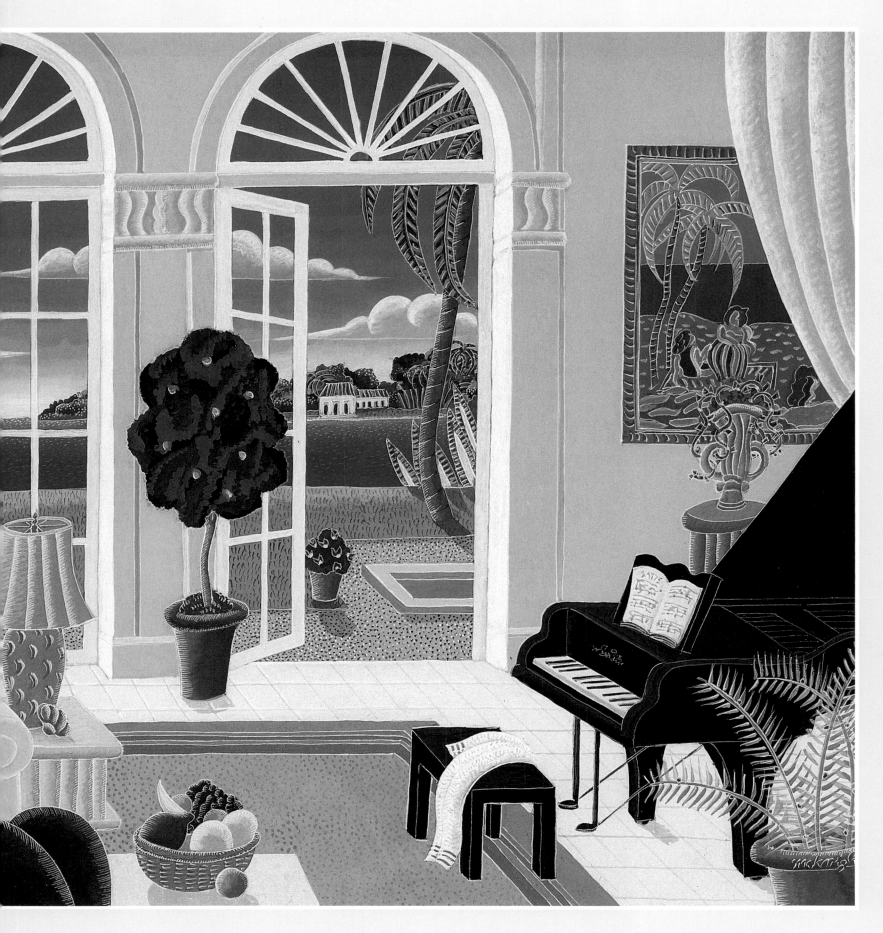

PALM ISLAND

FOUR CORNERS SUITE

After driving for miles through the Litchfield hills of Connecticut, through early American hamlets and over rolling hills, my wife and I imagined ourselves deeper and deeper in an eighteenth–century countryside. Imagine the shock when we suddenly burst onto a turnpike lined with filling stations, fast–food stops, and furniture stores. The old days of regional diversity in America have been framed in modern strips like these—all of them the same, whether they divide pieces of Connecticut or Nevada.

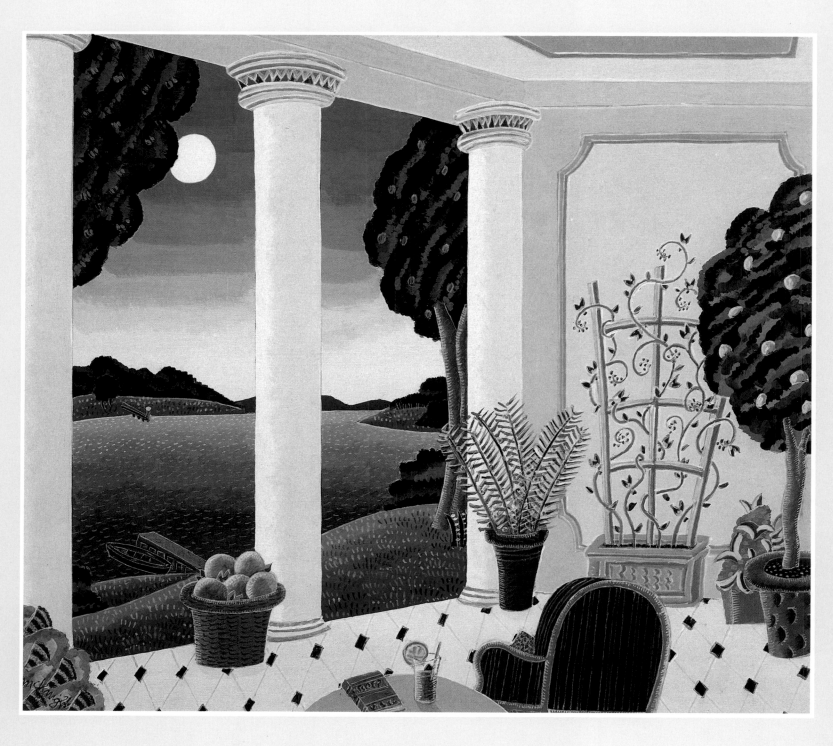

PLANTATION

Four Corners Suite

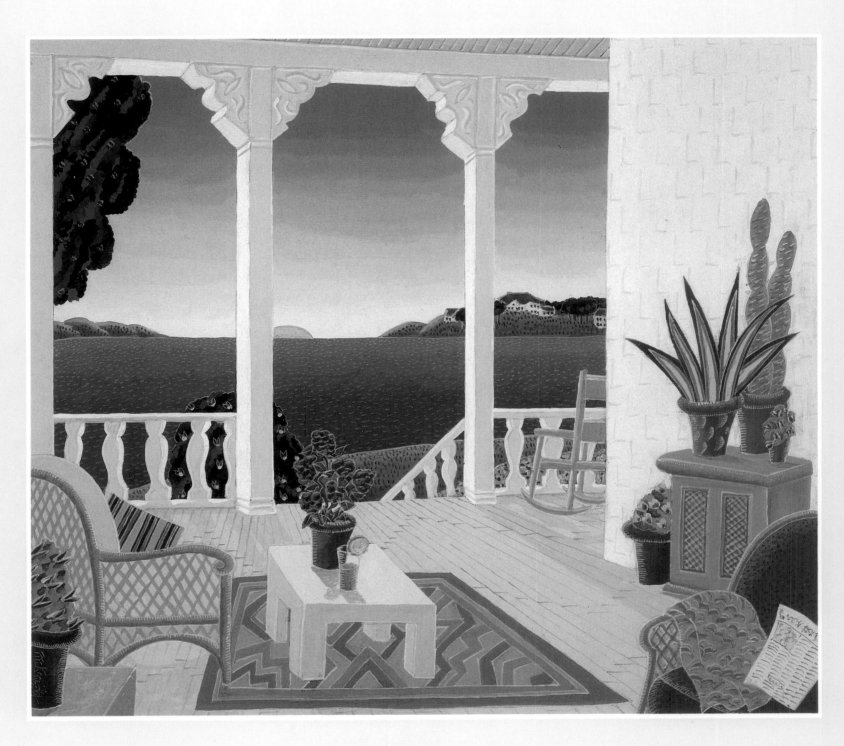

NORTHERN SUMMER
Four Corners Suite

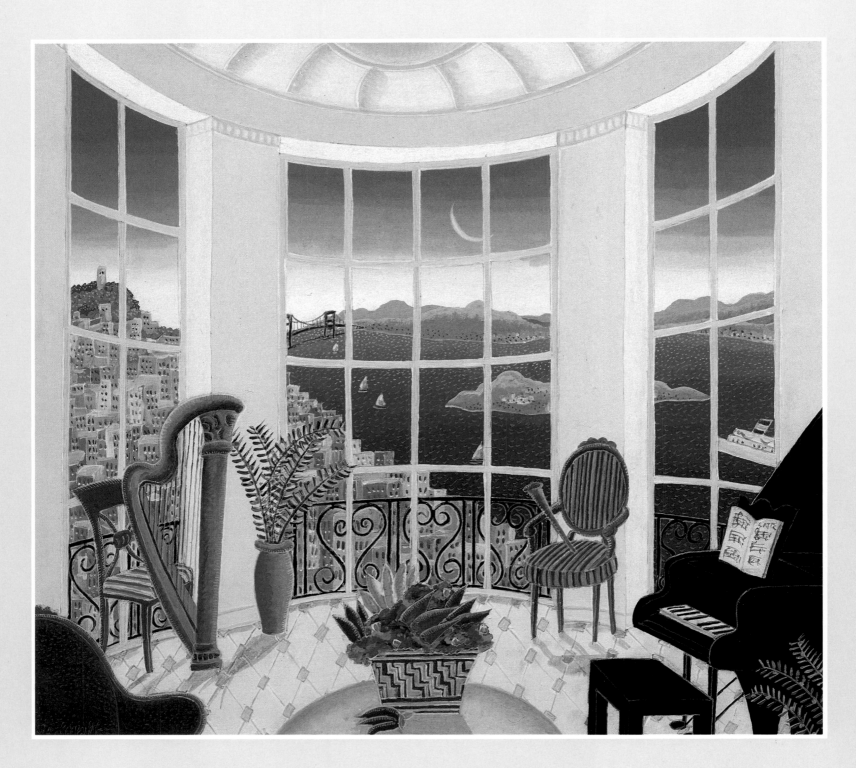

GOLDEN GATE

Four Corners Suite

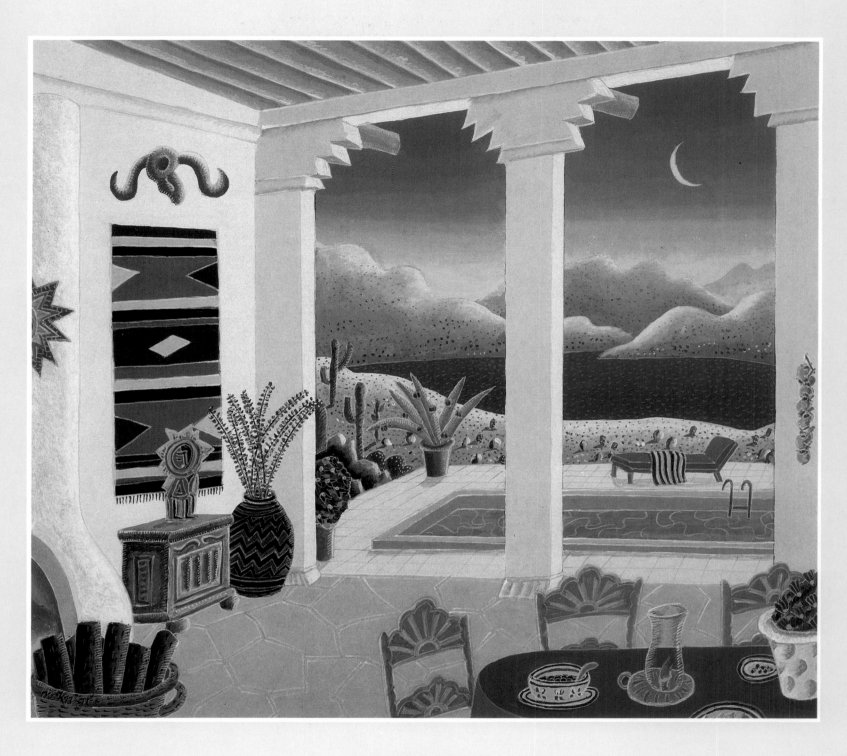

DESERT PATIO
Four Corners Suite

VENICE

Built of the fossilized thoughts and deeds of long–dead artists and grandees, Venice rises like a coral reef from its lagoon. Nature here acts only as the frame and mirror of what man can accomplish. And because it is all manmade and built on the grand scale of an epic opera, it evokes emotions worthy of a great work of art.

VENETIAN LAGOON
(overleaf)

Despite the popular misconception, Venice is a city more of stone than water. This view from a room in the Monaco et Grand Canal Hotel is unusual in that water really does predominate. In Venetian terms, it is Grand Central Station, the center of town where one hires a gondola or water taxi, sits in a cafe, or takes passage on the bus–boats called vaporetti *that ply the main water routes. I stared for hours at this panorama, watching it constantly rearrange itself—a symphony of people and boats. The sunlight that reflected off the water dappled the ceiling of our room.*

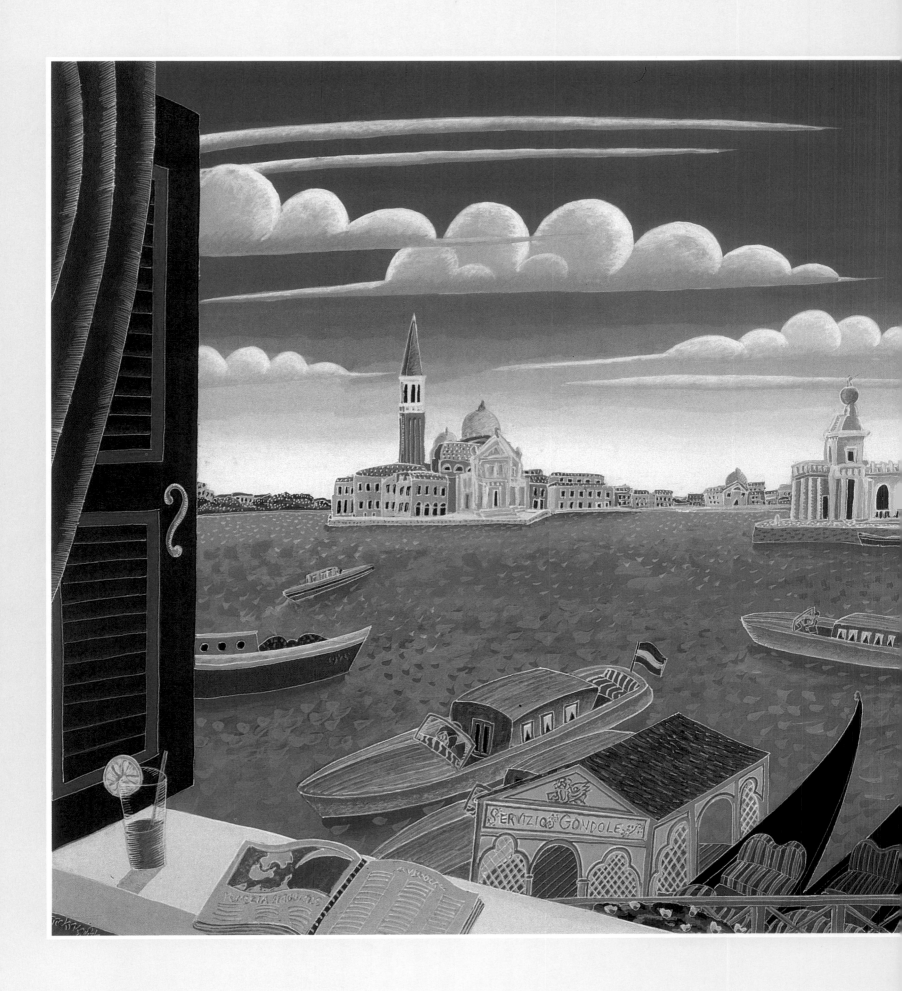

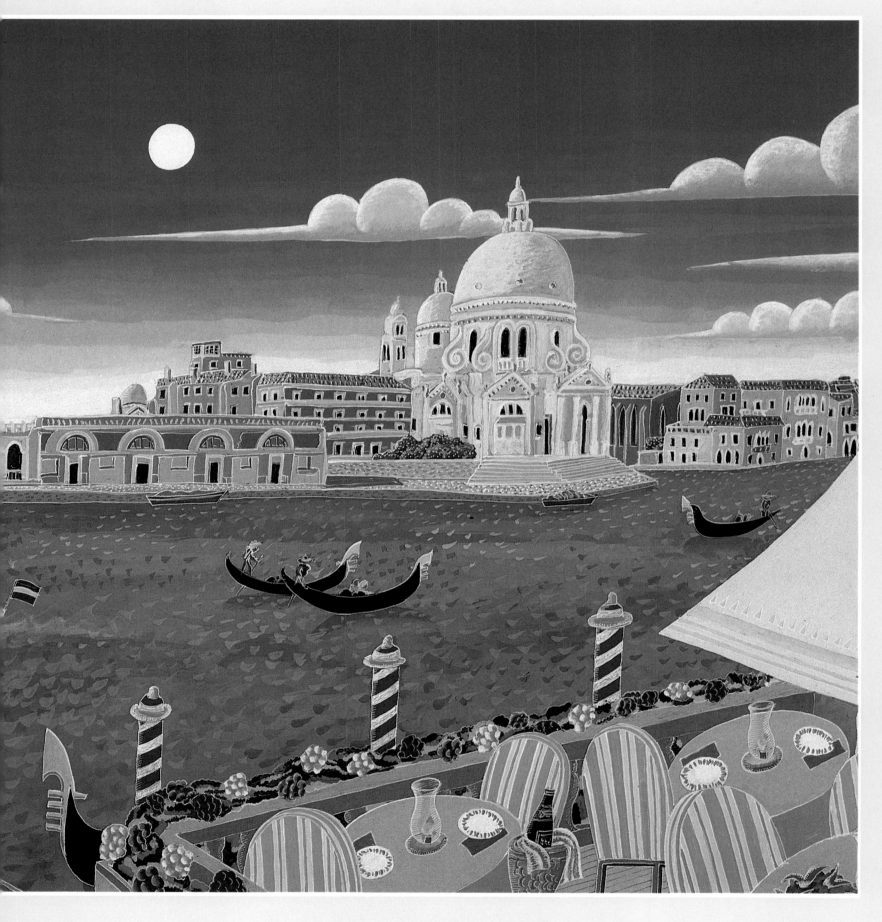

VENETIAN LAGOON

One September my wife and I went to a grand ball in a candlelit palazzo. A member of the British royal family was expected to attend and divers were searching the Grand Canal in front of the palazzo for bombs. The actual event reminded me of this image painted from my imagination a year before. Then Liszt was at the piano—now it was Bobby Short. I intended the print also to be a reflection on the changing roles we play in life, so, for example, the young Apollo becomes a bowed–down Saturn, or a young girl metamorphoses into Aphrodite.

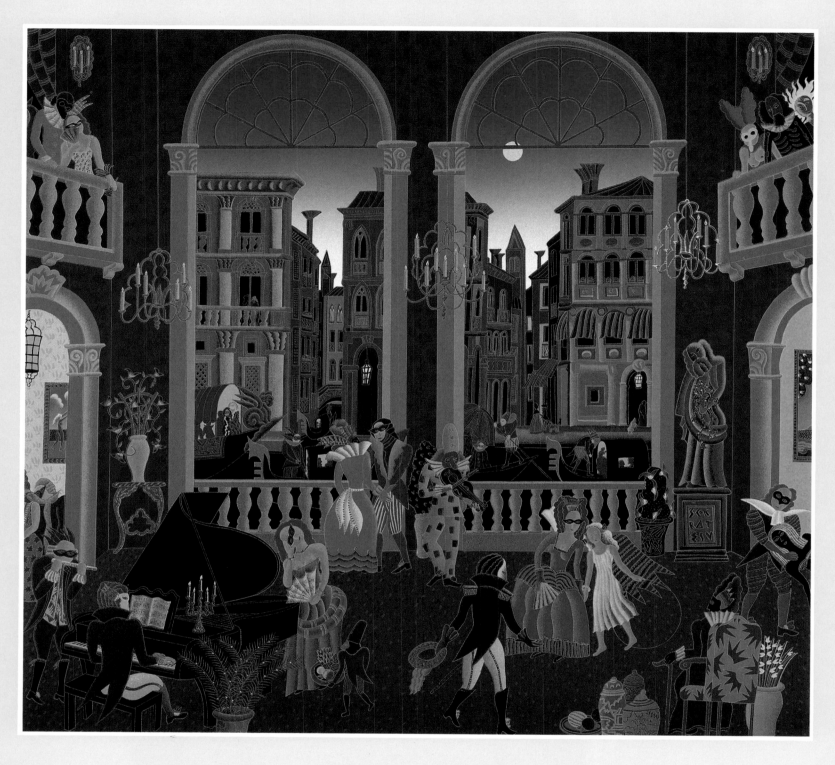

CARNIVAL IN VENICE

Mariano Fortuny was an artist and designer of the early years of this century who is best remembered for his finely pleated Grecian–style dresses and fabrics. He lived in a dark, wisteria–covered palace in an obscure corner of Venice. This image was inspired by the mood of that palace, now a museum.

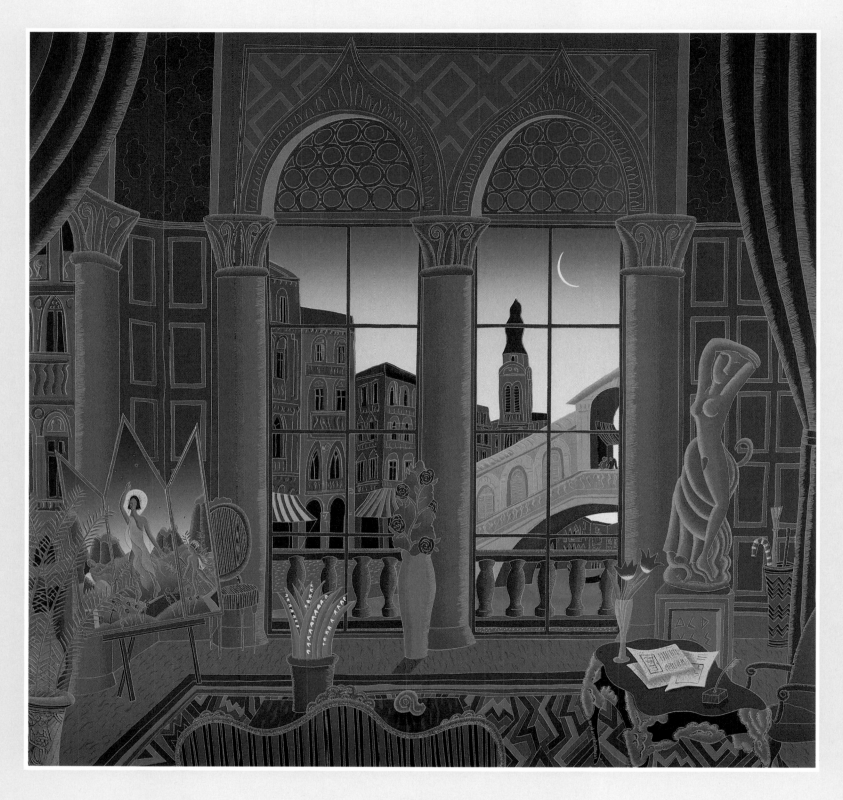

CAPRICCIO

VENICE REVISITED SUITE

The first Venice Suite was composed shortly after I first discovered the watery city. The famous views and monuments were new to me then and that is what I painted. It was a challenge precisely because so many artists before me had gazed at the same vistas and painted their interpretations. Was it possible to say something new about these views, themselves nearly unchanged over the centuries? This second suite is the fruit of many subsequent annual visits during which, by foot and gondola, I have explored the nooks and crannies where Venice reveals its picturesque age. All these images are of actual places, from the terrace of a room in the hotel Saturnia to the food and fish markets across from the Ca'd'Oro. In Venice, far–from–the–beaten–path can be just footsteps away from where most tourists cluster.

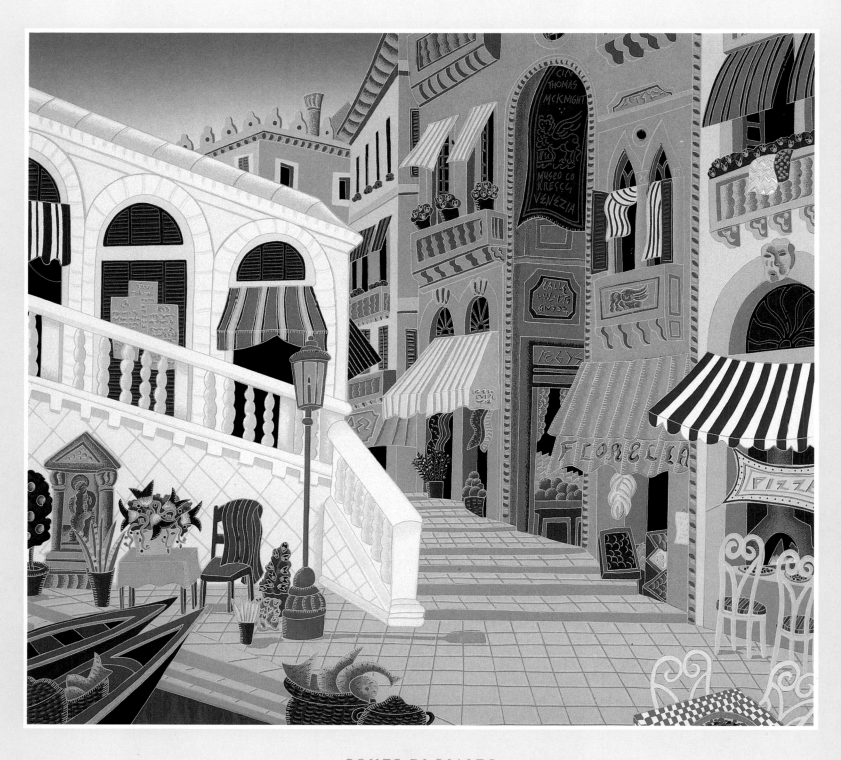

PONTE DI RIALTO

Venice Revisited Suite

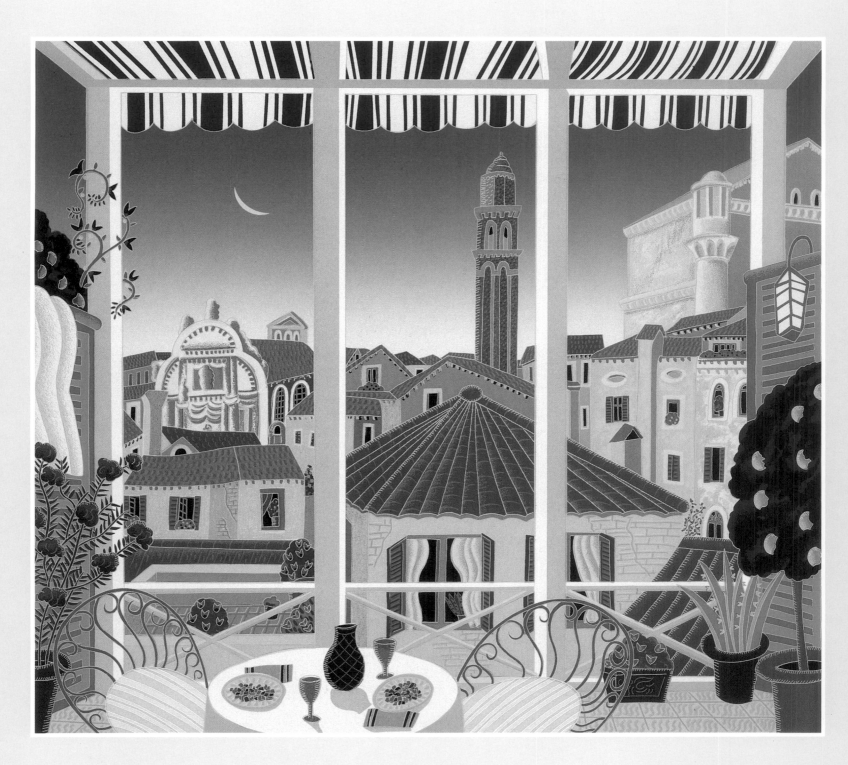

SATURNIA

Venice Revisited Suite

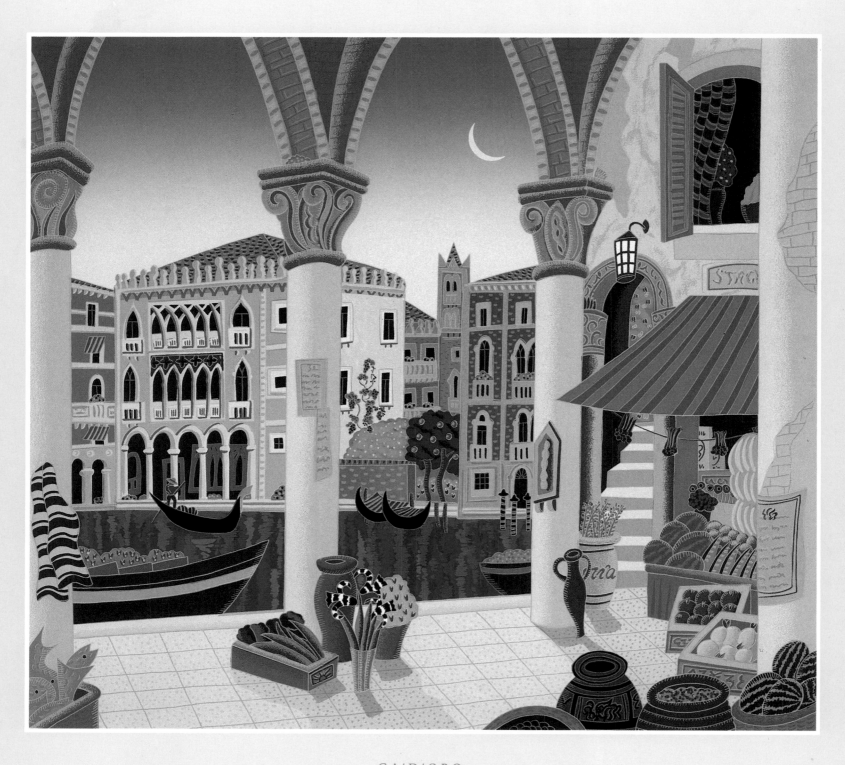

CA'D'ORO
Venice Revisited Suite

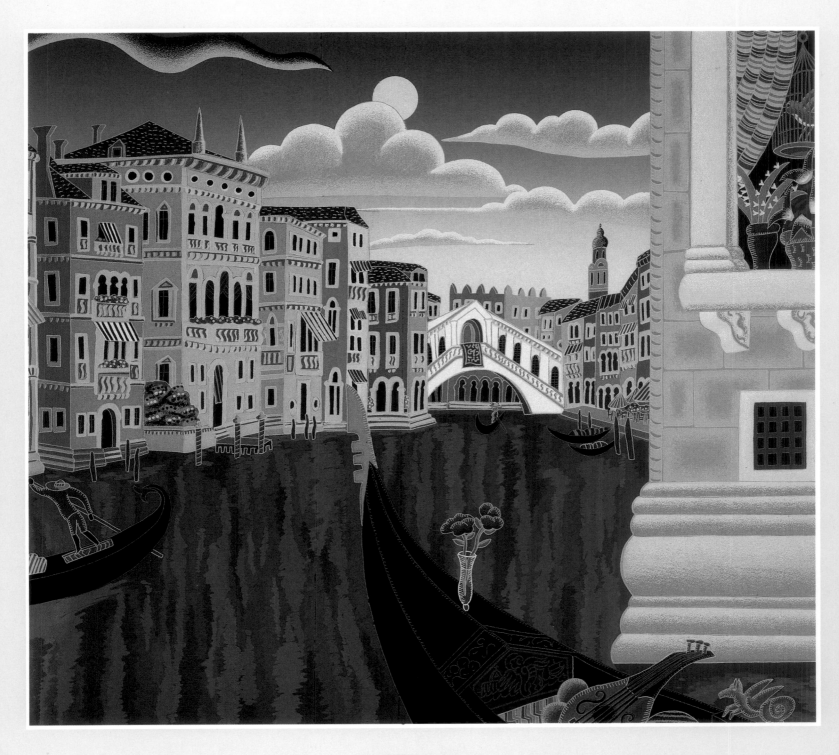

GRAND CANAL
Venice Revisited Suite

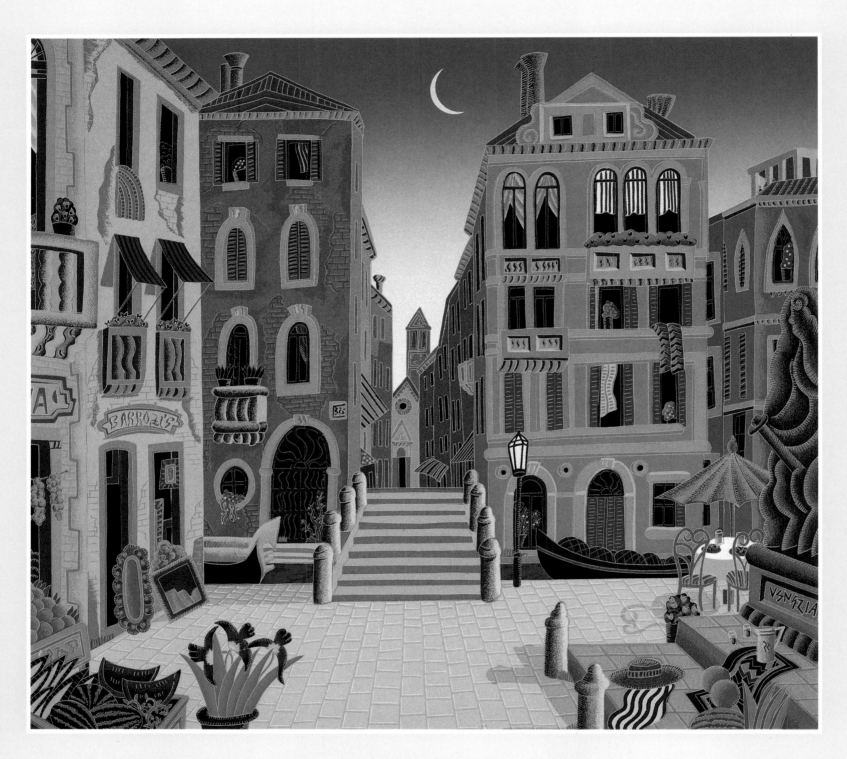

CAMPO MANIN
Venice Revisited Suite

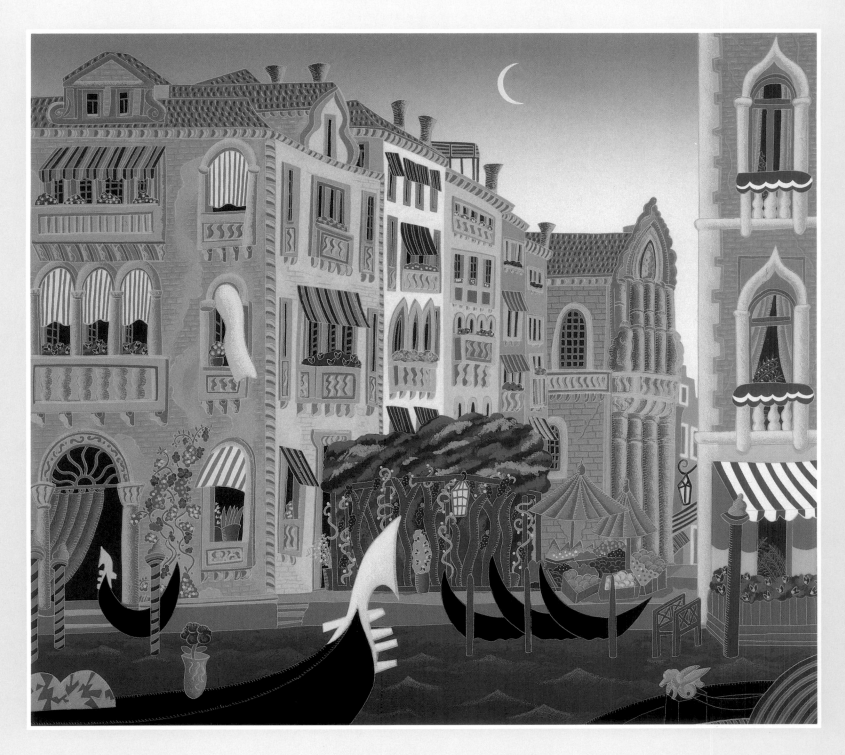

SANTA MARIA DEL GIGLIO

Venice Revisited Suite

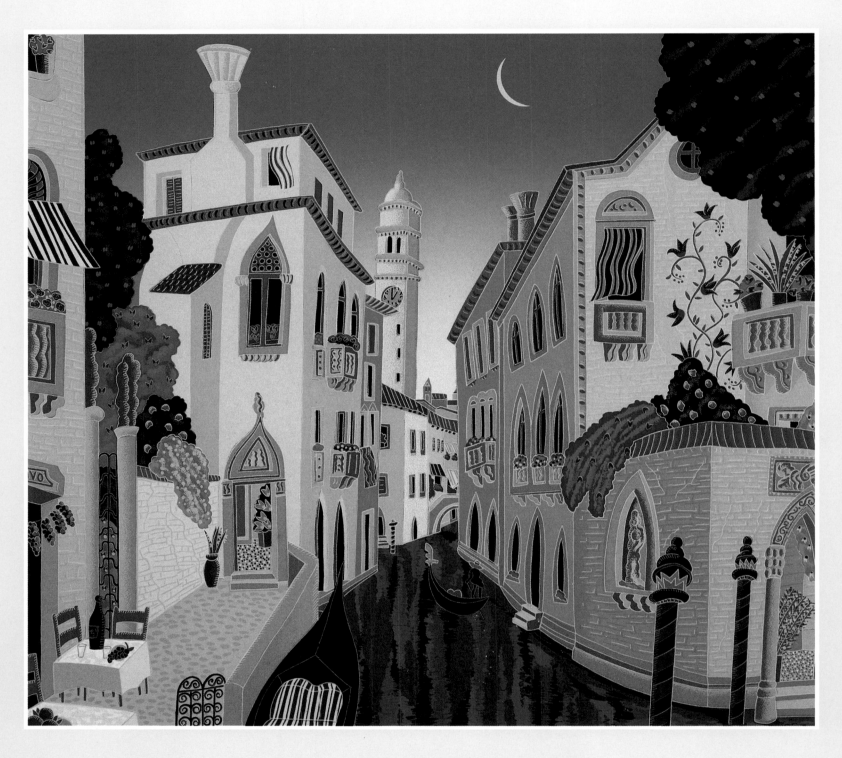

RIO VAN AXEL
Venice Revisited Suite

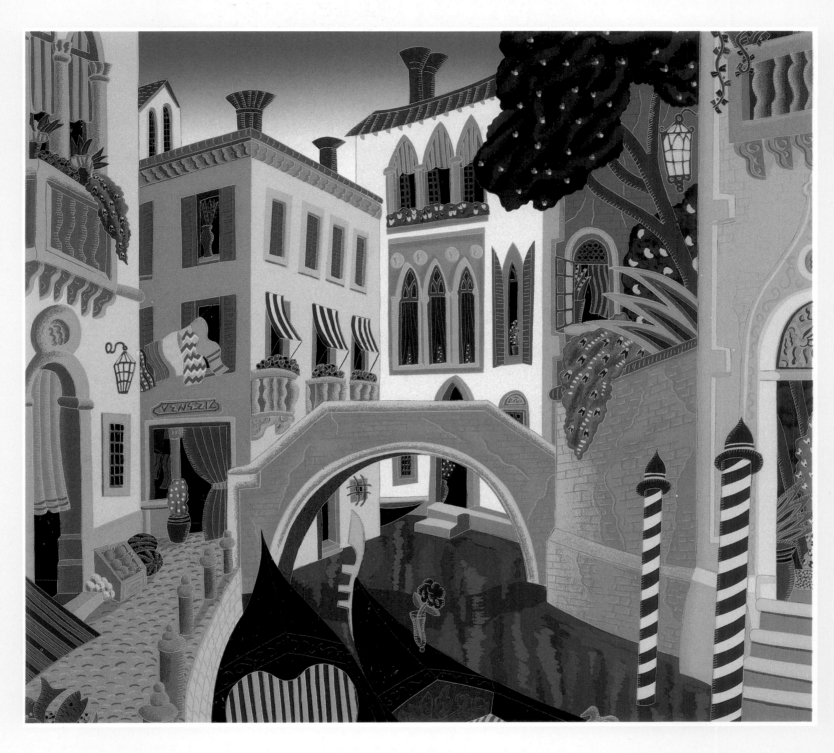

RIO SAN TOMA
Venice Revisited Suite

FLORIDA

Compared to the Caribbean, Florida is not very picturesque; it has the disadvantage of being extremely flat. But it has the same good weather and the advantages of being a few hours from New York and having local stores filled with the latest newspapers, Doritos chips, and diet Dr Pepper.

BIENESTAR COURTYARD
(overleaf)

Bienestar *in Spanish means "the place of well-being." It is the name of a 1920 Mizner–style mansion by the sea in Palm Beach, restored to a style it probably did not possess originally, and divided into six condominiums by the Mizner–like stylist of our day, Bob Eigelberger. Here I paint during the winter months to the splash of the fountain in the courtyard below my studio window. With St. Edward's Church and the former Biltmore Hotel in the background, the view could be many places in Latin America or southern Europe. I discovered the place by accident, but as soon as I entered its jasmine–scented, orchid–filled courtyard I knew I had to live there.*

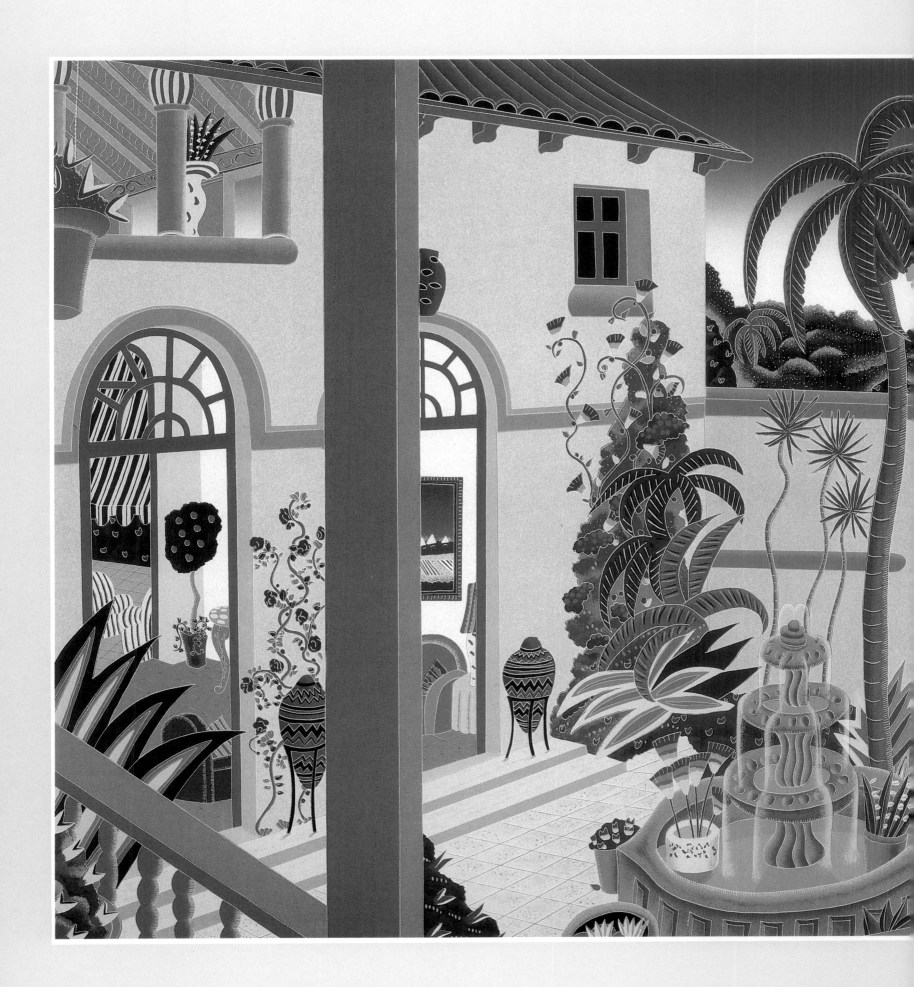

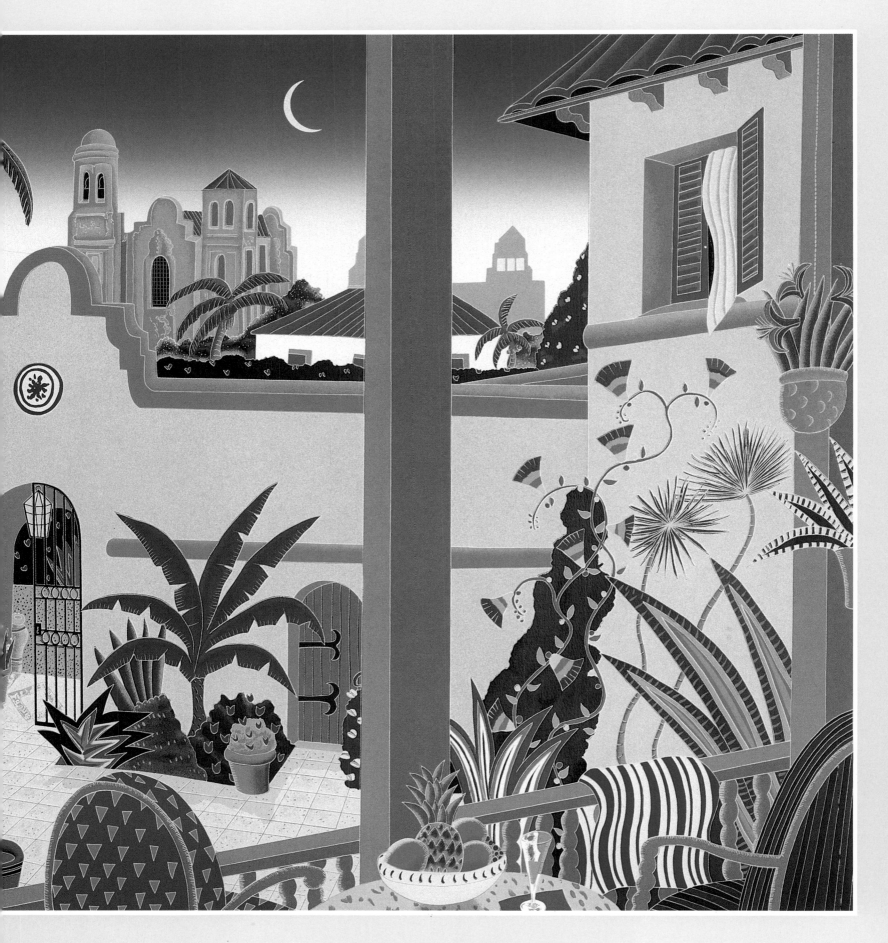

BIENESTAR COURTYARD

The real Villa Flora is a very large mansion by the sea in Palm Beach. A corner of it appears also in the print North Ocean Boulevard, *on the right side. It was built by Addison Mizner, the renowned architect of Palm Beach, whose eclectic amalgam of Venetian, Spanish, Moorish, and Mexican architecture defined the style of the town since the twenties.*

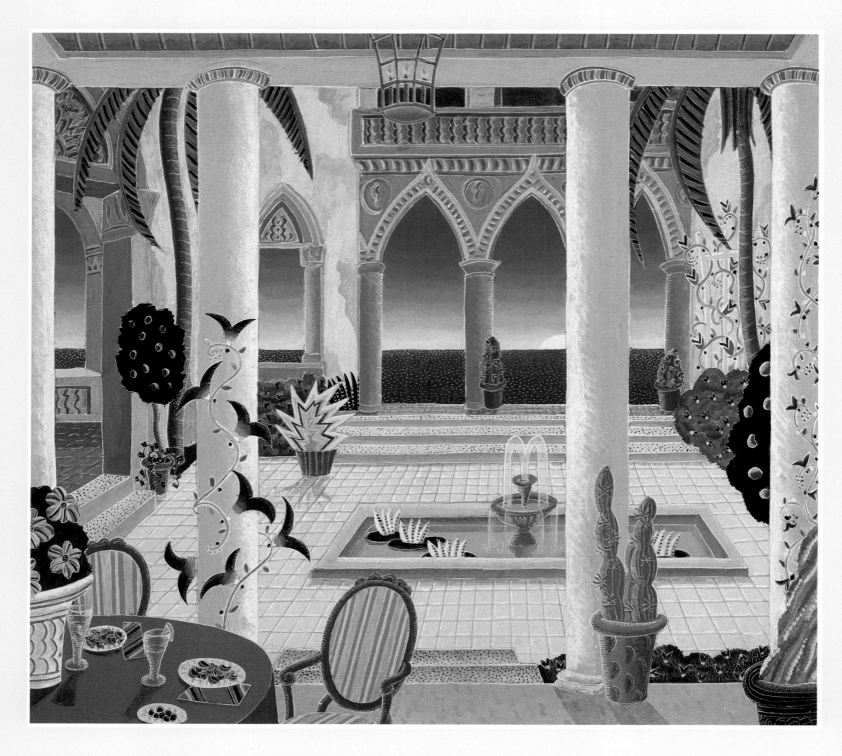

VILLA FLORA

Someone at a gallery opening, I think in Alexandria, Virginia, asked me if I would ever do a picture with a white piano in it. Well here it is, the first, although I've made many with black pianos. I can play no more than "Chopsticks," but I find the piano's visual structure, its curves and straight lines, as evocative as its sounds. That's why it is an important part of my repertory, along with objects like arched doors and terra cotta pots that reappear in my work in supporting roles.

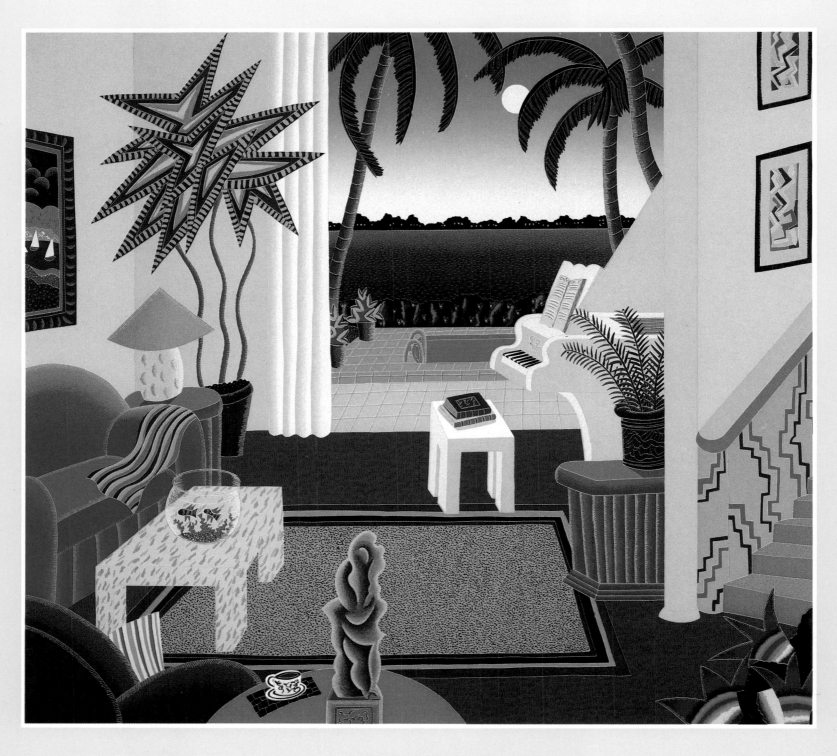

BOCA RATON

PALM BEACH SUITE

Painting with a sea breeze blowing through the yellow shutters of my studio doesn't make the work any easier, but knowing that my bicycle break will be in warm sunshine does. The popular image of Palm Beach is not so far removed from the real thing. It is a playground for the ultra–rich, with mansions and palm trees set to the tune of Cole Porter's **Anything Goes.** *Since I am neither social nor ultra–rich, people ask me what I am doing here. I suppose it is simply because ever since I was a child I wanted to live in a warm, sunny place. When I travel south, whether to Italy, Egypt, Greece, or Florida, my senses come alive.*
I am closer to where I was born to be.

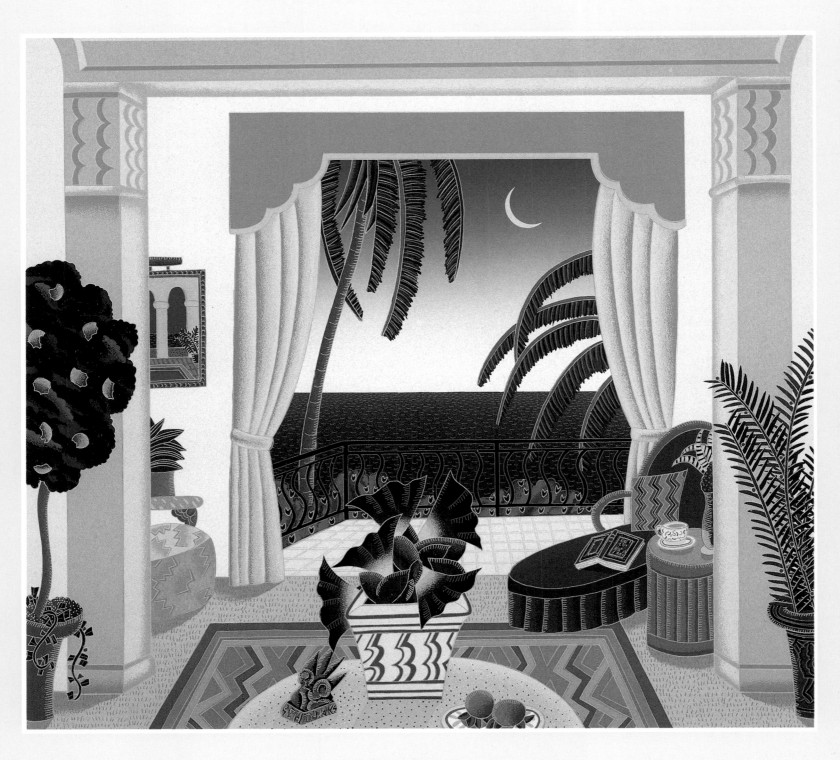

LAGOMAR

Palm Beach Suite

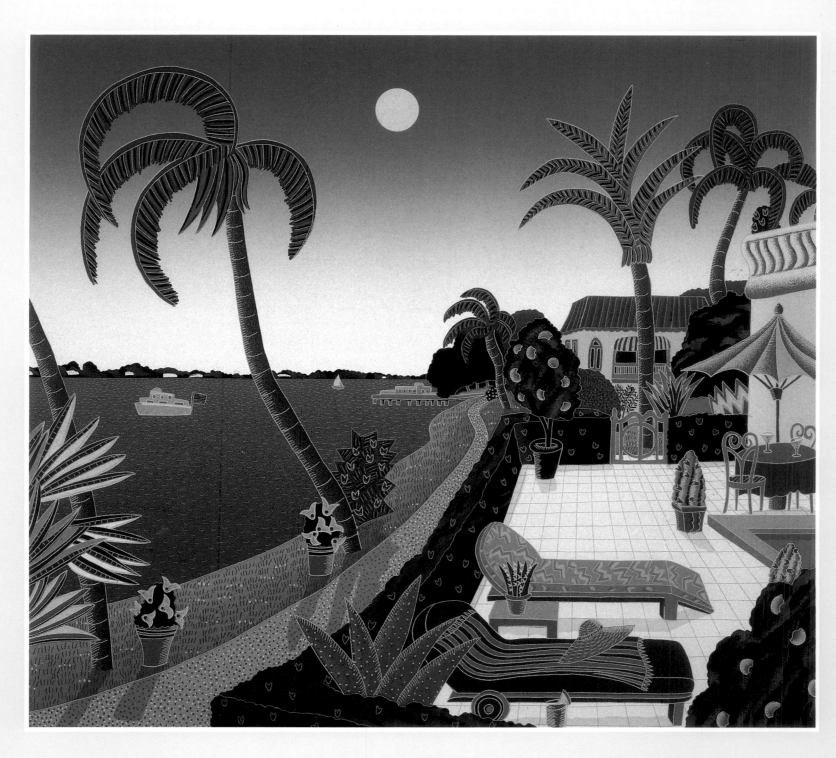

LAKE WORTH
Palm Beach Suite

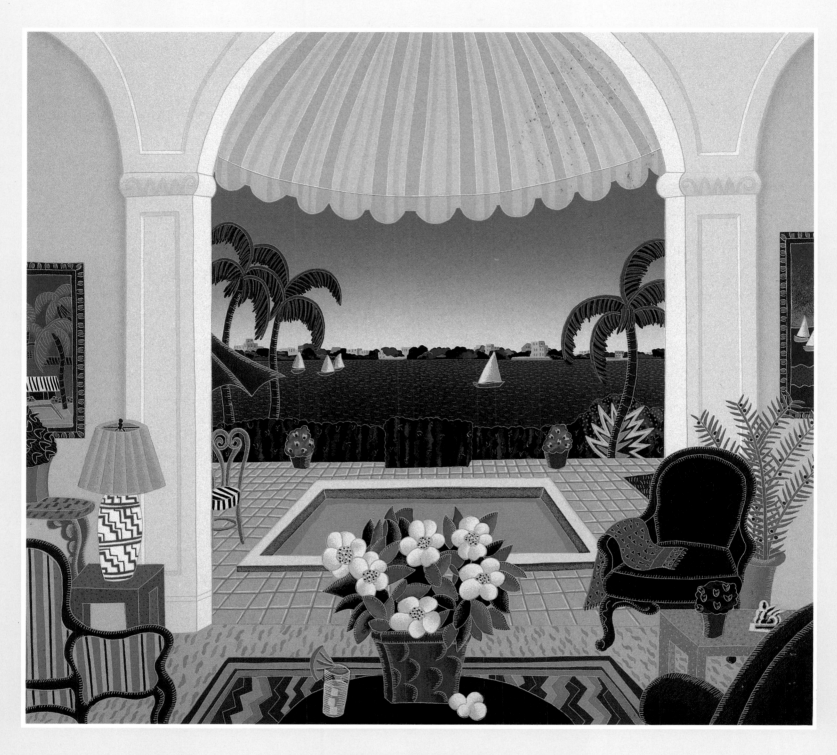

NORTH LAKE WAY

Palm Beach Suite

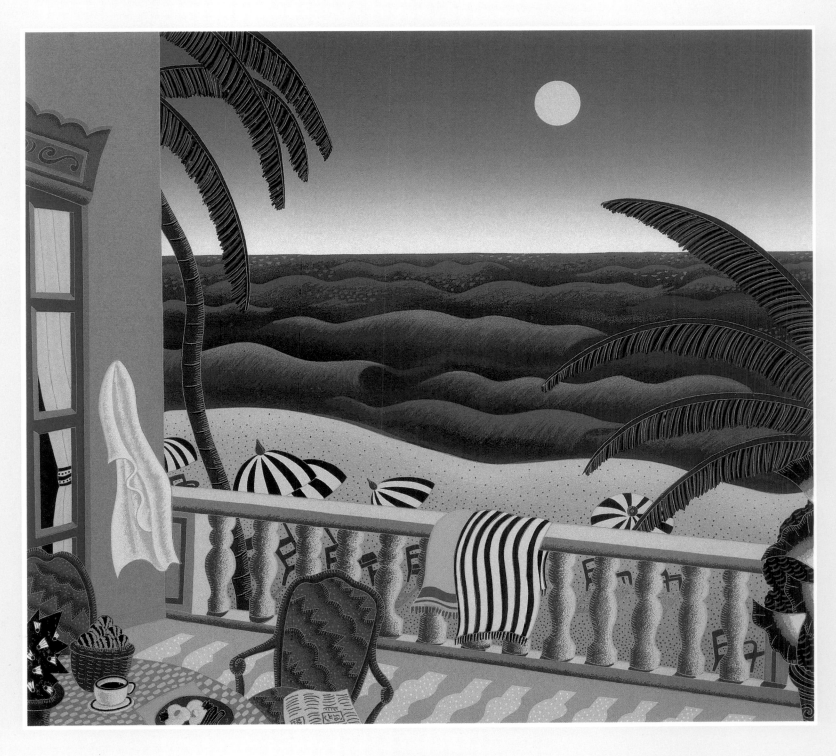

BREAKERS
Palm Beach Suite

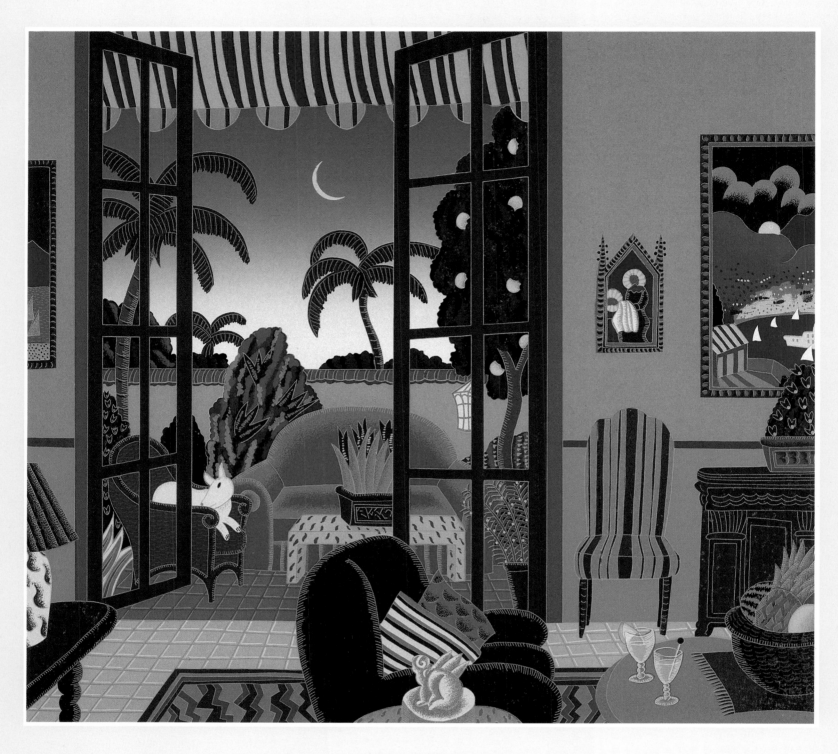

VILLA ROSA
Palm Beach Suite

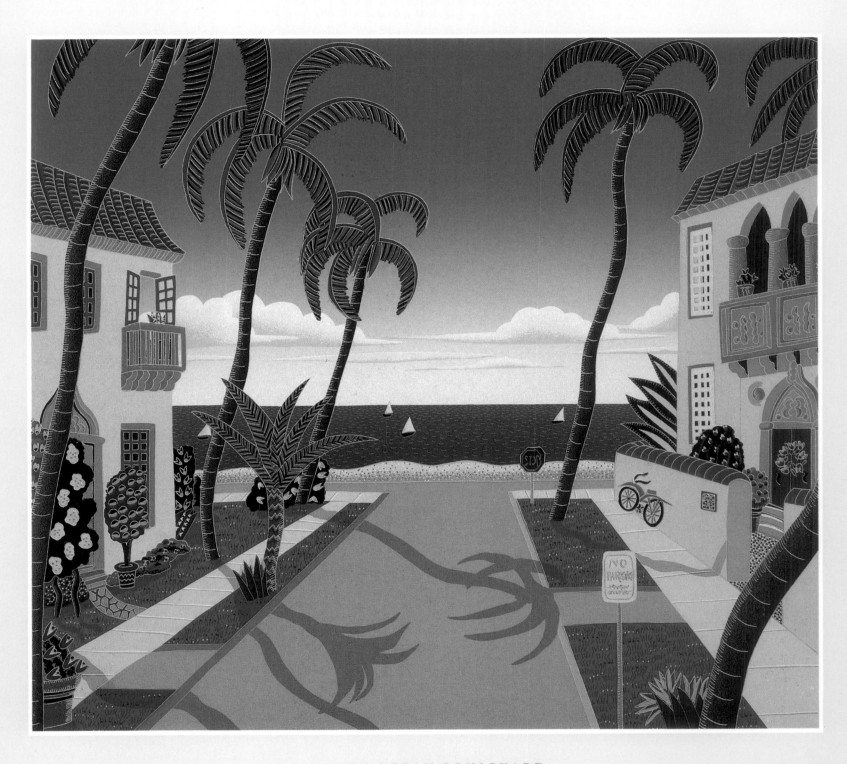

NORTH OCEAN BOULEVARD
Palm Beach Suite

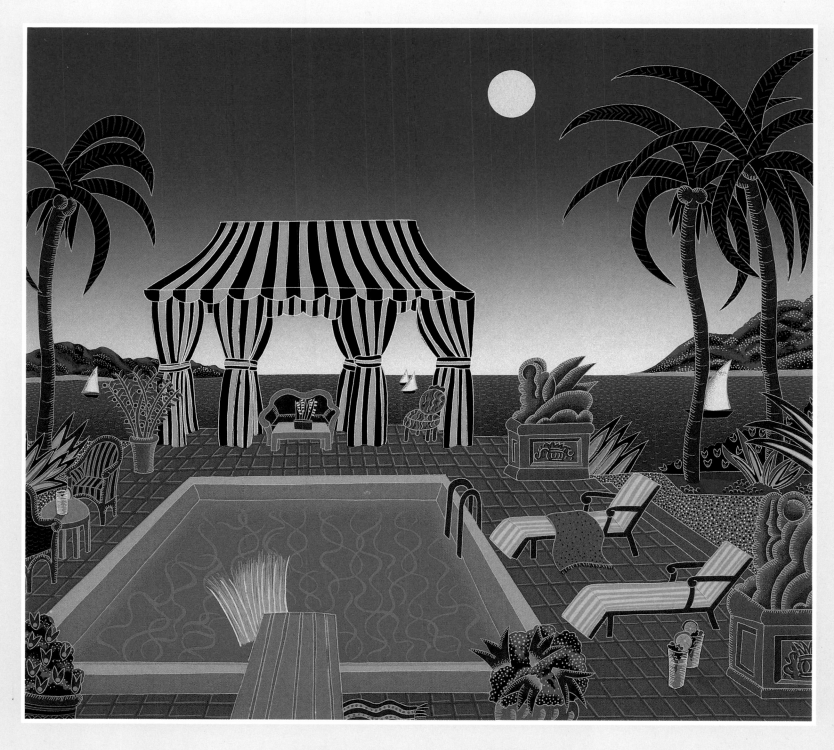

SOUTH OCEAN BOULEVARD

Palm Beach Suite

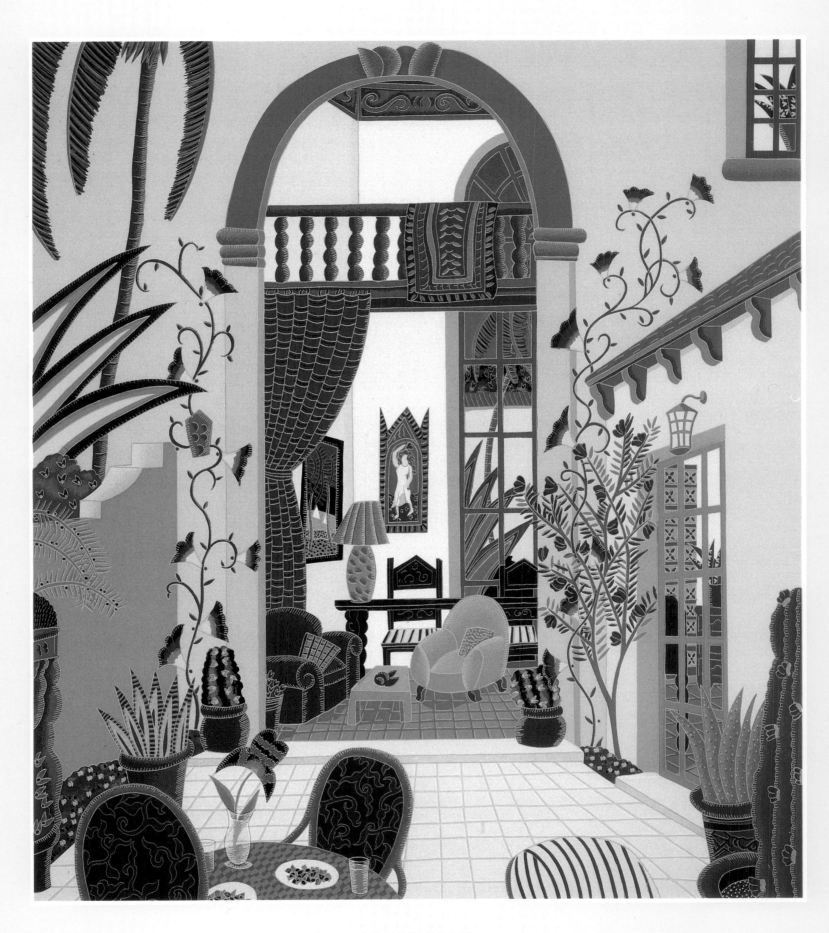

GRACE TRAIL
Palm Beach Suite

BIENESTAR GARDEN
(overleaf)

This is the view from the garden house of Bienestar, the twenties mansion in part of which I live and work. My terrace is the one with the yellow umbrella behind the sea grape trees. The trees remind me of those I used to admire in children's books, but lost hope of finding. Behind the garden house waves crash a hundred yards away. At night, lights behind the shrubbery cast Maxfield Parrish–like shadows on the stucco walls.

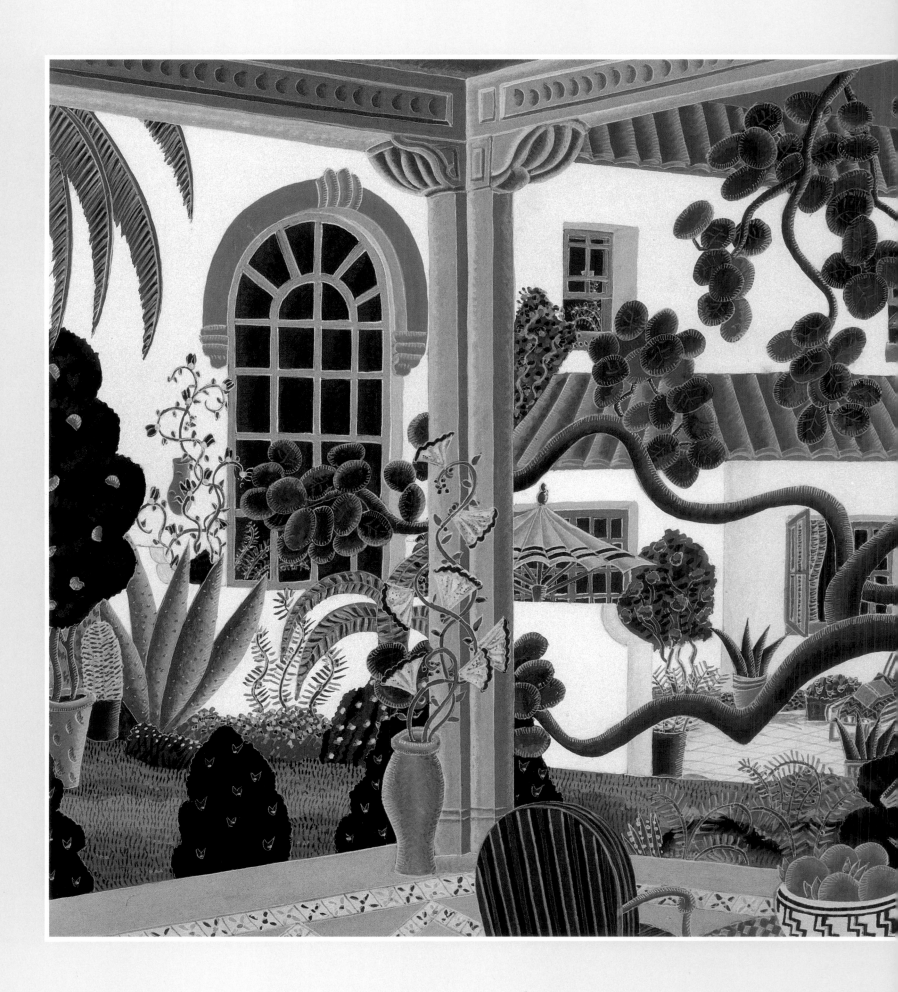

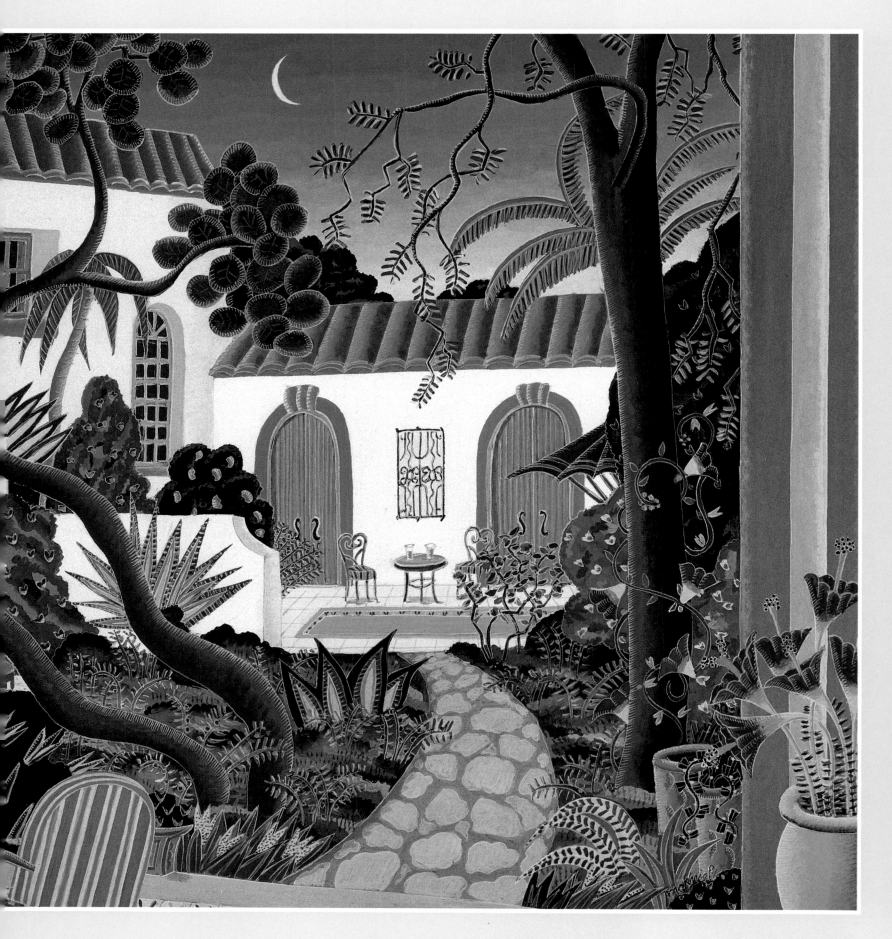

BIENESTAR GARDEN

APPENDIX

BIOGRAPHICAL NOTES

Thomas McKnight

Thomas McKnight, born in 1941 in Lawrence, Kansas, grew up the eldest child in a Midwestern middle–class family, although he was early transplanted to the suburbs of Montreal, Washington, D.C., and New York. He was a dreamer, taking long walks and devouring an eclectic mixture of Richard Haliburton's *Book of Marvels* and histories of Greece and Rome, along with the more traditional *Treasure Island*.

With junior high school, his purview extended to Washington itself. The National Gallery, the Phillips Collection and rare book shops became his Saturday haunts. It was at this time, at about age fourteen, that his mother gave him a set of oils and he began to paint. His first canvas depicted a medieval castle on a snowy hill, a subject he says he is still trying to perfect. During these first years of painting he read and tried every thing he could concerning the techniques of the old masters, but his enthusiasms ranged over the whole history of art, from Egypt to Rothko and Guston.

In a chance meeting with Alexey Brodovitch, the famed graphic designer, then Art Director of *Harper's Bazaar*, young McKnight received encouragement and praise for his work—and the advice that he should "go to Paris and look at everything".

While in high school, McKnight moved with his family to Long Island, and later enrolled at Wesleyan University in Middletown, Connecticut. In his junior year he managed to get to Paris, ostensibly to study French for a career in art history. There he stayed with a White Russian couple in haute bourgeois Passy but lived the bohemian life in the Latin Quarter cafe's.

Upon returning for his final year at Wesleyan he became "avant–garde," painting words and letters from Ionesco plays and images in the prevalent style of Pop Art. Although he graduated cum laude from Wesleyan, that was enough to have him refused admission to the Yale School of Fine Arts, which didn't think he was serious enough to benefit from its instruction.

He then attended Columbia University, an important aspect of which was that he was able to live in Manhattan. There he studied art history at the graduate school under the great art historian Meyer Schapiro and others, but he began to spend less and less time in class and more time painting, until finally he ceased attending class altogether.

A job as a file clerk at *Time* magazine followed. This was

succeeded by many different and ascending positions in the company over a period of more than seven years. A two–year hiatus in Korea, as an Army draftee, showed him a world that could not have been more different from New York. Hiring a local rice farmer to help him, he made huge pointillist paintings on local bleached muslin with imported paints.

After his return to civilian life and *Time*, he took on the additional job of an unpaid weekly art critic for a radical New York radio station. This experience opened his eyes to the vacuity of much contemporary art. A trip to Greece in the same year made him realize that there was more to life than the corporate world. After two weeks in the heady atmosphere of an island in the Agean he was determined to break away.

Upon his return to New York, he retreated every day after work into a small apartment to paint, and finally decided to leave his job at *Time*. A year later, his decision bore fruit. A first show took place in Washington, D.C. While it was not the financial and critical success that most debutante artists expect, it sold enough work to keep him going. Soon after that, an agent arranged his first show in Europe, in a gallery near Stuttgart. For a number of years he survived (but just barely) by the sale of his paintings in both Europe and America. His first silkscreen prints were published in 1979 and that proved to be a turning point. His imagery had tremendous popular appeal and propelled him as an artist to the position he holds today.

Also in 1979, on the Aegean island of Mykonos, the most romantic setting possible, McKnight met a glamorous student from Austria named Renate. They married and now live in Palm Beach, Florida, a lush sub–tropical setting of the kind that inspires much of his work.

Annie Gottlieb

Annie Gottlieb graduated from Radcliffe College in 1967. Her criticism, essays, and journalism have appeared in *The New York Times Book Review*, *The Village Voice*, *Vogue*, *McCall's*, *Redbook*, *Mademoiselle*, *MS.*, *Mother Jones*, *New Age Journal* and elsewhere. She is co–author with Jacques Sandulesco of *The Carpathian Caper* (Putnam, 1975) and with Barbara Sher of *Wishcraft* (over 300,000 sold in Ballantine trade paperback) and *Teamworks!* (Warner Books, 1989), and is the author of *Do You Believe in Magic? Bringing the Sixties Back Home* (Times Books, 1987; Fireside, 1988).

Index

Alphabetical List of the works with technical data

The data for each work are given in the following order:

Title (suite)
year issued (edition numbers, paper)
sheet size—image size
printer
page

Works that are part of a suite are listed individually in alphabetical order, as well as under the title of the suite. The data for these works are given under the title of the suite; only items that vary from these data are given under the title of the work.

All works are published by Chalk & Vermilion Fine Arts.

The works whose titles are followed by an asterisk are reproduced from paintings. Prints inspired by these paintings will be published later and may have other dimensions.

ABBREVIATIONS

AP = Artist's Proofs
HC = Hors de Commerce
PP = Printer's Proofs
TP = Trial Proofs

Aegean Bar
1988. (Numbered; 1–200, I–CC, AP 1–40, PP 1–4, TP 1–6, HC 1–40)
32⁹/₁₆x35³/₈"—26 x 29³/₈"
Chromacomp, New York
63

Alefkandra (see Return to Mykonos Suite)
58

Anguilla (see In the Tropics Suite)
97

Antibes (see Côte d'Azur Suite)
117

Antigua (see In the Tropics Suite)
93

Art Deco Room
1988. (Numbered: 1–200, I–CC, AP 1–40, I–CC, TP 1–4, PP 1–6, HC 1–40)
39³/₄ x 43"—34¹/₄ x 38"
Chromacomp, New York
79

Barbados (see In the Tropics Suite)
91

Beacon Hill*
1989. Casein on canvas.
28 x 30"
29

Bel Air
1989. (Numbered: 1–200, I–CC, AP 1–50, PP 1–6, TP 1–4, HC 1–50)
39 x 43"—34¹/₂ x 37¹/₂"
Willco Fine Arts, Brooklyn, New York
129

Beresford
1988. (Numbered; 1–200, I–CC, AP 1–40, TP 1–4, PP 1–6, HC 1–40)
32 x 34"—27 x 30"
Willco Fine Arts, Brooklyn, New York
81

Bienestar Courtyard
1989. (Numbered: 1–200, I–CC, AP 1–50, TP 1–4, PP 1–6, HC 1–50)
36¹/₂ x 66"—30 x 60"
Chromacomp, New York
164/165

Bienestar Garden*
1989. Casein on paper.
18¹/₄ x 36"
180/181

Boca Raton
1989. (Numbered; 1–200, I–CC, AP 1–50, PP 1–6, TP 1–4, HC 1–50)
38⁷/₈ x 43"–33⁷/₈ x 38¹/₈"
Willco Fine Arts, Brooklyn, New York
169

Boston Public Gardens
1989. (Numbered: 1–200, I–CC, AP 1–40, TP 1–4, PP 1–6, HC 1–40)
43³/₈ x 39¹/₈"—35³/₈ x 33⁵/₈"
Chromacomp, New York
22

Breakers (see Palm Beach Suite)
174

Ca' d'Oro (see Venice Revisited Suite)
157

Campo Manin (see Venice Revisited Suite)
159

Cannes (see Côte d'Azur Suite)
115

Cap Ferrat (see Côte d'Azur Suite)
116

Cape Ann (see New England Suite)
42

Capriccio
1988. (Numbered; 1–200, I–CC, AP 1–40, TP 1–4, PP 1–6, HC 1–40)
32¹/₂ x 33⁷/₈"—26 x 27⁷/₈"
Chromacomp, New York
153

Carnival in Venice
1988. (Numbered: 1–200, I–CC, AP 1–45, TP 1–4, PP 1–6, HC 1–45)
40³/₈ x 42³/₄"—34¹/₂ x 38¹/₄"
Chromacomp, New York
151

Catalina
1989. (Numbered: 1–200, I–CC, AP 1–50, PP 1–6, TP 1–4, HC 1–50)

N.B. In the index of *Thomas McKnight's World* (1987), the edition sizes of three prints were given incorrectly. The correct information is as follows:

La Jolla *(Numbered: 1–175, I–CL, AP 1–40, HC 1–40, PP 1–26, TP 1–4)*
Santa Barbara *(Numbered: 1–175, I–CL, AP 1–40, HC 1–40, PP 1–26, TP 1–4)*
Palm Beach *(Numbered: 1–175, I–CL, AP 1–40, HC 1–40, PP 1–40, TP 1–4)*